LIGHTHOUSES

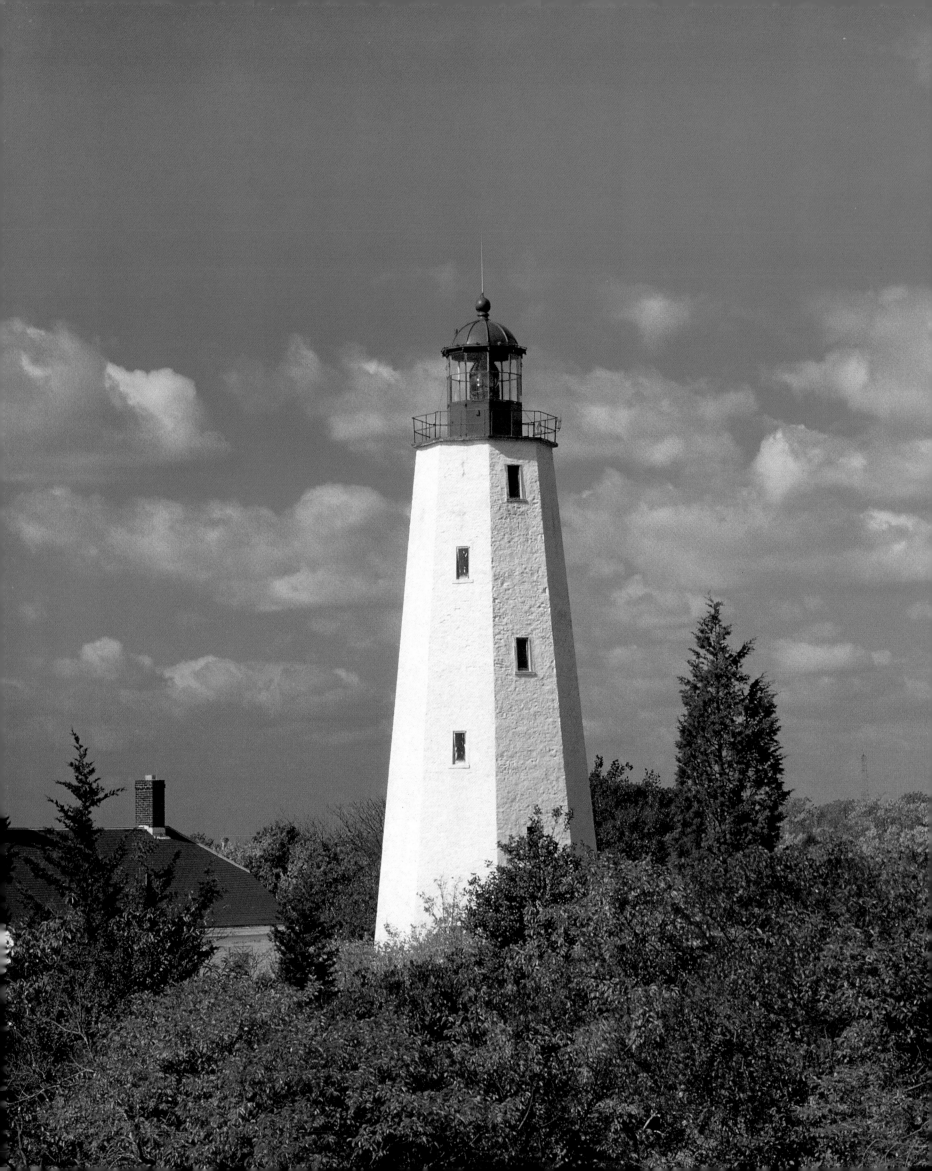

LIGHTHOUSES

F. Ross Holland

MetroBooks

MetroBooks

An Imprint of Friedman/Fairfax Publishers

Library of Congress Cataloging-in-Publication Data
Holland, F. Ross (Francis Ross), date
Lighthouses/F. Ross Holland.
p. cm.
Includes bibliographical references and index.
ISBN 1-56799-201-3
1. Lighthouses—History. I. Title.
VK1015.H65 1995
387.1'55'09—dc20 95-5545
 CIP

Editor: Hallie Einhorn
Art Director: Jeff Batzli
Designer: Lynne Yeamans
Layout: Philip Travisano
Photography Editor: Jennifer Crowe McMichael

Color separations by HK Scanner Arts Int'l Ltd.
Printed in China by Leefung-Asco Printers Ltd.

For bulk purchases and special sales, please contact:
Friedman/Fairfax Publishers
Attention: Sales Department
15 West 26th Street
New York, NY 10010
212/685-6610 FAX 212/685-1307

Dedication

For Henry and Desiree

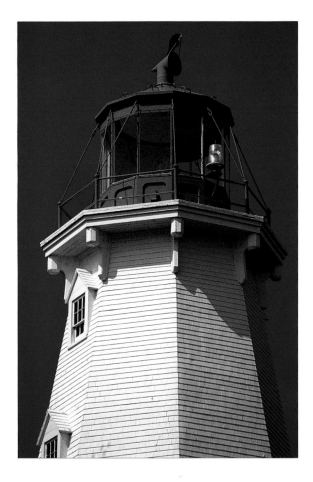

Contents

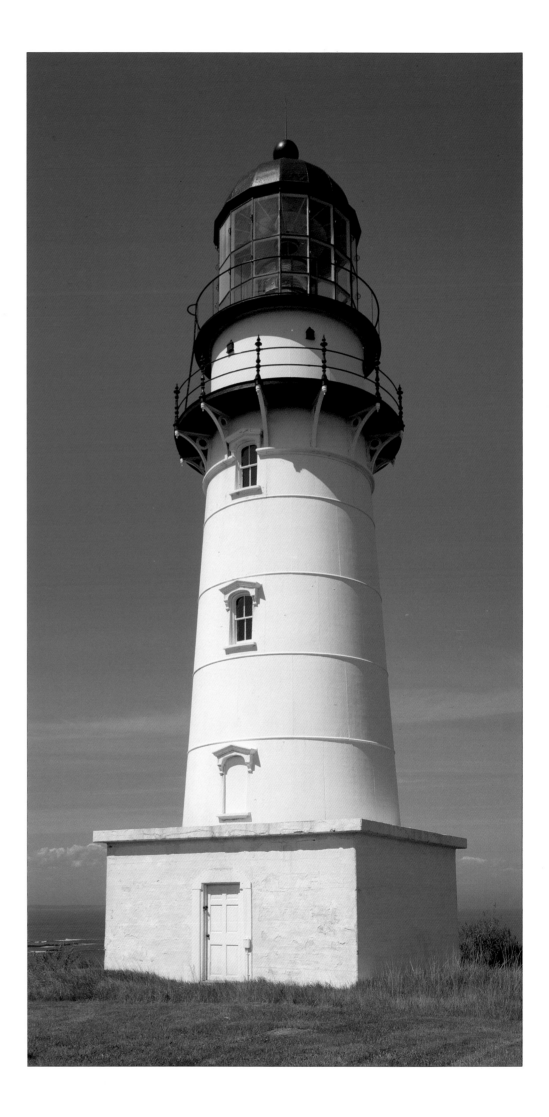

LIGHTHOUSES
OF
ANTIQUITY

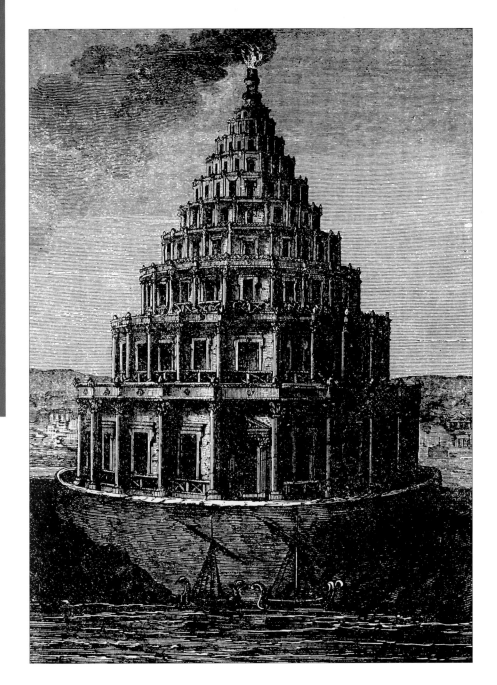

This page: A magnificent and daring structure for its time, the Pharos of Alexandria served mankind for one thousand years as a lighthouse and five hundred years as a daymark. Opposite: The Tower of Hercules stands on a hill overlooking La Coruña Harbor. Much of the original tower is covered by repairs made in the seventeenth, eighteenth, and nineteenth centuries.

The lighthouse has been a feature of navigation and cultural growth for most of recorded history, though its greatest use has occurred in only the past two centuries. Its proliferation as an aid to navigation has sometimes followed and sometimes led the technological advance of methods for providing light of enough intensity at a height sufficiently above sea level to serve as an accurate guide for ships.

In addition to their navigational function, lighthouses have architectural significance as artifacts of cultural development that have often outlasted their builders by years, even millennia. While the height of their development as technical aids to navigation has been reached during recent times when technological advance has been greatest, the peak of their development as

architectural specimens was reached during the early centuries of their use when technology moved at a slower, sometimes barely perceptible pace.

Architecturally, the golden age of the tower occurred during the earlier centuries of lighthouse construction. The Pharos of Alexandria, generally regarded as the world's first lighthouse, was considered one of the Seven Wonders of the World. Completed in Alexandria, Egypt, in the third century B.C., this light tower was a striking

structure, displaying elaborate carvings as well as other ornamentations. About 450 feet (137.1m) tall, the Pharos rested on a square base of thick stone that was 360 feet (109.7m) on each side. The lighthouse itself was built in three sections, each a different size and shape. The bottom component was the largest. Square in shape, it was nearly 100 feet (30.4m) on each side and 236 feet (71.9m) tall. The middle section was octagonal, rising 114 feet (34.7m) into the air. Sitting atop the other two,

the smallest section was an 85-foot-tall (25.9m) cylinder surmounted by a container for holding fire, the source of light.

Designed and built by a man named Sostratus, the lighthouse was requisitioned by Ptolemy, a Macedonian ruler of Egypt. The presence of the architect's name on the wall of the completed structure gave rise to two contradictory legends. One legend holds that Ptolemy, in a fit of generosity uncharacteristic of a monarch, directed Sostratus to take credit for the structure. The other legend, however, suggests that it was Sostratus' idea to display his own name on the lighthouse wall. According to this account, the clever architect carved his own name deep into the wall, plastered over it, and then carved Ptolemy's name on the plaster, knowing that the substance would wear away within a few years and expose the name underneath.

The lighthouse served as an aid to mariners for more than fifteen hundred years, but during that time it suffered at the hands of man and nature. Several times invaders and earthquakes damaged the structure. The final blow came in the fourteenth century when an earthquake totally demolished it.

Another well-known early lighthouse was the one erected at Ostia, the port of Rome. Built around A.D. 50, this lighthouse survives today only on coins and in mosaics, which show it to have been a four-stage structure, each

stage being smaller than the one below it. A fire glowed atop the upper tier in order to guide vessels into the commercially active port.

The Romans also built a lighthouse north of La Coruña on the northwest coast of Spain. Originally named La Coruña lighthouse, this structure has

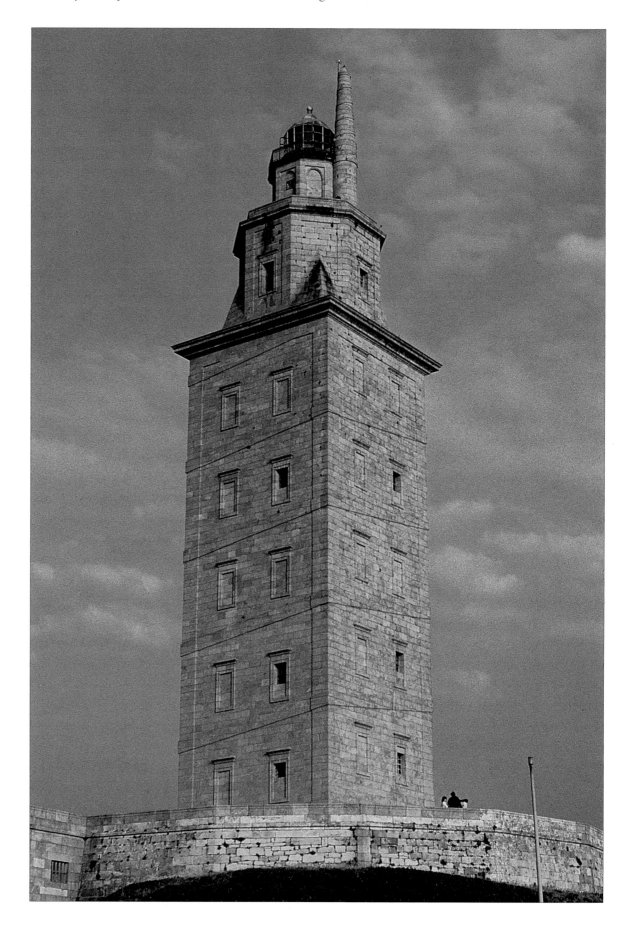

COLOSSUS OF RHODES

There are a number of structures dating back to the time of the Roman Empire and earlier that purportedly served as lighthouses, though no evidence that they actually fulfilled this purpose exists. One such structure was the Colossus of Rhodes. Although there are tales of lights having been maintained in this statue's eyes and in one of its hands, there is no corroborating evidence. Allegedly, the statue was destroyed by an earthquake around the time that work first began on the Pharos of Alexandria.

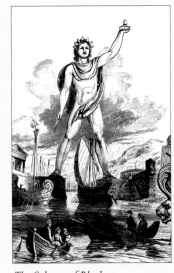

The Colossus of Rhodes.

come to be known as the Tower of Hercules. The architect was Gaius Sevius Lupus, a native of Lusitania, a Roman province claiming roughly the same boundaries as today's Portugal. The lighthouse was active during at least the fourth and fifth centuries A.D., but apparently it was abandoned after the Romans left the area. It was not until 1682, as area shipping increased, that Spain refitted the structure as a lighthouse and brought it back into service. The Spanish undertook a major renovation of the light tower in 1791, increasing its height, strengthening it with new stone that covered the exterior, and adding a new stone lantern. Though the entire Roman exterior was covered, elements of the original construction can still be seen on the interior walls.

Before 1791 the tower had been lit with two braziers atop it. The new lantern housed just one, which was later replaced by a lamp and reflector system of lighting. This light served until 1847 when it was replaced by a Fresnel lens containing an oil lamp. In more recent years, the oil lamp was replaced with electricity. Today this lighthouse survives as the oldest active lighthouse in the world.

The original lighthouse at Boulogne was another tower possessing an interesting history. Erected on the French side of the Dover Straits in A.D. 44, this structure came to be known as the Tour d'Ordre. Caligula, the mad Roman emperor of the time, was particularly

hungry for power and glory. He arrayed his troops in military formation along the shore and challenged Neptune to battle. When the god of the sea failed to appear and accept the challenge, Caligula simply declared himself the winner. The lighthouse was erected in commemoration of Caligula's victory over Neptune.

Built in twelve incremental stages, each smaller than the one below it, the 124-foot-tall (37.7m) tower was octagonal. A fire at the top supplied light to guide the ships. Constructed of red bricks and gray and yellow stone, the tower was considered to have been a memorable edifice. However, with the waning of Roman power, the structure fell into disuse. It is believed that in A.D. 800 Charlemagne ordered that it be repaired and put back into service. Apparently, it was lit from time to time until 1600. Then, in 1644, the cliff on which this monument stood gave way and the tower, which had served as a lighthouse and daymark for about sixteen hundred years, collapsed.

According to legend, the first lighthouse to be erected on the islet of Cordouan, five miles (8km) offshore at the mouth of the Gironde River, was built in the ninth century by Louis the Pious, son of Charlemagne. This lighthouse, like its successors, was built to warn ships engaged in the wine trade with Bordeaux of a hazardous collection of rocks located near the estuary's center. Monks conducted the operation

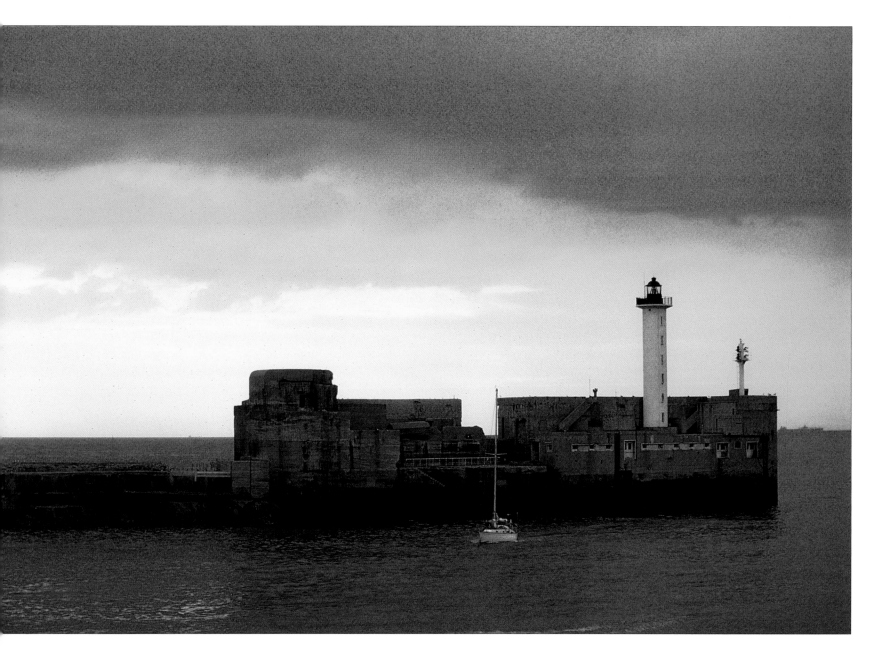

of the lighthouse, collecting duties from ships trading in the area.

In the late fourteenth century, Edward the Black Prince had a new lighthouse erected on the island. The tower was polygonal and held an open fire on top. For the benefit of the monks, who continued to operate and maintain the lighthouse, a chapel and living quarters were built adjacent to the tower.

This lighthouse continued in use until the late sixteenth century, when the structure was found to be beyond repair. At this point, the engineer-

architect Louis de Foix undertook the design and erection of a replacement. The structure he designed was ornate and elaborate, boasting a royal chapel. During the early part of the lighthouse's construction, the island began rapidly wearing away, but the structure was saved by quickly erecting a seawall to halt the erosion.

Construction continued for over twenty years, first under Foix, then under his son, and finally under the chief mason. Light, which emanated from a fire held in a lantern, shone from the

tower in 1610, though work on the lighthouse was not completed until four years later. Given the elaborate design of the structure and the difficulties presented by the site of construction, it is no wonder the project took so long to finish.

Due to renovations undertaken from 1788 to 1791, much of the tower's original ornateness can no longer be seen. The lower half of the structure survives, but the upper half was given a tapered tower. Nevertheless, this lighthouse, which is the tallest

The original light tower at Boulogne fell into the sea in 1644, after long and distinguished service. Many years later the lighthouse shown here went into service, and it is still in operation.

rock lighthouse in the world, is still a remarkable structure. As a matter of fact, it was here that Augustin Fresnel tested his new lens light in 1822.

Around the end of the Dark Ages (about 1100), when the various countries of Europe began trading more with one another, shipping activity increased and more lighthouses were erected, particularly in France, Germany, England, and Italy.

One of the best known Italian lighthouses built during this period was the one at Genoa, erected during the twelfth century. In 1449 the keeper of this light was Antonio Columbo, uncle of Christopher Columbus. Perhaps the young Christopher received his interest in the sea from Uncle Tony. It is unlikely he received such inspiration from the remainder of his family since they were all weavers.

Damaged by military activities, the Genoa tower was taken down in 1544 and replaced by a square tower that consisted of two sections, each 100 feet (30.4m) tall, the smaller placed on top of the larger. Unfortunately, the 200-foot-tall (60.9m) brick tower had a tendency to attract lightning, so the keepers turned toward religion in an attempt to fend off the dangerous bolts. They erected a statue of Saint Christopher nearby and engraved pious statements on it. But the religious approach did not succeed, and although Benjamin Franklin's lightning rod reached Europe by 1759 at the latest, it was not until

nearly twenty years later that the Italians used it to solve their problem. The Genoa lighthouse is considered to be the tallest lighthouse that is still active. It is a remarkable monument to the lighthouse idea.

Other lighthouses were erected in Italy during the Middle Ages: at Meloria in 1157, at Messina in 1194 (used to guide ships through the Strait of Messina), and at Venice in 1312. The one in Meloria, built on a shoal, was the first rock, or wave-washed, lighthouse. The shoal had been a hazard on the route to Porto Pisano. This lighthouse was destroyed several times during wars between Italian city-states, its final destruction occurring in 1290. In 1304 a replacement lighthouse was erected in the harbor of Livorno.

The light provided by early lighthouses was produced by a flame, usually an open fire exposed to the elements and whipped around by the wind. A heavy wind from the land would produce a brighter light on the seaward side of the tower, thus providing a better light for the mariner. A heavy wind from the sea, however, was less than helpful, diminishing the flame on the seaward side and making navigation more difficult for sailors.

Heavy rain must have played havoc with the flame. In later years, covered lanterns helped protect it from the elements. Still later, some lanterns were enclosed with glazing to shelter the flame. The light emanating from such a

lighthouse was often reduced, particularly if the keeper did not clean the glazing regularly and meticulously.

For many years the fuel for the fire in these lighthouses was wood, which could be consumed at a prodigious

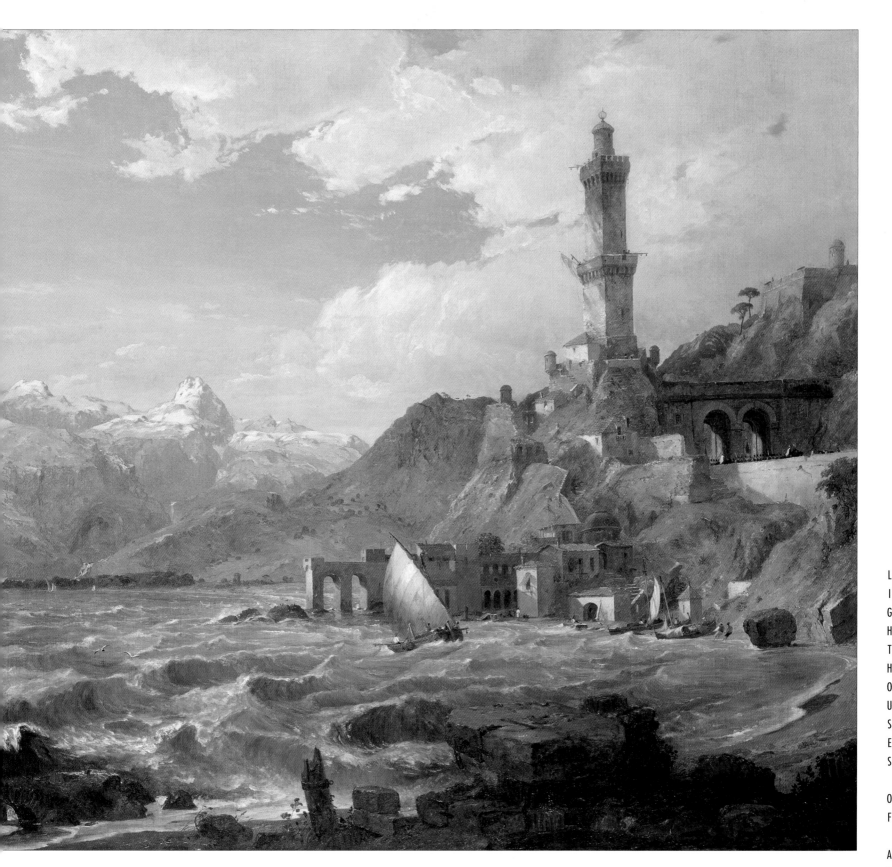

rate. A lighthouse erected on the seashore at the edge of a forest could denude the area in a relatively short period of time.

It was after 1500 that the use of coal in lighthouses increased. Because coal burned more slowly and produced a better light than wood, it proved to be a more satisfactory fuel. When blown by the wind, however, a coal fire could become hot enough to melt and damage the brazier or grate holding it.

Despite this major disadvantage, coal-burning lighthouses continued in use well into the nineteenth century. The last open coal fire displayed in Europe was extinguished in the middle of the nineteenth century.

The present Genoa tower was erected in 1544. This painting of the tower was done in 1854.

LIGHTHOUSES OF THE BRITISH ISLES

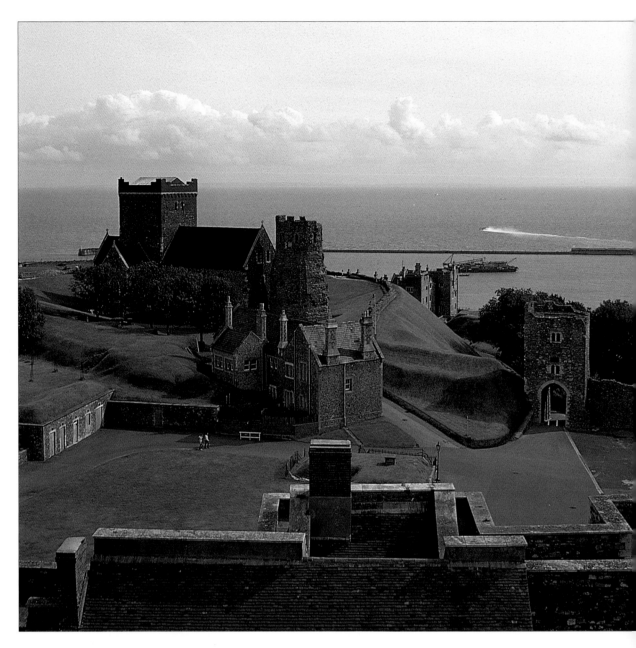

Although the Romans occupied the territory of the British Isles for a lengthy period of time, they erected only a few lighthouses to illuminate the waters and shores of this region. At Dover, the Romans constructed two lighthouses sometime during the first century. One of these structures still exists, but many questions regarding its early operation remain unanswered. Standing about 79 feet (24m) tall, the octagonal tower possesses beautiful, round arched windows that allow a substantial amount of light to penetrate its square interior.

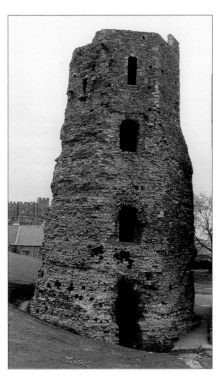

MEDIEVAL PERIOD

Dover tower can lay claim to being the oldest lighthouse in the British Isles, but the oldest active lighthouse in this region is Hook Point, at the entrance to Waterford Harbor in Ireland. Apparently the tower at Hook Point was erected in the late twelfth century. As at

Top: *Located beside St. Mary's church, the Dover light tower is a magnificent sight.* ***Bottom:*** *Dover lighthouse, one of the few lighthouses erected by the Romans in the British Isles, went into service about the end of the first century A.D.*

other sites, monks operated and maintained the lighthouse, as well as collected tolls. This stone tower was more than 100 feet (30.4m) tall and about 40 feet (12.1m) in diameter.

In addition to the light in Waterford Harbor, medieval Ireland purportedly had a lighthouse at Youghal that was attended by nuns who used torches to guide vessels into the harbor. Built in 1190, the lighthouse remained in operation until 1542, when the nuns left.

Only one coastal lighthouse, Tynemouth, is known to have existed in England before 1600. Located at the mouth of the Tyne, as its name suggests,

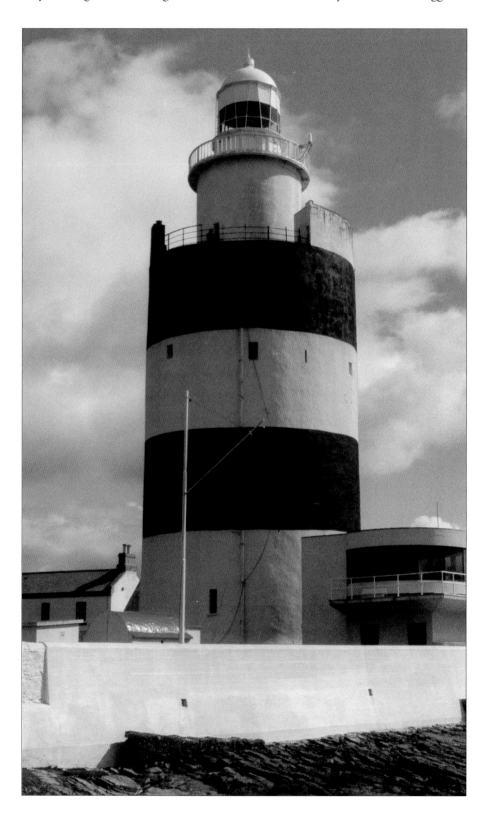

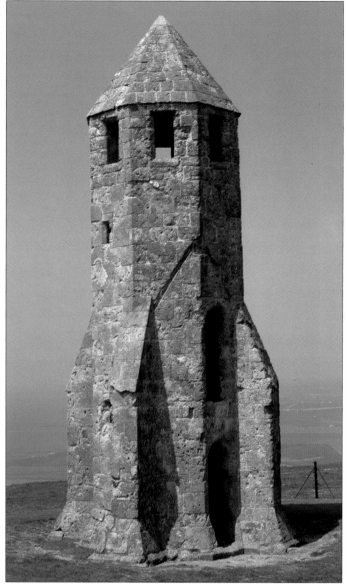

this coal-burning lighthouse served to guide mariners into that river. Just up the Tyne, two masonry towers were erected as range lights for navigating the river. These aids were collectively named North Shields, and they dutifully performed their service until 1808, when they were rebuilt.

Other lighthouses of the period were relatively small, such as the light at St. Catherine's on the Isle of Wight, built in 1323 to warn navigators of the dangerous shoals along that coast. At Spurn Point, on the eastern coast of England, a hermit petitioned the king

Left: Formerly operated by monks, the Hook Point light came under private operation in 1665.
Right: *St. Catherine's light tower was established after a shipwreck occurred in the area. The original tower, shown here, was out of service by 1785, and a new tower took its place.*

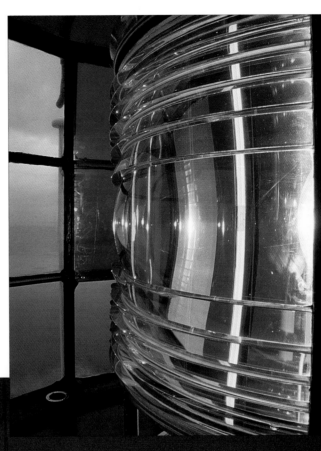
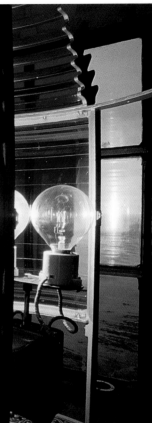

*op: Lens light of
the Youghal light-
house. Note the
1,000-watt lamp.
Bottom: The
present lighthouse
at Youghal (shown
here) went into
service in 1852.

to assist him in building a lighthouse to
guide vessels into the Humber River. In
response to this plea, the king gave him
a permit to collect tolls for ten years.

Scotland also erected several light-
houses during the medieval period.
In 1556 Aberdeen placed a portable
lantern on a chapel to guide ships into
the harbor. The light, which was funded
by a system of tolls, was active only
from September to April. The harbor
of Leith apparently had a light at its
entrance as well.

Administration of British Lighthouses

England's lighthouses are under the administration of Trinity House, a corporation that grew out of medieval mariners' guilds, which were primarily concerned with the welfare of aged members and seamen's widows and orphans. These guilds, which were located at various ports throughout England, had control of the pilots in their districts. In 1514 the guild operating on the Thames requested that the king reauthorize it to honor the Holy Trinity and Saint Clements. The new charter changed the name of the group to the Brethren of Trinity House of Deptford Strond. Although the guilds were independent organizations, a unity of sorts developed in time as each of these groups, whether based at Hull, Leith, or London, adopted the name Brethren of Trinity House. The first Trinity House to receive authorization to build and maintain lighthouses was the one at Newcastle. In order to pay for the construction and maintenance of two proposed lighthouses, the organization was given the power to collect duties from foreign and domestic ships.

This authorization initiated a change in the way lighthouses were built and operated. Originally, the crown either erected a lighthouse or gave a patent to a private citizen to build and operate one at a designated site; such a patent included the right to collect tolls from ships that used the lighthouse. At the time, these tolls were referred to as dues or duties. Today they would be called "user fees." England was one of the few countries that charged for their aids to navigation. Other countries paid for them out of the general treasury, believing that, as George R. Putnam of the United States Lighthouse Service once said, "the building and the keeping of the lights is a picturesque and humanitarian work of the nation."

Of all the Trinity Houses around England, the one at Deptford Strond became the most prominent and influential. At its rechartering it had been authorized to develop and enforce rules regarding shipping. Later, in an act of Parliament under Queen Elizabeth, Trinity House of Deptford Strond was recognized as being composed of the leading experts on ships and shipping, and it was given the authority to erect beacons, seamarks, and other navigational aids along the coasts of England and Wales. Some monarchs later found this authority troublesome since it had the potential to curb the sale of lighthouse patents to private individuals—a welcome source of money for the king.

Private Lighthouses

Trinity House of Deptford Strond had obtained primacy over its sister organizations, but it did not seem to assert its position to take charge of England's lighthouses. Perhaps it refrained from taking aggressive action out of concern over the ruling monarch's attitude regarding those revenue-producing lighthouse patents. Meanwhile, the crown continued to issue patents for lighthouses to private individuals. Not everyone who applied obtained a license, nor were their motives completely altruistic. Douglas B. Hague and Rosemary Christie, who wrote an admirable history of British lighthouses, said it was a shameful aspect of the country's maritime history.

The monarch himself did not issue a patent directly; rather, he sent an application for a lighthouse to the Privy Council. This council would then turn to Trinity House and various other sources for information and advice before making a recommendation to the king or queen. Potential patentees were responsible for obtaining statements from shipping interests of the need for a lighthouse at the proposed site. These documents were an important part of the application. The potential patentee also enlisted the support of courtiers who had connections with the crown, the council, or Trinity House by offering them peddler money or a percentage of the proposal.

ARGAND LAMP
AND
PARABOLIC REFLECTOR

The Argand lamp was the invention of Ami Argand. His lamp had a hollow, circular wick that permitted oxygen to travel up the inside and outside surfaces, giving a brighter burn. The light of its flame was equivalent to that of seven candles.

The reflectors were made from thin copper sheets that were molded into a parabolic shape. Once formed, they were silvered on the inside in order to maximize the light reflection.

The lamp and reflector were mounted together with the reflector placed behind the lamp. The reflector would then be adjusted in the appropriate manner to help focus the light. The number of sets of lamps and reflectors that were used in a lighthouse depended on the purpose of the light. As many as fifteen or more lamps and reflectors would be used in a coastal lighthouse that required a bright light.

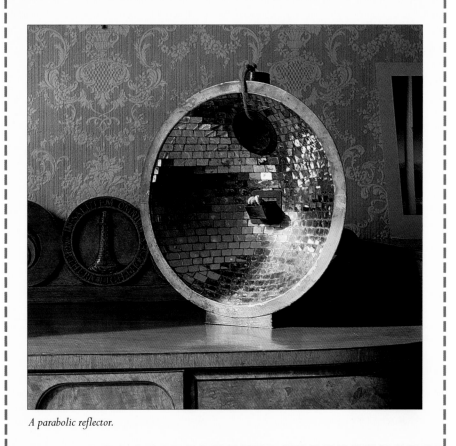

A parabolic reflector.

TRINITY HOUSE OF DEPTFORD STROND TAKES OVER LIGHTHOUSES

As the eighteenth century approached, Trinity House of Deptford Strond began to play a more assertive role in the establishment of new lighthouses, for after 1679 all new lighthouse patents went to the corporation. Many lighthouses thereafter were erected by private individuals who obtained patents from Trinity House, which would receive the rents for these lighthouses.

The corporation itself erected few lighthouses. But in the late 1700s, its interest in operating lighthouses and lightships increased sharply; this change occurred in part because a number of the private lighthouses' and lightships' leases were about to expire at this time and the dues from them would be beneficial to Trinity House's charities, which included pensioners, alms houses, and seamen and their dependents. Moreover, the Argand lamp and parabolic reflector, a much better light, was being manufactured in London, and shipping interests were demanding stronger lights. If Trinity House had control of the lighthouses, it could respond with greater alacrity to the shippers' concerns.

In 1822 Parliament authorized Trinity House to purchase several lighthouses. Then, in 1836, after examining

Trinity House's operations, Parliament passed an act authorizing the corporation to buy the patents for all coastal lights still in private hands. Thereafter it was no longer necessary for Trinity House to have a patent to erect a lighthouse. A new uniform rate for dues came into service, and tolls for coastal lights went solely to lighthouse needs. By 1841, Trinity House owned all of England's coastal lighthouses.

ADMINISTRATION OF SCOTLAND'S LIGHTHOUSES

In 1786 Parliament established a board of trustees, authorizing it to build four lighthouses in Scotland. After completing that task, the board was authorized to erect more lighthouses. In 1798, Parliament changed the board's name to Commissioners of Northern Light-

houses. Since that time the commissioners have been responsible for putting up lighthouses and operating them. They are sometimes referred to as the Lighthouse Board.

ADMINISTRATION OF IRELAND'S LIGHTHOUSES

As of 1767 the Commissioner of Barracks was responsible for managing Ireland's lighthouses. This duty, however, was transferred to the Customs Board in 1796. Over the next few years, Parliament became unhappy with the way the board operated, and once again the responsibility for lighthouse operations was transferred, this time to the Port of Dublin Authority. For the next fifty years or so, this organization carried out its duties satisfactorily, but in 1867 the Commissioners of Irish Lights was

established to take over the management of lighthouses. It is with this administrative body that the control over Irish lighthouse operations lies today.

ENGLISH COASTAL LIGHTHOUSES

The patent for the first English coastal lighthouse was given out in 1615 to Sir Edward Howard, whom the king had appointed Admiral of the Narrow Seas, a position roughly akin to Admiral of the Montana Navy. The tower was erected at Dungeness, on England's southern coast, around 1616. The coal fire atop the tower induced many to see

the efficacy of such a light at that point. Over the years the shore in that area accreted, putting the lighthouse too far inland to be of use. In 1792 it was replaced by a new tower, which was ultimately replaced by one made of reinforced concrete in 1965.

Lizard Point in Cornwall was the site of numerous shipwrecks from which many of the local citizens profited. Indeed, they have been accused of causing many of the wrecks. In 1619 the owner of the land, Sir John Killegrew, received a patent to put up a light tower at this hazardous point. His neighbors, all wreckers, were of course unhappy with this development; they claimed that Killegrew was interfering "with God's grace." To make matters worse, Killegrew was receiving very little money from this venture, mainly because the patent had stipulated that duties would be obtained by voluntary

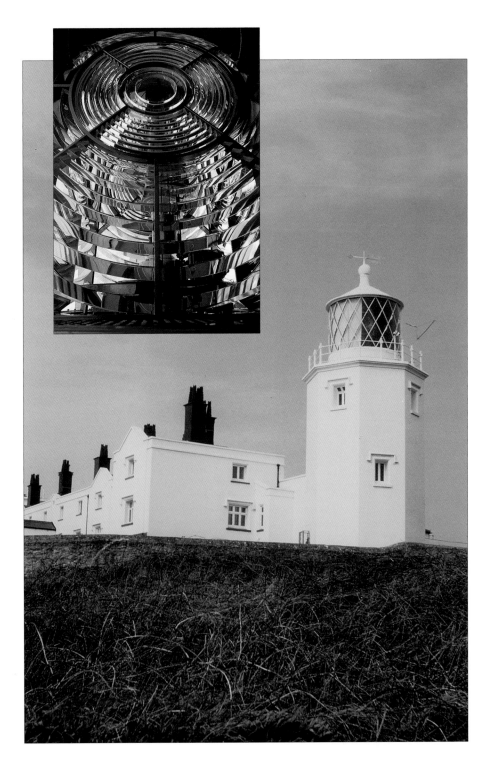

eft: This two-story circular structure is what is left of the 1792 Dungeness lighthouse. The black and gray structure in the foreground is the 1904 reinforced concrete tower, and the slender black and white banded tower in the background was built in 1961.

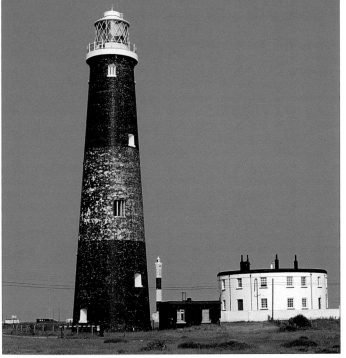

contribution. The lack of profit combined with the aggravation presented by his neighbors led Killegrew to close down the lighthouse in 1625; it was not lit again until 1752.

The Spurn light was one of those lighthouses that Trinity House of London fought, arguing that it was not needed. Spurn Point, located at the entrance to the Humber River about twenty miles (32km) south of Hull, saw an increasing number of shipwrecks because of dangers created by the shifting sands off the point. Some members of the shipping community, however, felt that a light might be more detrimental than beneficial because the shifting sands would change the channels, causing the light to be unreliable. In time, though, a substantial number of people

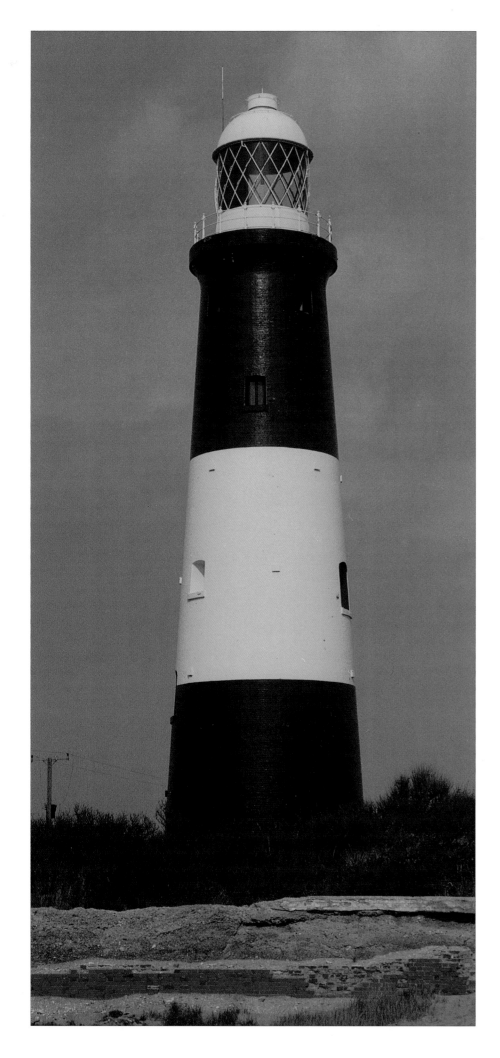

came to the conclusion that any light would be better than none. The shippers approached the owner of the land, Justinian Angell, and asked him to erect a lighthouse with the understanding that they would pay dues according to an honor system. He put up the light around 1672. The arrangement was successful, and in 1676 Angell applied for a patent, which he received with the help of the Trinity Houses at Hull and Newcastle.

After examining the site, those involved realized that one light would not be as effective as two, so Angell applied for and received a patent for a second light. This second light was a lever light, or vippefyr. The lever light served as the front light of a range light. Range lights are used to help vessels stay in a channel; the ship's captain lines the lights up so that one appears to be on top of the other. As long as they are in that position, the vessel is advancing on the proper course.

Shipping traffic to and from the Humber increased greatly, and Angell and his heirs received a good income from the duties. By the time the original patentee's grandson inherited the lights, however, everyone realized that these lights, because of shifting sands at the point, were dangerously out of place for navigators. But the grandson, a devious man, used as many tricks as he could to avoid building new lighthouses. Meanwhile, the Trinity Houses of Hull and London were deeply

Opposite, right: *Although the Lizard Point lighthouse once had two towers, one has been deactivated. Note the diagonal braces on the lantern glass. This type of lantern came into use in the late nineteenth century. Lighthouse engineers felt the diagonal bars would interfere less with the light than the horizontal and vertical braces used in earlier lanterns.*

Opposite, inset: *This is one panel of a 4-panel first-order lens used at Lizard Point. The bull's-eye at the center indicates that this lens was designed to rotate and give off a flashing light.*

This page: *The lighthouse shown here was erected at Spurn Point in 1895 to replace the former rear light.*

Top: The Skerries lighthouse has had dwellings and storage areas added to it over the years.

Bottom: *Flatholm was a private lighthouse that Trinity House purchased in 1923. Originally, the tower burned coal for its light. In 1820 it received a lantern and lamps and reflectors. Forty-six years later a new lantern and lens were installed.*

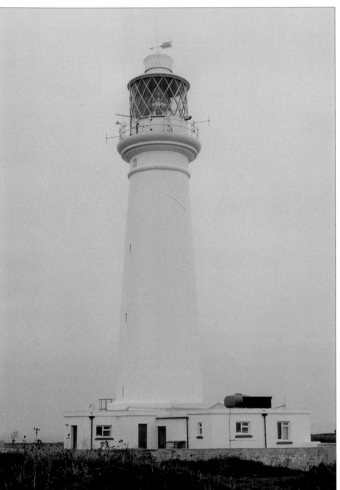

concerned about the accuracy of these lights, so they sent John Smeaton, engineer for the construction of the third Eddystone lighthouse (see page 26), to develop a solution to improve the efficacy of the range lights. Fighting to retain control, the Angell heir resorted to guerrilla tactics, including hiring hooligans to attack the workers and to dig a hole in the ground where the new lighthouse was to be placed. But the workers persevered, and the range lights went into service in September 1776. By 1786 erosion had taken the front range light, which was not replaced until 1816.

In 1846 Trinity House purchased the Angell range lights, paying £309,531. The price was high because

LEVER LIGHTS

The lever light was invented by Pedersen Grove of Denmark around the year 1625. It was a simple structure that consisted of a lever resting on a wooden frame. One end of the lever had a container that held the coal fire; this end was raised to the height that would put the flame in sight of mariners. When the fuel needed to be replenished, the container end was lowered, filled with coal, and raised back into position. Grove called it a vippefyr; the English referred to it as a swape.

the crown had given the first Angell a patent in perpetuity, instead of one that had to be renewed in a specific number of years. The original decision of Trinity House to fight the installation of a lighthouse at Spurn Point had not been a good one. Trinity House missed out on a sizable revenue, and ended up having to spend an enormous amount later to acquire the range lights.

Many other coastal lights were erected during the eighteenth century.

Trinity House had the patent for a lighthouse at Milford Haven in southern Wales and put up two towers there in 1714. These were the first lighthouses on the west coast of Wales. Portland, on the south coast of England, also had two lights, but both were within one tower with one light positioned above the other. This lighthouse first exhibited its lights in 1716. Also activated during this time were lighthouses at the Skerries (1717) on the north coast of Wales, Flatholm Island (1737) in the Bristol Channel, and the Farne Islands (1778) in the north of England.

ENGLISH WAVE-WASHED LIGHTHOUSES

The British Isles are noted for their offshore lighthouses and the engineers who built them. One of these wave-washed lighthouses is located on the Smalls, a low rock outcropping in the Irish Sea about twenty miles (32km) from the Welsh mainland.

A lighthouse at the Smalls was the brainchild of John Phillips, the assistant dockmaster in Liverpool. He envisioned a two-light configuration; a fixed white

light of 360 degrees would warn sailors of the dangerous rocks, while a green light would guide them through the nearby channels. Phillips obtained a lease for these rocks from the British Treasury, and he advertised for a design for the lighthouse. Although Henry Whiteside was a maker of musical instruments, the design he submitted

appealed to Phillips, perhaps, as has been suggested, because it was the simplest and least expensive. The lighthouse that Whiteside designed was a pile structure made mostly of wood. It was the country's first pile lighthouse.

Work began in the summer of 1775. The lighthouse was assembled ashore, then disassembled, and then

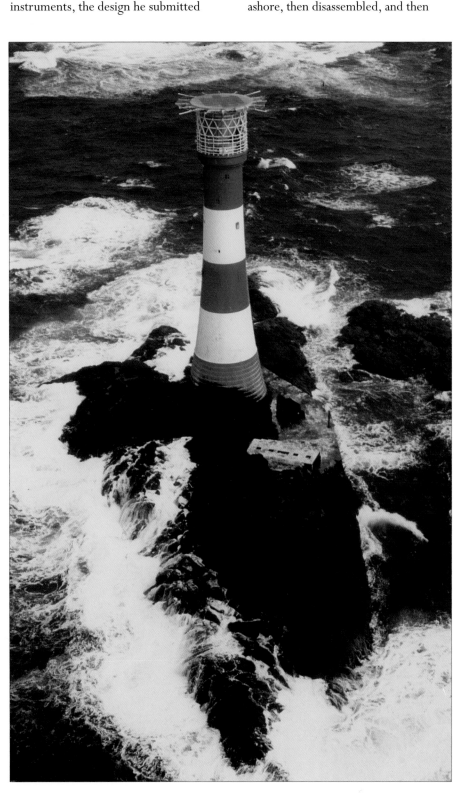

This masonry structure replaced the wooden pile structure that graced the Smalls until 1861. A helicopter platform was built on top of the lantern in order to facilitate rescues.

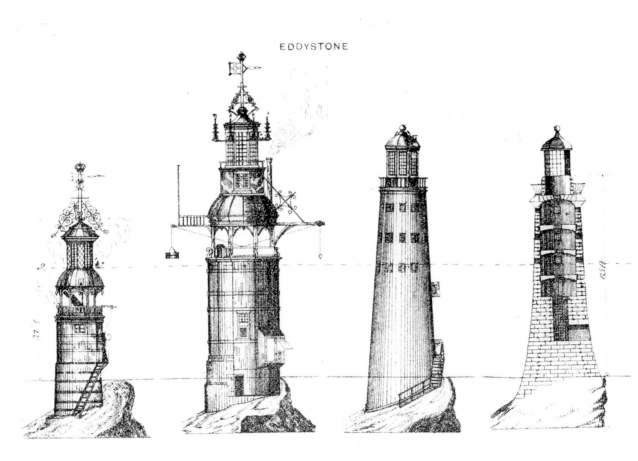

EDDYSTONE

From left to right, various towers erected at Eddystone: the original tower built by Henry Winstanley, the Winstanley tower with its addition, the tower built by John Rudyerd, and the tower built by John Smeaton.

transported to its designated site. While putting the structure together on the mainland, Whiteside found the iron legs to be unsatisfactory, so he substituted wooden ones, making the lighthouse all wood. At the actual site, construction progressed more quickly, partly because of the experience gained in the assembly, and more importantly, any ill-fitting parts had been taken care of ashore. Consequently, by the end of the 1776 season of construction, the lighthouse displayed its steady white light and the green light above it, just as Phillips had planned.

The lighthouse's first winter did not pass before it became apparent that the sea was damaging the supports. In the month of January, Whiteside and a worker journeyed to the Smalls in order to strengthen the lighthouse and

undertake repairs. Storms were taking their toll on the structure, and in February, Whiteside, unable to get back to the mainland, threw bottles into the Irish Sea with the hope they would drift to shore. Each bottle contained a note pleading for help; Whiteside and his companion were out of supplies, and there was no fire to light the aid to navigation. Fortunately, a note did reach the shore, and assistance was dispatched.

Having run out of money, Phillips closed the lighthouse and turned over his share to a consortium of Liverpool businessmen. This group appealed to Trinity House to take over, repair, and operate the lighthouse. When the work was completed, Trinity House leased the lighthouse to Phillips for ninety-nine years at the rate of five pounds a

year. The lighthouse went back into service in September 1778, but it no longer had the green light. Meanwhile, the white light was created from a lamp and reflector system.

Suffering through many instances of rough weather, the Smalls lighthouse survived for eighty-five years with the help of various repairs. The lighthouse proved very profitable to the lessee— so profitable, in fact, that Trinity House had to pay £170,468 to buy back the lease. Whiteside's lighthouse was in service until 1861 and was replaced by a 107-foot-tall (32.6m) stone lighthouse built by James Douglass, a renowned engineer who later became chief engineer for Trinity House.

Of the wave-washed lighthouses in the British Isles, the best known is Eddystone light, recognized by many from a popular folk song. The Eddystone Rocks, which had always been a hazard to ships, brought many to their end. Unfortunately, the rocks offered little room to sustain a lighthouse. But Henry Winstanley, a mechanical genius, rose to the challenge and entered into an agreement with Trinity House to erect an aid to navigation at this troublesome site. Construction began in 1696. Each day Winstanley and the crew would go out to the site from Plymouth where they would return in the evening, though occasionally they would stay overnight at the rocks.

During the second season of construction, the site was raided by a

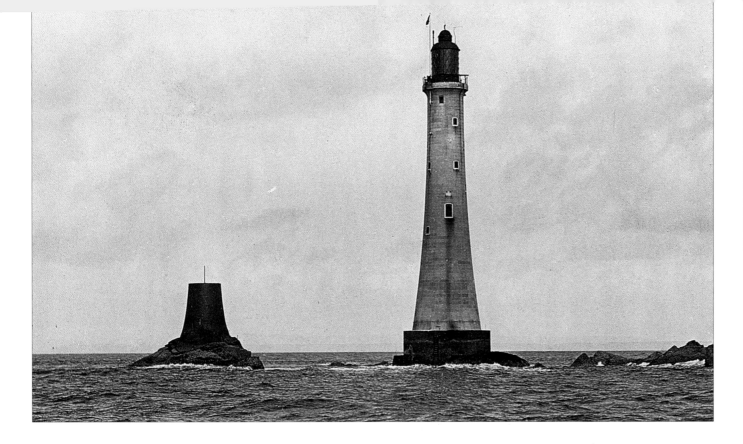

French privateer. The work crew was set adrift in the work boat and was rescued after the raiders had escaped. Winstanley, however, was taken to France, and was later exchanged for French prisoners in England.

Upon obtaining his freedom, the engineer returned to the rocks, where he completed construction in 1698. The 80-foot-tall (24.3m) lighthouse was lit for the first time on November 14 of that year.

As Winstanley watched over the lighthouse during the winter of 1698–1699, he noticed that storm waves would wash over the top of the structure. Consequently, he turned out the light and began work on what was in effect a second lighthouse, with the former one serving as its core. Winstanley placed heavy stones around the core, holding them together with metal banding. He also increased the height of the superstructure and raised the top of

the lantern by 40 feet (12.1m). The revamped light was in operation before the end of the year.

By November 1703, the lighthouse needed repairs, so Winstanley went out to the lighthouse with a work crew. Shortly after they arrived, however, a storm of notable severity arose. When the blow eased several days later, the residents on the mainland shore looked out toward the lighthouse only to find it had disappeared. No trace was found of Winstanley, the workmen, or the keepers; only a few iron rods protruding from the rock left testimony that a lighthouse had once been there.

Winstanley had established the need for a lighthouse at Eddystone, and the maritime community began clamoring for another. In 1706 John Lovett, a member of the Irish Parliament, and John Rudyerd, a silk mercer knowledgeable in mechanics, applied to erect a new lighthouse. Parliament passed an

act authorizing them to erect an aid to navigation there and to collect duties for ninety-nine years.

Rudyerd secured the foundation of the structure to the rocks with iron bolts. He then laid a base of stone and wood, upon which he raised a conical tower also made of these two materials. Sheathed with wood planks, the tower was surmounted by a wood lantern.

Rudyerd exhibited the light on July 28, 1703, and for fifty-two years it served the seamen who plied the area's waters. Disaster struck on December 2, 1755, however, when the lantern caught fire. Although the keepers attempted to extinguish the fire as it crept slowly down the wood-clad tower, their efforts were unsuccessful. Eventually, they were forced to seek safety on the rocks at the base. But not everyone escaped unscathed. Standing there helplessly, one of the keepers looked up in awe, his mouth wide-

open; a glob of hot lead fell into his mouth and down his throat. The eighty-four-year-old keeper reported the incident to a doctor, who examined his gullet but found no burns and dismissed the complaint. Twelve days later the keeper died; an autopsy disclosed a piece of lead weighing nearly half a pound (226.8g) in his stomach.

A group of businessmen now owned the tower, and they wanted to rebuild it since there were nearly fifty years left on the lease. Seeking an engineer to design and build a new lighthouse, they discovered John Smeaton. The investors wanted to erect a light tower similar to that of Rudyerd, for they felt the wood allowed the tower some give during storms. More knowledgeable on the subject, Smeaton retorted that it was not the elasticity that kept the tower from blowing over, but rather the weight of the heavy stones.

Smeaton began work in 1756. He designed a modified conical tower with a base that flared out to give a broader foundation. Meanwhile, the investors had outfitted a lightship and stationed it near the construction site so they could continue collecting dues. The vessel remained on site until October 9, 1759, when Smeaton exhibited the new tower's light, which consisted of twenty-four candles.

After the lighthouse had been in service for 123 years, defects were discovered, so a new tower was built. The upper part of the old tower was taken

down piece by piece and reassembled on the mainland at Plymouth on a base that replicated the original one. The new and taller tower, completed in

ILLUMINANTS

———

Illuminants for lighthouses evolved over the years as technology advanced. Fires fueled by wood or coal held out for a long time, the last one being extinguished in England in 1823. Candles came into use in some lighthouses perhaps no earlier than 1540, when they were used at North Shields. Some sites used oil lamps, which consisted of small containers filled with oil and a floating wick. The next step up was a cresset, which was a stone bowl containing oil and a fixed wick. Though many kinds of oil were used, the most popular were spermaceti and colza.

During the nineteenth century, gas was used in some British lighthouses. This fuel source, though, was not successful, due in part to the need to manufacture the gas at the site. By the end of the century, only small harbor lights that could obtain gas from their towns used it.

Petroleum oil or kerosene began being used around the 1870s in the regular lamps. In the early 1900s the incandescent oil vapor lamp came into use. This lamp vaporized oil and burned it on a mantle, giving off a bright light well suited to the Fresnel lens.

The next step was electricity, which was first used in arc lamps at Dungeness, in England, in 1862. These lamps were used until 1875. Electrified lighthouses originally needed to have a generator, but when power lines came, lighthouses could be quickly electrified. The first British lighthouse to receive electricity in this manner was at South Foreland in 1922.

In more recent years some lighthouses have been converted to use the xenon discharge lamp, which gives off a light infinitely brighter than any other light source previously used.

1882, was erected on another site at the Eddystone Rocks. It was built by Sir James Douglass, renowned engineer of Trinity House.

SCOTTISH WAVE-WASHED LIGHTHOUSES AND THE STEVENSONS

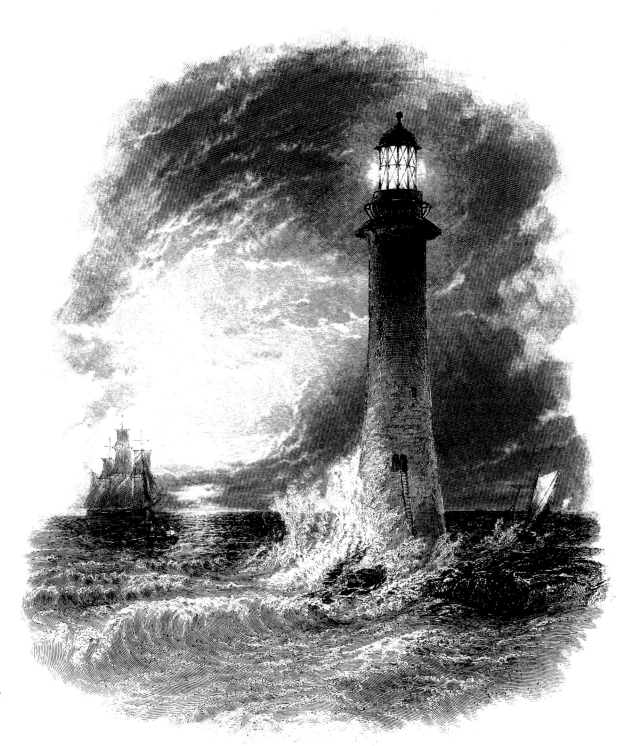

Another site similar in reputation to Eddystone Rocks was Bell Rock, or Inchcape Rock as it is also known. Located on the east coast of Scotland, a little north of the Firth of Forth and about 12 miles (19.2km) from Arbroath, the lighthouse is associated with Robert Stevenson, the progenitor of a remarkable family of lighthouse engineers.

Finding themselves in great need of a light at Bell Rock, various maritime interests struggled to persuade the government to erect an aid to navigation. The Northern Lighthouse Board had quietly instructed Robert Stevenson to gather information on the site and determine exactly what sort of aid ought to be installed. On visiting the site, the masterful engineer concluded that a stone tower was required. He prepared plans and estimated the cost of the tower. The Northern Lighthouse Board

then asked Parliament for authorization to erect the lighthouse, but all sorts of conflicts arose when the Corporation of London reduced the extent of the area in which dues could be collected; the smaller area would not provide enough money to financially support a tower such as Stevenson proposed. The board then turned to John Rennie, a leading engineer of the day (though one not

experienced in sea construction), to review Stevenson's plans and estimates. After visiting the site, he supported Stevenson's choice of a stone tower and reported only a slight difference in estimated cost. Upon receiving notice that the government would lend £25,000, the Northern Lighthouse Board decided to move forward with the plans for construction. The board appointed

Bell Rock light-house, completed in 1811, still serves commerce and safety. The involvement of two engineers in the project has given rise to a debate over who should have credit for its construction.

THE STEVENSON FAMILY OF SCOTLAND

The Stevenson family dominated the Scottish lighthouse service throughout the nineteenth century and well into the twentieth. Robert Stevenson, born in 1772, followed in the footsteps of his stepfather, who had become engineer of the Commissioners of Northern Lighthouses, the "Trinity House" of Scotland. His eldest son, Alan, also joined the commission, and his two younger sons, David and Thomas, became lighthouse engineers. David Alan Stevenson became engineer of the commission in 1887. His nephew D. Alan Stevenson was the last Stevenson to be involved with lighthouses. The latter wrote a number of books on these aids, including The World's Lighthouses Before *1820; he was at work on others when he died in 1972.*

Not only did the Stevensons build and design lighthouses— eighty-one over the years—but they studied them as well. They wrote learned books dealing with light- house optics and the construction of aids to navigation.

The novelist Robert Louis Stevenson, son of Thomas, started out as a lighthouse engineer, but early in his career digressed into other channels. Although he studied law and even passed Scotland's bar, he never actually practiced. Instead, he turned to writing, which even- tually brought him much success and fame.

Rennie to be chief engineer on the pro- ject, but Stevenson was involved in the construction as well. The controversy over who should receive credit for the erection of the successful lighthouse continues even today. Stevenson had prepared the construction drawings, participated on-site, and arranged construction activities. Correspondence on construction problems between Stevenson and Rennie seemed to be friendly. D. Alan Stevenson contends in *The World's Lighthouses Before 1820* that Rennie did not issue instructions to Stevenson, but rather made sugges- tions that could be adopted or ignored.

Although it appears that Stevenson had the greatest involvement in the work, this controversy probably will not be resolved for a while.

Once the green light had been given for construction of the light- house, Stevenson erected a beacon on the rocks and stationed a lightship out there as well. The lightship was like other sailing vessels, but it had a light on the mast to serve as an aid. He fig- ured the lightship could hold about forty workers and the work boat an- other twenty. These vessels allowed workers to remain at the construction site rather than return to the mainland each evening, which would have cut down on work time.

After these preliminaries, Steven- son turned his attention toward the tower and began work on the founda- tion. His first act was to chip out a hole that was 42 feet (12.8m) in diameter. The first course of stone was laid in August 1808, and work continued through 1810. In autumn of that year, the workmen began putting up the lantern, which was fitted with Argand lamps and parabolic reflectors.

The lamps and reflectors in the Bell Rock lighthouse were fitted on a four-sided rotating chandelier. In order to achieve a distinctive light, Stevenson used red glass for two sides of the chan- delier. The light, consequently, flashed red and white. The new lighthouse, which was lit on February 1, 1811, is still active today.

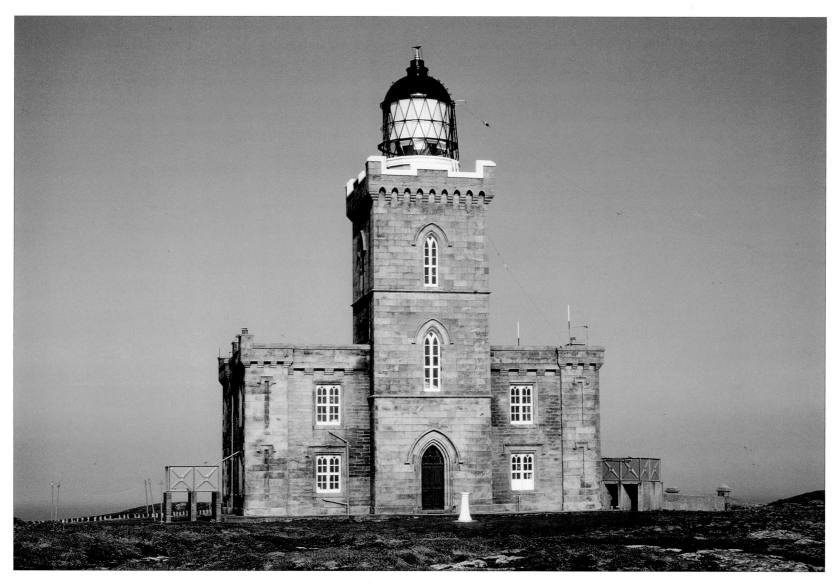

Some years later, Robert's son Alan put up a similar light tower on a site not unlike Bell Rock. It was located on the west side of Scotland at Skerryvore Reef near Tyree Island. Alan profited from the experience of his father at Bell Rock, and accordingly made the appropriate modifications for the Skerryvore plans. Work progressed reasonably well from the time the first course of stone was laid in 1840 to the lighting of the new Fresnel lens on February 1, 1844. Despite a serious fire in the tower in March 1954, the lighthouse, a fine monument to a remarkable family, is still active.

OTHER
SCOTTISH
LIGHTS

A lighthouse at the Isle of May was erected as early as 1636, six years after Charles I had sent the patent for it to the Scottish Privy Council. There was some difficulty in locating a satisfactory patentee, but finally James Maxwell and John and Alexander Cunningham were given the patent.

The Isle of May is a rocky island at the entrance to the Firth of Forth. The lighthouse erected there was a square masonry tower 40 feet (12.1m) high. Stone slabs paved the top, where an iron grate held the light source, a coal fire. Boats would bring the coal to the island, where it was dumped on the shore. From there, the lighthouse keeper, who was paid thirty bushels of meal and seven pounds a year, would carry the coal on his back up to the lighthouse, which stood on the highest point of the island.

In 1816 Robert Stevenson designed and built a new lighthouse (shown here) on the Isle of May to replace the original one erected in 1636. At the behest of Sir Walter Scott, Stevenson saved a major portion of the old structure, which still stands on the island. The 1816 lighthouse remains active.

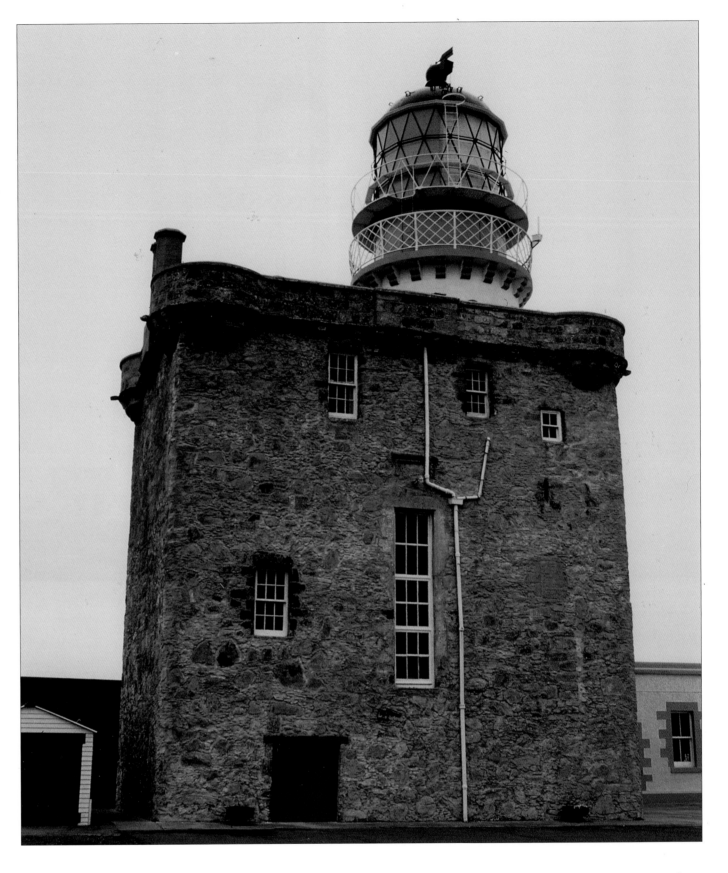

This light, designed to help save lives, ironically had a few victims of its own. In 1791 fumes from the ashes entered a window of the keeper's quarters, which were built into the tower, killing the keeper, his wife, and five of his eight children in their sleep. In 1814 the Commissioners of Northern Lighthouses bought the May lighthouse and shortly thereafter improved its light with a set of Argand lamps and parabolic reflectors.

When a new tower was erected at this site in 1816, the old tower was reduced in height so as not to block the new light. Remains of the original tower can be seen on the island, and the second lighthouse is still active today.

Coastal lighthouses were erected at various sites in Scotland including Kinnairds Head, North Ronaldsay, Eilean Glas, and Pladda. These four lighthouses arose between 1787 and 1790. In 1794 two towers 60 feet (18.2m) apart were erected on Portland Skerries, an outcropping of rocks between the mainland and Orkney. By 1819 Scotland had sixteen coastal lighthouses, in addition to harbor lights at Buddon Ness, Leith, and Portpatrick.

River lights, too, were important in Scotland. The deepening of the Clyde River in the late eighteenth century was transforming Glasgow from a small inland town into a major port. As the river developed, the town council decided to put a lighthouse on top of Little Cumbrae Island in 1755. One year later, Parliament approved the proposal, and the town council erected a masonry tower 28 feet (8.5m) tall on the island. The light from the coal fire was more than 400 feet (121.9m) above sea level. This Clock Point lighthouse of 1797 helped improve the flow of traffic and safety on the Clyde.

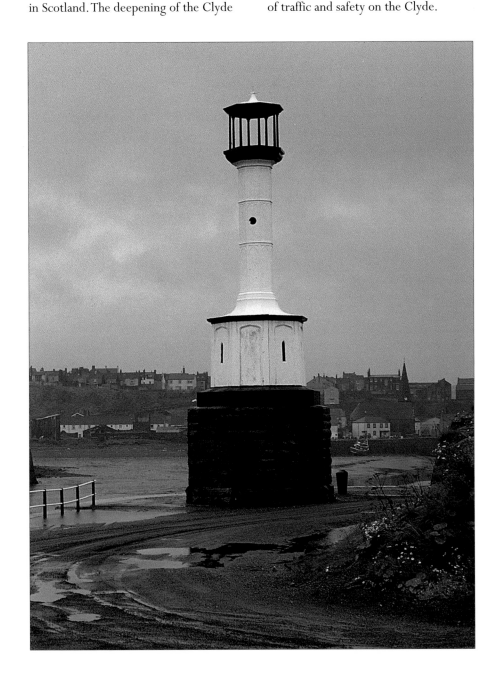

NEW MATERIALS AND NEW LIGHTHOUSES

Over the years the British Isles continued to build new lighthouses, some to replace older ones no longer safe or useful as aids to navigation. This construction helped fill in the dark spaces along the shores of the British Isles so that coasting vessels were not without light to assist the navigators in plotting courses. As the British proceeded to light their coasts, they incorporated new materials in lighthouse construction, and they designed new types of lighthouses.

IRON LIGHTHOUSES

Iron was introduced as a construction material in the nineteenth century. An early lighthouse of cast iron was built at Swansea in 1803 and taken down later in that century. The oldest surviving iron light tower in Great Britain is located at Maryport, Cumberland, where it was erected in 1834. In subsequent

Though not the first of its kind, Maryport lighthouse is Great Britain's oldest surviving cast-iron light tower.

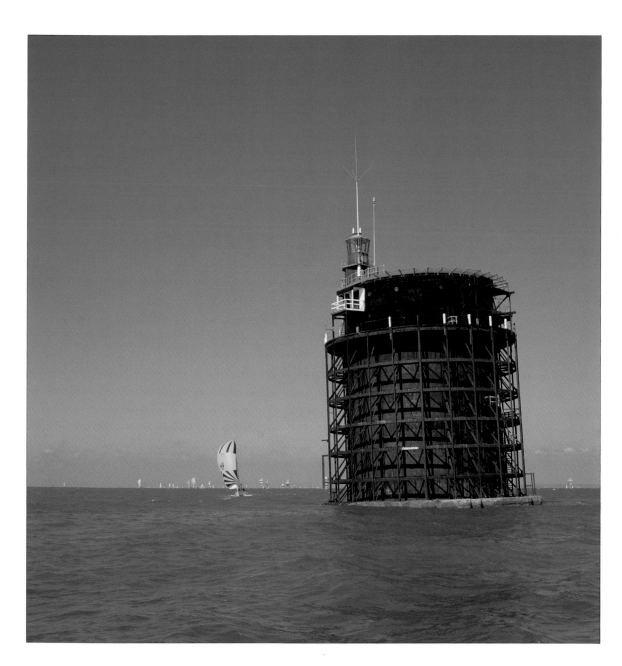

the Minots Ledge pile lighthouse went into service in the United States, but within sixteen months a severe storm blew it over. Then, in 1851, a pile lighthouse went into service at Mucking in Great Britain. Over the years the British erected similar lighthouses at other sites, including Dovercourt (1863), Thorngumbald (1870), and Bamburgh (1910). In the United States they were erected along the coast of southern Florida and the Gulf Coast.

CAISSON LIGHTHOUSES

Another development in lighthouse construction in the nineteenth century was the caisson lighthouse. Its base was a container filled with concrete that was positioned securely on the sea bottom. Caisson lighthouses were used extensively in the United States (see page 71). A few were erected in the British Isles, mostly for the purpose of replacing lightships. Bembridge Ridge, off the Isle of Wight, went into service in 1920, Kish Bank in 1965, and Royal Sovereign in 1967.

Great Britain's reputation as a maritime nation is borne out in its role in developing and establishing aids to navigation. A leader in the promotion of lighthouses and in the adaptation of emergent technology to improve aids to navigation, this nation continues to look for brighter lights and more efficient means of operating lighthouses.

Nab tower, built on a caisson, went into service in 1920 at Bembridge Ridge. The site had been a lightship station for over one hundred years.

years, other iron lighthouses went into service, including towers at Aberdeen (1842), Whiteford Point (1865), and Fastnet Rock (1854) off the southern coast of Ireland.

PILE LIGHTHOUSES

Pile lighthouses, which are made of both wood and iron, have played an important role over the years. A major step forward in lighthouse construction occurred with the development of the screwpile lighthouse by the Irish engineer Alexander Mitchell. It was first tried in 1841 at Maplin Sands at the mouth of the Thames River, where it proved quite successful. The great value of these lighthouses was that they could be erected in the water on top of or close to a navigational hazard.

Another kind of pile lighthouse came into use in both Great Britain and the United States apparently around the same time. The piles or legs, made of iron, were straight and driven into the sea bottom or set into rocks. In 1850,

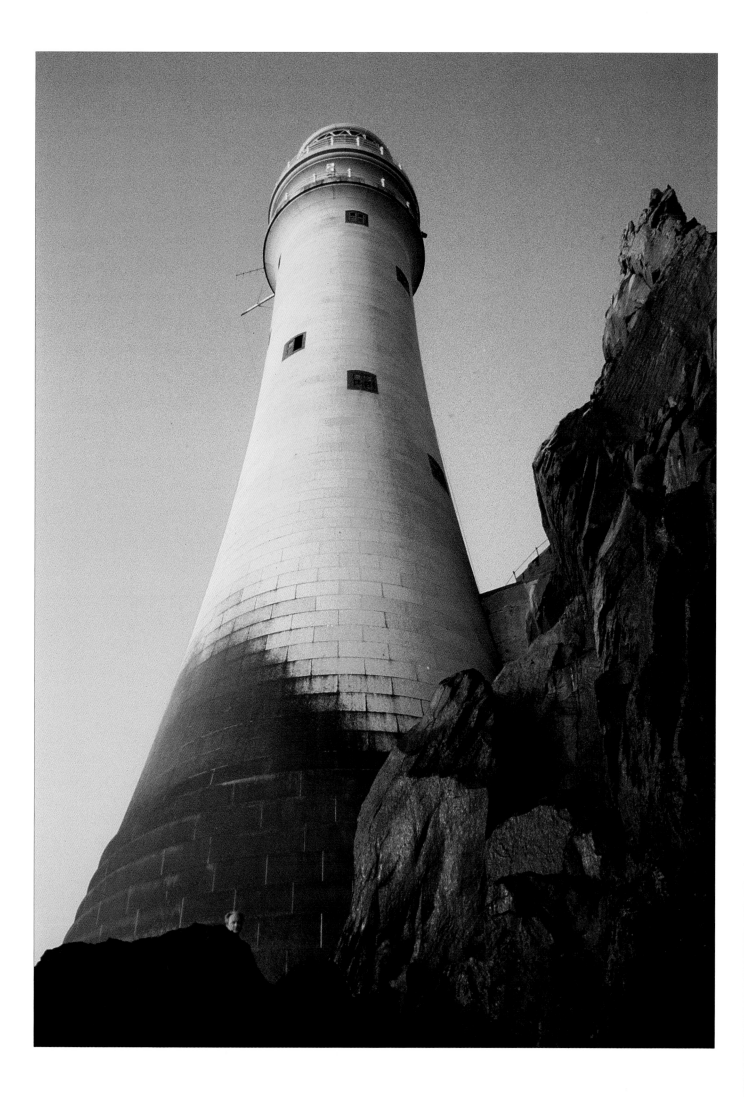

A cast-iron lighthouse was constructed at Fastnet Rock in 1854, but there were problems with its foundation from the start. Repairs were unsatisfactory, and in 1904 the chief engineer of the Commissioners of Irish Lights designed and built a masonry tower (shown here) in its stead.

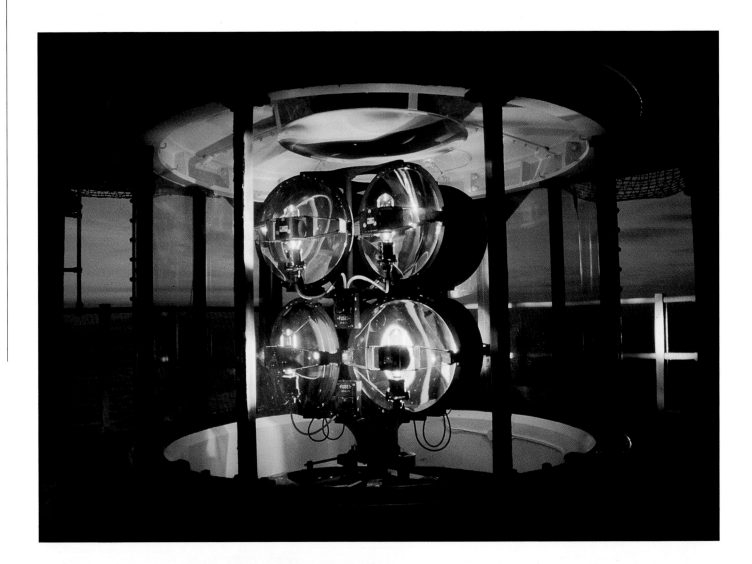

op: In 1842 Alexander Mitchell, inventor of the screwpile lighthouse, failed in erecting this type of structure at Kish Bank. In 1965 a caisson lighthouse was successfully installed at the site; shown here is its illuminating apparatus.

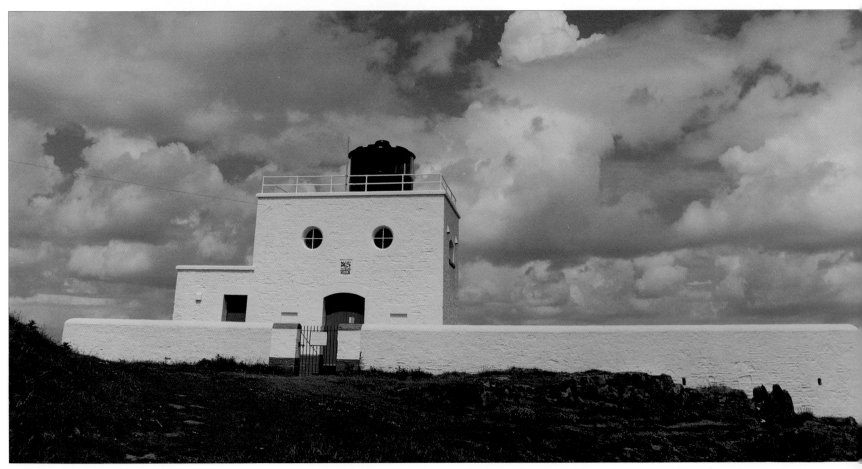

BAY SCREWPILE LIGHTHOUSES

Screw flanges, sometimes three feet (0.9m) across, were attached to the ends of heavy iron rods and screwed into the bottom of the lighthouse site. The flanges provided a secure seating and were almost impossible to pull up. Nine legs were normally used for each lighthouse—one placed in the center surrounded by eight others arranged in an octagonal plan. It took about a day to get each leg seated. The legs formed a base, which was strengthened by tying together all the legs with braces and tension rods. A platform was built on top of the legs, and on this flat area the lighthouse was erected. The superstructure usually consisted of one story that held the living quarters surmounted by the lantern containing the light.

Alexander Mitchell, in partnership with James Walker, erected this type of lighthouse at Gunfleet and Chapman. The design proved to be useful and popular. England used it at other sites, and France adopted it as well. The United States erected many lighthouses of this type, particularly in Chesapeake Bay, the sounds of North Carolina, and the Gulf Coast. In fact, more screwpile lighthouses were constructed in the United States than in any other country.

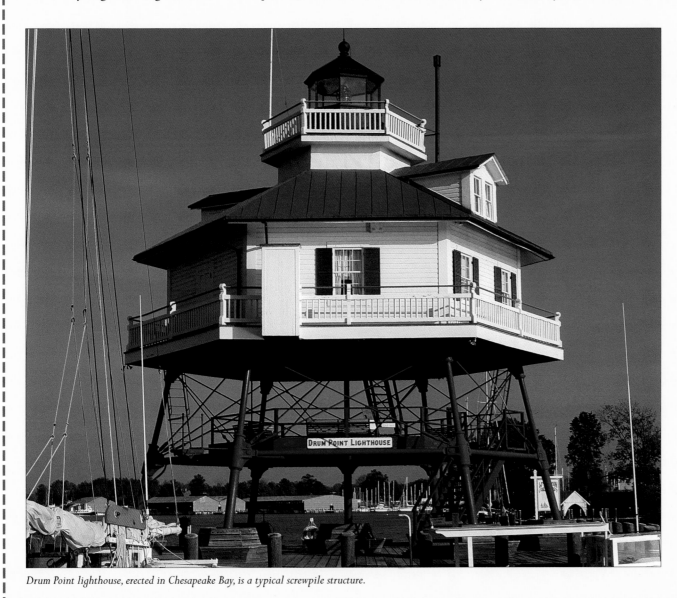

Drum Point lighthouse, erected in Chesapeake Bay, is a typical screwpile structure.

Opposite, **bottom:** *The lighthouse erected at Bamburgh in Northumberland in 1910. Although this lighthouse was erected onshore, the foundation was built using techniques similar to those used for screwpile lighthouses.*

U.S. LIGHTHOUSES BEFORE 1852

THE COLONIAL PERIOD

The first lighthouse to be erected in what is now the United States went up in 1716 at the entrance to Boston Harbor. (In fact, there is good reason to believe that this lighthouse was the first one in the New World.) Merchants and members of the maritime community had lobbied the Massachusetts colony to erect the lighthouse, which was a circular tower somewhere between 60 and 75 feet (18.2 and 22.8m) tall. It is generally believed that the light was produced by candles or lamps that burned whale oil.

In the 1790s spider lamps were installed in lighthouses. Each lamp consisted of a pan of oil from which four wicks protruded. These lamps were soon found to be unsatisfactory, however, for they gave off acrid fumes that burned the keeper's eyes and nostrils, limiting his stay in the lantern. Despite this disturbing problem, the lamps continued to be used in American lighthouses until the introduction of Winslow Lewis' lighting system.

The lighthouse at Boston Harbor was the first one to be erected in the United States. Damaged severely by the British during the American Revolution, it was virtually rebuilt from the ground up in 1783. This restoration and a 14-foot (4.2m) addition raised the tower to 89 feet (27.1m) above the ground.

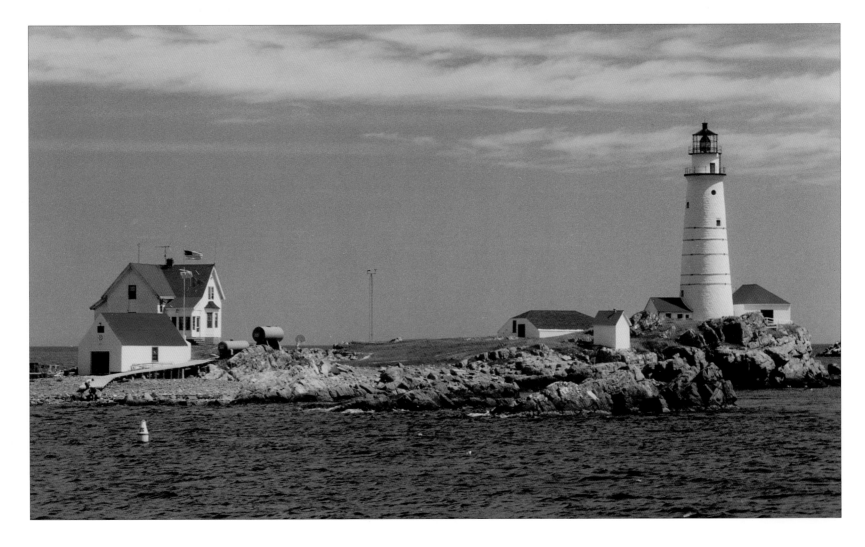

The first light keeper to serve at Boston Harbor was George Worthylake, a pilot. He had reached an arrangement with the colonial government that allowed him to continue piloting as long as he was diligent in maintaining and operating the lighthouse. But after only two years of serving as light keeper, Worthylake, along with his family and two other men, drowned when his boat capsized on the way back to the lighthouse.

Over the next fifty years, this lighthouse, located on Little Brewster Island, continued to have its share of ups and downs. As early as 1719, it came to share its site in Boston Harbor with a cannon that served as a fog signal—the first in the country. The lighthouse continued to service the harbor without interruption until 1751, when a fire destroyed the wooden portions of the tower. Repairs permitted the light-

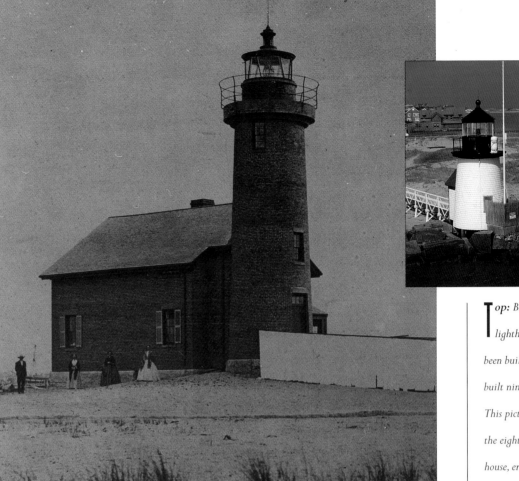

house to remain active until the American Revolution, when British troops destroyed it, putting the tower out of service until the war was over.

Before the war with England, the colonies had erected ten other

lighthouses at various locations: Brant Point (1746), at the entrance to Nantucket Harbor on Nantucket Island, Massachusetts; Tybee Island (c. 1748), marking the entrance to the Savannah River; the Beavertail lighthouse (1749),

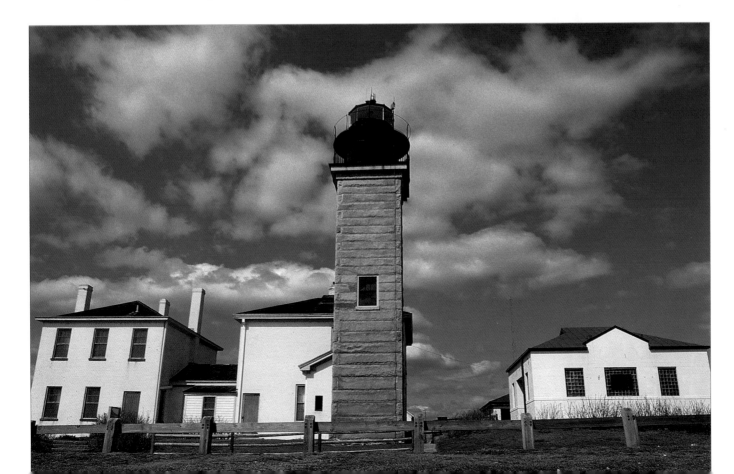

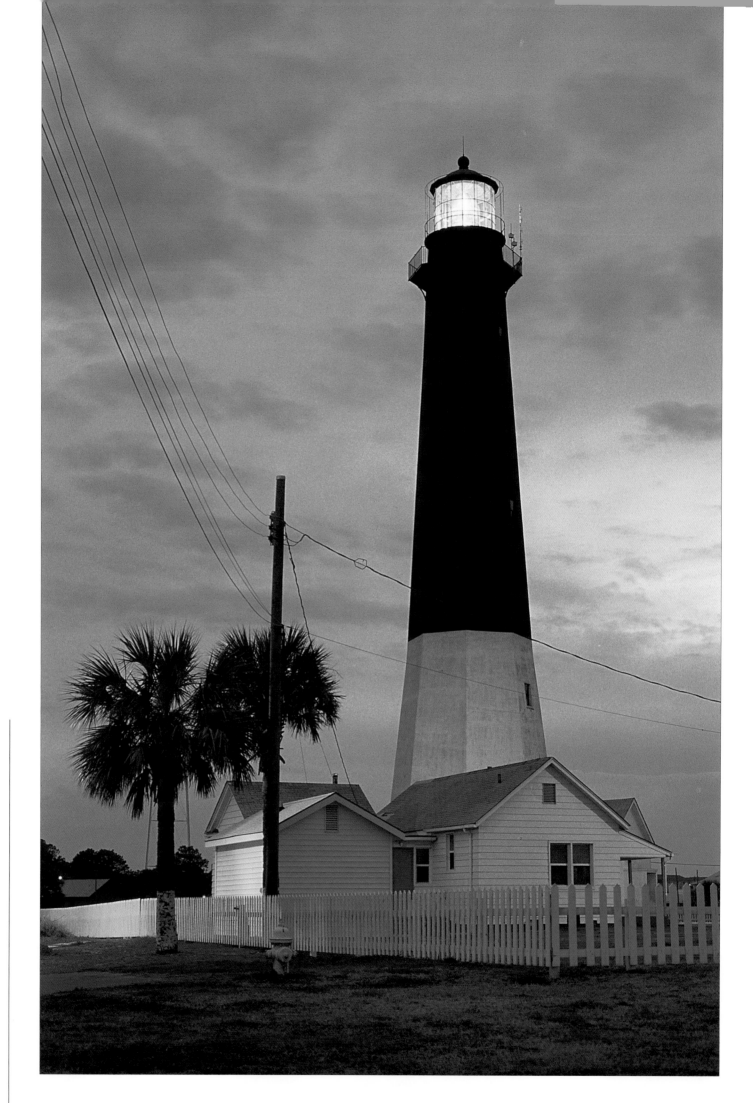

The original light
tower guiding
ships into the Sa-
vannah River of
Georgia served until
the American Civil
War when the Union
troops severely dam-
aged it. The tower
was restored, raised
from 100 feet
(30.4m) to 144 feet
(43.8m), and relit
in 1867.

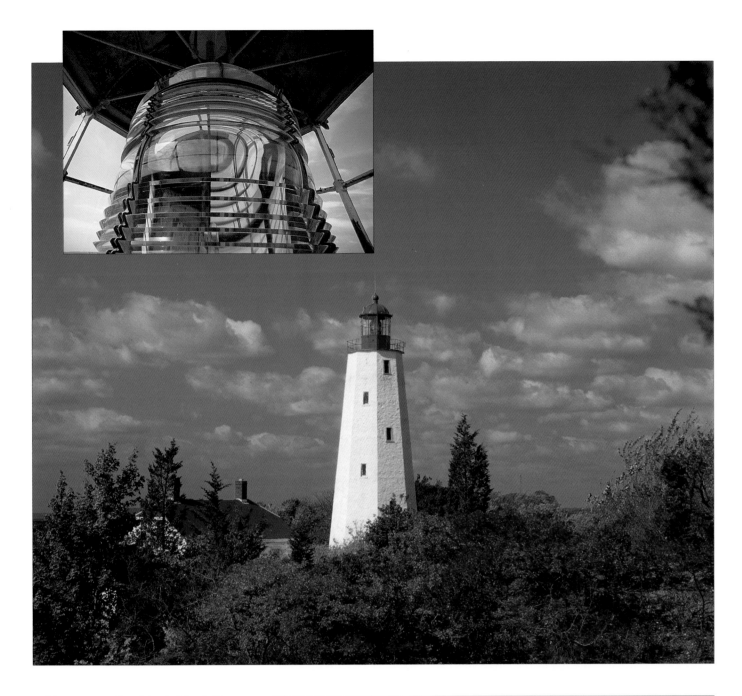

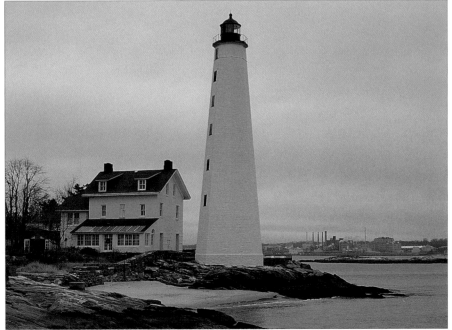

in Narragansett Bay, Rhode Island; New London, Connecticut (1760); Sandy Hook, New Jersey (1764), which is the only surviving colonial lighthouse and the oldest active lighthouse in the United States; Cape Henlopen, Delaware (1767); Charleston, South Carolina (1767), at the entrance to Charleston Harbor; Plymouth or Gurnet Point lighthouse (1769), at the entrance to Plymouth Bay, Massachusetts; Portsmouth, New Hampshire (1771), at the harbor's entrance; and Cape Ann,

Inset: *The Fresnel lens used in the Sandy Hook, New Jersey, lighthouse.*
Top: *Erected in 1764, Sandy Hook lighthouse is the only surviving colonial lighthouse in the United States. Still active, it is part of Gateway National Recreation Area.*
Bottom: *The lighthouse that currently serves New London, Connecticut, was erectd by the federal government in the year 1801.*

Top: *The Cape Ann light station went into service in 1771. Funded by Massachusetts, there were two towers, each 45 feet (13.7m) tall. Turned over to the federal government in 1790, the two short towers served well until 1861 when they were replaced by two taller towers. Today only one is active.* **Bottom, left:** *The lighthouse serving Portsmouth, New Hampshire, was built in 1771. By 1804 the original tower was past repair and was replaced with another tower 80 feet (24.3m) tall. This tower, too, in time became beyond repair. In 1877 the Lighthouse Board built a new iron tower (shown here) on the foundation of the old one.*

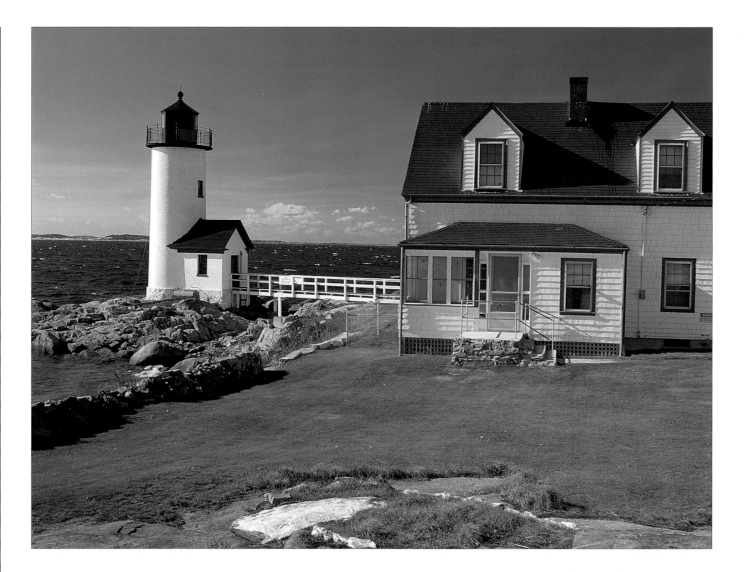

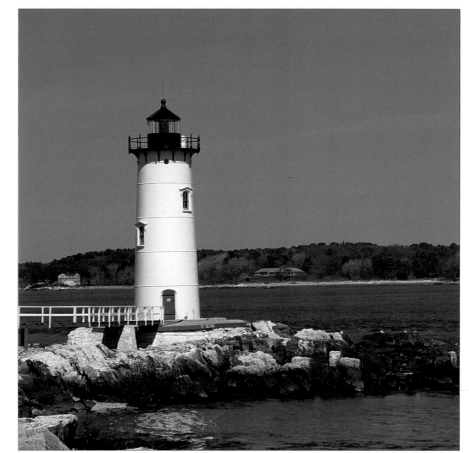

Opposite, bottom right: The tower that today guides ships into the harbor of Charleston, South Carolina, was built in the early 1960s. It is the only U.S. lighthouse with an elevator. **This page:** *Officially the Plymouth lighthouse, the tower at Gurnet Point is known to many as the Gurnet light. The first tower erected at this site was built in 1769; it was rebuilt with twin towers in 1803 and 1842. The latter set of towers remained active until 1924 when multiple lighthouses at U.S. light stations were eliminated. A single tower continues to serve the area.*

Massachusetts (1771), on the northwest side of Massachusetts Bay.

After the American Revolution, the individual states, which were now loosely tied together in a confedera-

tion, continued to maintain control over their respective lighthouses. The states with lighthouses that had been damaged during the fight for independence reactivated them by making the

appropriate repairs. Massachusetts even had a few brand new lighthouses constructed, namely one at Great Point on Nantucket in 1784 and one at Newburyport Harbor in 1788.

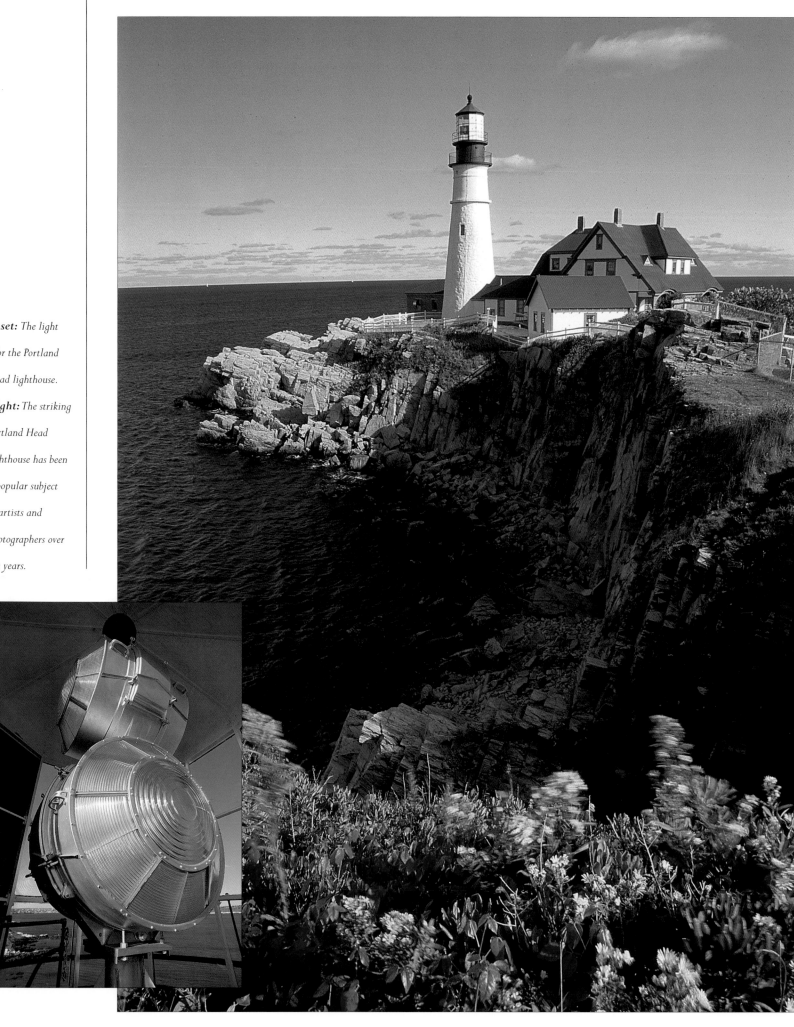

Inset: The light for the Portland Head lighthouse.
Right: The striking Portland Head lighthouse has been a popular subject of artists and photographers over the years.

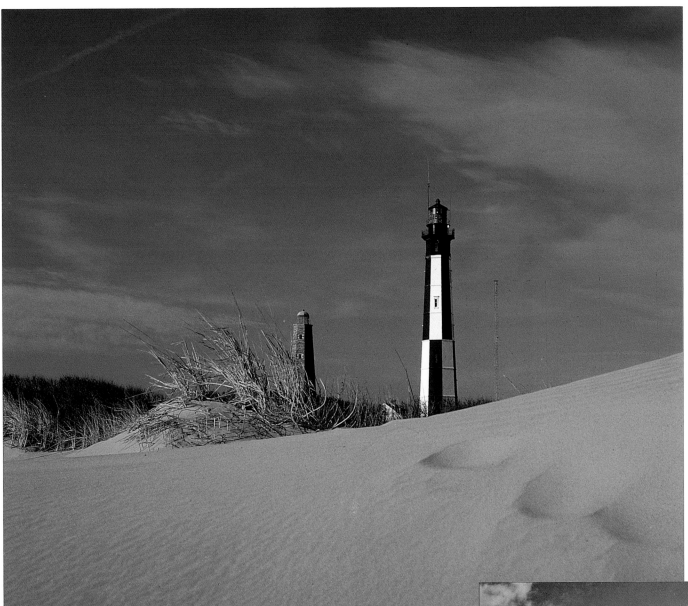

Early Federal Management

In 1789, when the federal government came into being, Congress, in its ninth act, gave the central government responsibility for all activity regarding aids to navigation. This was an important step because it made lighthouses and other aids to navigation the work of the nation. The bill also provided for the completion of the Portland Head lighthouse, originally started by the state of Massachusetts in what is now Maine, and for the construction of a new lighthouse at Cape Henry in Chesapeake Bay.

Under the new law, the states were required to turn over their lighthouses and all other aids to navigation to the Treasury Department. Alexander

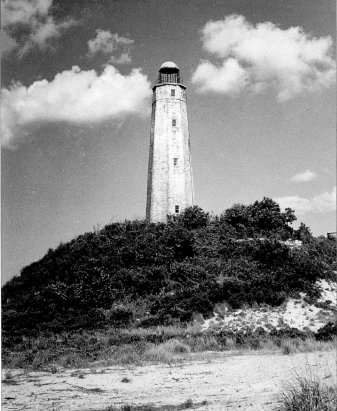

Hamilton and Albert Gallatin, two early secretaries of the treasury, demonstrated a special interest in lighthouses and supervised them closely. The nation's presidents also took personal roles in the operation of these aids. Indeed, until about 1840, the signature of the president was necessary for the appointment of keepers. President George Washington was personally involved in establishing the salaries of keepers, sometimes lowering them. Thomas Jefferson once observed, "I think the keepers of lighthouses should be dismissed for small degrees of remissness, because of the calamities which even these produce"

The secretaries of the treasury who decided not to have any direct involvement in the supervision of the nation's aids to navigation assigned this responsibility to the commissioner of revenue. But no matter who had control at the central level, the field persons taking care of the day-to-day activities were the local collectors of customs. These people were given the additional title of superintendent of lighthouses, and for this extra duty they received 2.5 percent of all the money related to lighthouses that passed through their hands. In addition to overseeing the operation of the lighthouses and supervising the keepers, these collectors were responsible for the construction and repair of lighthouses, the selection of sites for new lighthouses, and the acquisition of the land.

Opposite, top: The Bald Head lighthouse served until 1818 when a new octagonal brick tower replaced it. Although the tower was deactivated in 1935, it still stands and is under private ownership. **Opposite, bottom:** *Although one of the original twin lights of Bakers Island lighthouse was eliminated in 1861, the other is still active.*

LIGHTHOUSE BUILDERS

———

Until 1852, when the Lighthouse Board took charge of governing U.S. aids to navigation, the building of lighthouses was contracted out, generally to the lowest bidder. John McComb, Jr., builder of the Cape Henry lighthouse as well as two others, was a first-rate builder, as was Alexander Parris. A Boston architect, Parris erected several stone lighthouses on sites off the coast of Maine. John Donohoo, who put up about a half dozen lighthouses in Chesapeake Bay, always managed to keep costs within the set budget, and all but one of his lighthouses still stand. The one that no longer exists fell to erosion. Although these builders were extraordinarily talented, they were the exception to the rule. The quality of most lighthouse construction predating 1852 ranged from ordinary to poor.

EARLY FEDERAL LIGHTHOUSE PLACEMENTS

———

The first two lighthouses to go into service after the central government took over aids to navigation were the one at Portland Head (1791) and the one at Cape Henry (1792) in the Chesapeake Bay. The latter, built completely with federal money, was the nation's first authorized public works project. As Cape Henry was being completed, Congress appropriated money to complete the Bald Head lighthouse, which went into service in 1795 at the entrance to the Cape Fear River in North Carolina. Two lighthouses went into service in 1797: one on Seguin Island 25 miles (40km) east of Portland, Maine, and the other, which still stands today, at Montauk Point at the far end of Long Island.

The lighthouse at Bakers Island, Massachusetts, at the entrance to Salem Harbor, a major port during the colonial and early Federal periods, was constructed in 1798, as was the Cape Cod lighthouse at Truro. The following year two more went into service: one at Gay

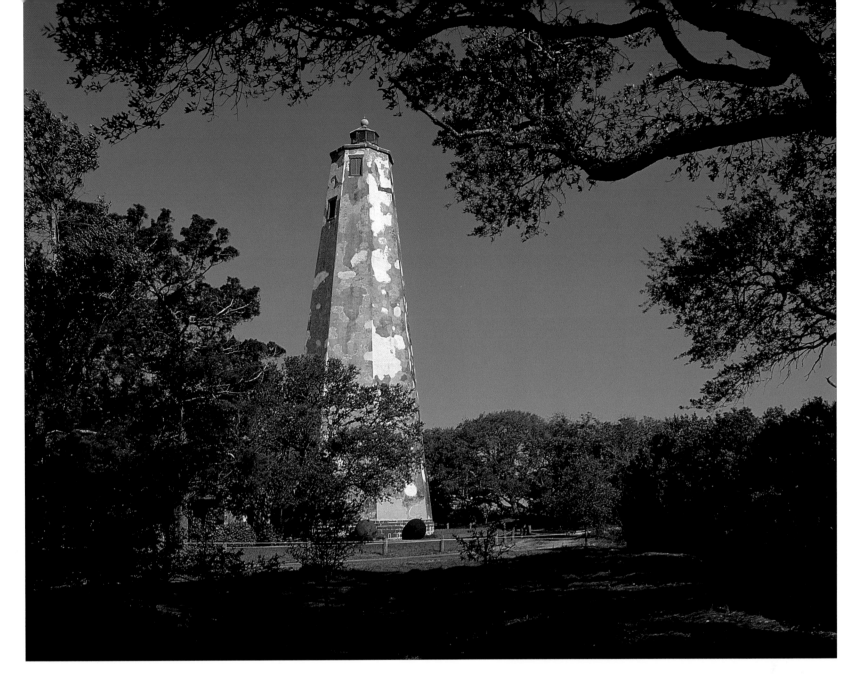

Head on Martha's Vineyard and one at Eatons Neck at Huntington Bay on Long Island.

For the first decade after the turn of the century, most of the light towers erected were located in New England and New York; indeed, only five of the nineteen built during this time were located south of New York. The large majority of the lights established in the northern states were harbor lights, while only three were coastal lights. (One of these coastal lights, Point Judith [1810], actually doubled as a harbor light in Narragansett Bay, Rhode

Island.) The large amount of lighthouse construction that occurred in the New England area was a result of the thriving trade that had emerged after the American Revolution.

The lighthouses erected in southern waters also reflected, though to a lesser magnitude, growing trade. Three lighthouses were established in Chesapeake Bay: the Smith Point lighthouse (1802), which was established at the entrance to the Potomac River to guide vessels to the ports at Alexandria and the nation's capital; Old Point Comfort lighthouse (1802), which marked the

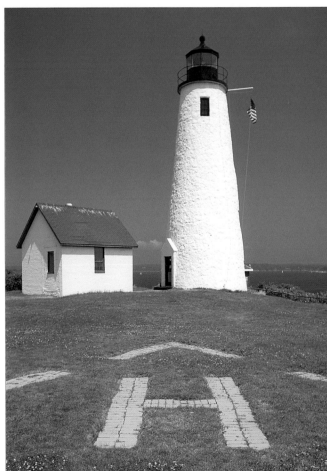

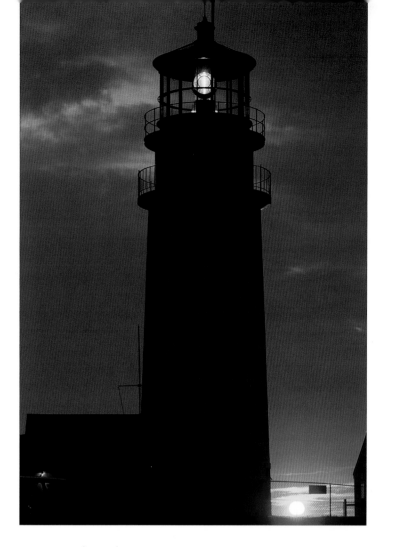

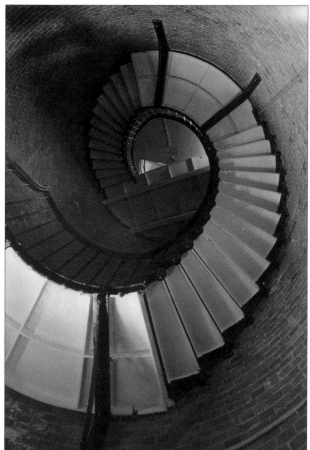

*op, left: Known officially as the Highland lighthouse, but more popularly as the Cape Cod light, the original 45-foot-tall (13.7m) tower was rebuilt in 1833 and 1857. In its last reconstruction, the tower was raised to 66 feet (20.1m) tall and had a first-order lens installed in the lantern. The lighthouse is currently threatened by erosion. **Top, right:** The stairway in the Cape Cod light tower. **Bottom:** Because the original Gay Head light tower at Martha's Vineyard was found to be ineffective, the structure was rebuilt in 1856. The tower gets its name from the various colored earths found at its location.*

entrance to Hampton Roads; and the New Point Comfort lighthouse (1805), which lit the entrance to Mobjack Bay.

In North Carolina, two lighthouses went into service in 1803. Both had been constructed by Henry Dearborn, a former congressman who was later to become secretary of war, collector of customs in Boston, minister to Portugal, and senior major general of the army. He even had a city in Michigan named after him. Dearborn erected both lighthouses at the same time, beginning work in 1799. The effort progressed slowly, mainly because the work crew became afflicted with malaria. He finally finished work in 1802, but for some reason the lighthouses were not lit until sometime between June and October of the fol-

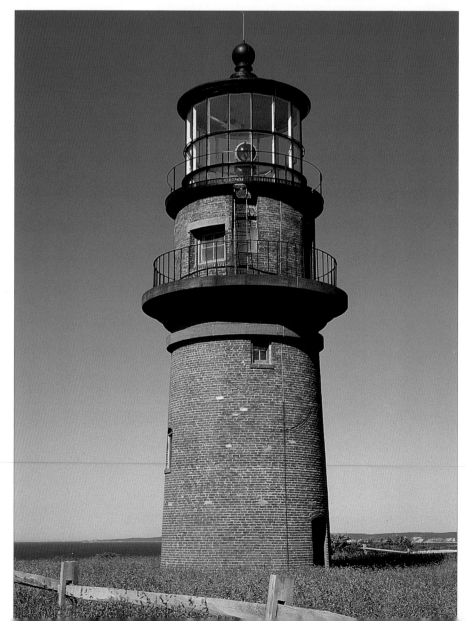

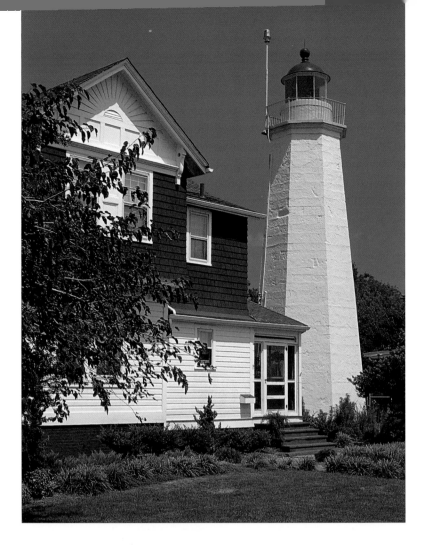

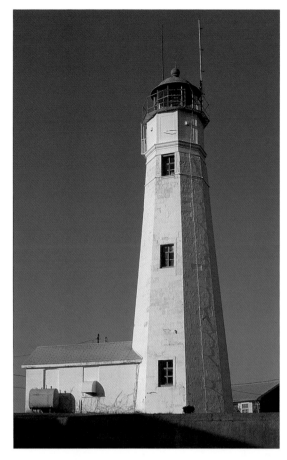

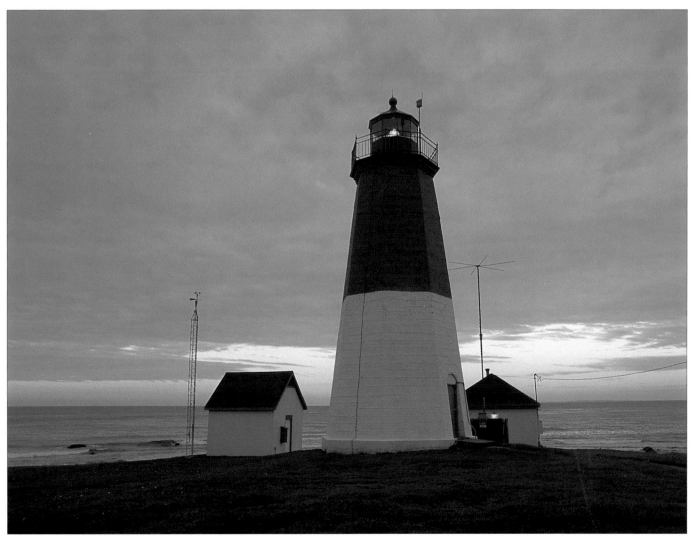

U.
S.

L
I
G
H
T
O
U
S
E
S

B
E
F
O
R
E

1
8
5
2

⚓

4

7

*op, left: Old
Point Comfort
lighthouse was the
second light tower
erected in the Chesa-
peake Bay. Located
at Hampton Roads,
this octagonal pyra-
midal lighthouse
witnessed the battle
between the ships
Monitor and Mer-
rimac. **Top, right:**
Eatons Neck light-
house was built by
John McComb, Jr.
Bottom: Point
Judith is located on
the west side of the
entrance to Narra-
gansett Bay and at
the east entrance to
Block Island Sound.
Erected in 1810, the
tower had to be re-
built in 1816 and
again in 1857. Its
brown and white
coloring makes it an
effective daymark.*

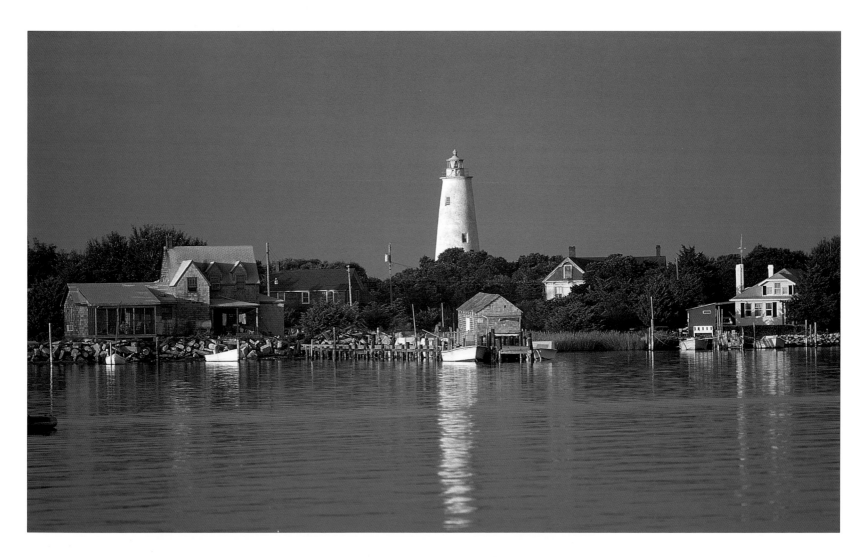

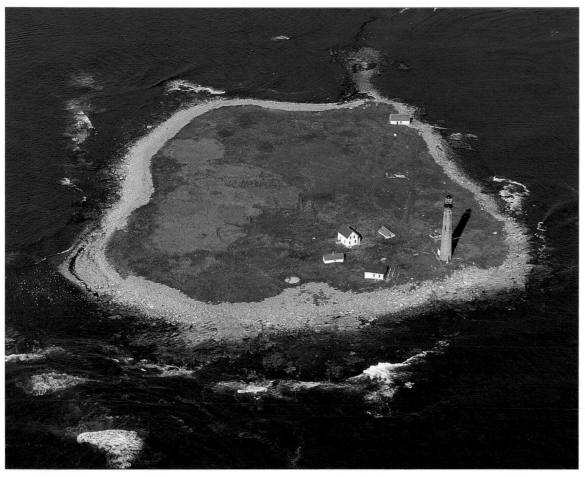

lowing year. One of these lighthouses was built on Shell Castle Island inside Ocracoke Inlet to serve as a guide to vessels crossing the Ocracoke bar at night. The Ocracoke lighthouse had been in use for fifteen years when it was destroyed by lightning. In 1823, a conical masonry tower was erected as a replacement. Today this structure is one of the oldest existing lighthouses south of Chesapeake Bay.

The other Dearborn lighthouse was erected at Cape Hatteras. An octagonal masonry tower 95 feet (28.9m) tall, it was one of the most important lighthouses on the East Coast during the nineteenth century. Its purpose was to guide ships past Diamond Shoals, an

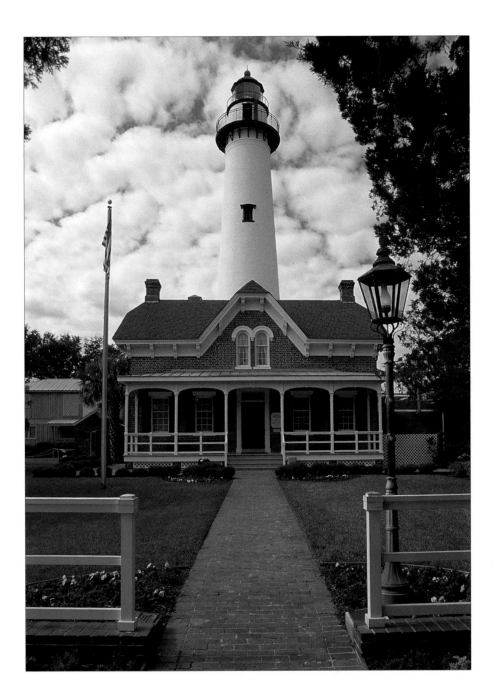

8-mile-long (12.8km) shallow shoal extending out from Cape Hatteras that has been the cause of many shipwrecks. This area is extremely dangerous on account of two currents that flow offshore: the northward moving Gulf Stream and the southbound Labrador Current. The latter narrows to just a few miles in width at Cape Hatteras, giving southbound vessels following this current very little room in which to squeeze past Diamond Shoals and avoid the Gulf Stream.

The second decade of the nineteenth century saw a few more lighthouses erected in the South, though New England continued to lead the nation in lighthouse construction. Several of the northern lights established were coastal lights, such as the 70-foot (21.3m) tower on Boon Island (1812) and the 53-foot (16.1m) tower on Petit Manan Island (1817), both of which are on low islands off the coast of Maine. For the most part, though, the lighthouses built were harbor or bay lights.

GULF STREAM

The Gulf Stream is a band of water that pours out of the Caribbean, moves around the tip of Florida, and flows north, east of the mainland, often at about four knots. Well known, this current was used by the Spanish to speed their vessels home. Benjamin Franklin drew a chart of the current and encouraged American seamen to take advantage of its flow.

Just north of Cape Hatteras, the stream dives underwater, surfacing every so often as it travels north. Its warm water moderates the climate off the shores that it passes.

The Gulf Stream is kept off the shoreline by the colder Labrador Current, which helps keep the stream, or "river in the sea" as it has been called, defined. The Gulf Stream stays within its boundaries as a river would on the mainland.

Opposite, top: Built in 1823 to replace the lighthouse on nearby Shell Castle Island, the 76-foot-tall (23.1m) Okracoke tower continues to aid vessels. **Opposite, bottom:** In 1855 a 119-foot (36.2m) tower was erected on Petit Manan Island to replace a shorter one built in 1817. The replacement is still active and has been subject over the years to many storms and frequent fogs. **This page:** Erected in 1810 and destroyed by the Confederates during the Civil War, the original St. Simons tower was replaced with a 100-foot (30.4m) conical tower attached to the keeper's dwelling. It is still active though leased to the Coastal Georgia Historical Society, which maintains a museum in the dwelling.

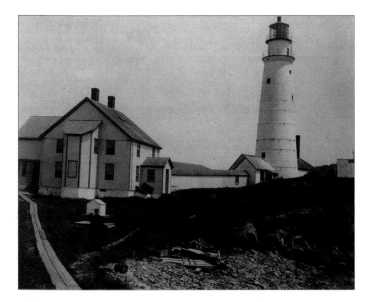

op: A truly historic monument, Boston Harbor lighthouse was an early testing site for Winslow Lewis' lighting system.
Bottom: *Cape Lookout lighthouse, with its distincitive diamond pattern, was first built in 1812. It was reconstructed in 1859 as one of the first tall brick towers that came to dot much of this country's Atlantic Coast after the American Civil War. Though part of Cape Lookout National Seashore, the tower is closed to the public because the light is still active.*

To the south of Ocracoke, the important Cape Lookout light tower went up in 1812 as a coastal light and a warning to vessels of the nearby shoals. Designed with a brick interior and a wood exterior, this light tower was located at the tip of the cape on Shackleford Banks. Farther south on the shores of Georgia, near Brunswick, a lighthouse was erected in about 1810 to mark the entrance to St. Simons Sound. Some years later, it became a coastal guide as

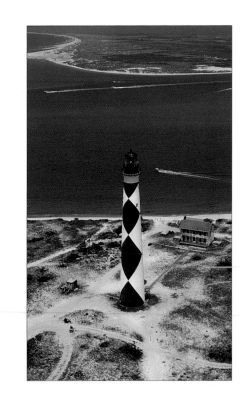

well when a stronger light was installed in its lantern.

By 1820 the United States had fifty-five coastal and harbor lights, an increase of thirty-nine from 1800. Two of these lights—one in Erie, Pennsylvania, and one in Buffalo, New York—were on the Great Lakes, having just been put into operation in 1819. None existed yet along the Gulf Coast.

WINSLOW LEWIS AND THE ARGAND LAMP

The lighthouses of this time were equipped with a standard lighting apparatus, designed by Winslow Lewis, an unemployed shipmaster. Lewis had developed a lighting system that was modeled after one used in England and other European countries: the Argand lamp and parabolic reflector. Indeed, Lewis' nephew, a lighthouse engineer, said that his uncle had copied the system employed in the South Stack lighthouse in England. That accusation is supported by the Scottish lighthouse historian D. Alan Stevenson, who said that Lewis' use of a lens with each lamp and parabolic reflector set was at that time being used only at South Stack. The other British lighthouses had discarded it as being useless.

After developing the lighting system, Lewis tried to persuade the government to buy it. In his attempts to sell the system, he ran tests for officials at the Boston Harbor lighthouse. These tests revealed that Lewis' lamps and reflectors gave off a light far superior to the spider lamps then being used in U.S. lighthouses. He also tested the light at one of the Cape Ann light towers for Henry Dearborn, who was the Boston collector of customs at the time. Greatly impressed, Dearborn urged the secretary of the treasury, Albert Gallatin, to take Lewis up on his offer. Gallatin approached Congress for an appropriation and passed a bill allotting $60,000 for the purchase of Lewis' patent, the installation of the lights in all existing lighthouses, and their maintenance for a period of seven years. Lewis quickly went about installing the lights in 1812. He finished all but nine before the War of 1812 halted his efforts. When fighting ceased in 1815, he fitted the remaining lighthouses.

STEPHEN PLEASONTON: FIFTH AUDITOR OF THE TREASURY

The office of the commissioner of revenue was abolished by Congress in 1820, and the secretary of the treasury transferred the commissioner's duties, including lighthouse management, to the fifth auditor of the treasury. This office was held at the time by Stephen Pleasonton, who after inheriting the new responsibilities proceeded to sign his correspondence "Fifth Auditor and Acting Commissioner of Revenue." He also liked to call himself "General Superintendent of Lighthouses."

The aids to navigation function was but one of Pleasonton's jobs. He was one of the nation's principal bookkeepers,

responsible for all accounts relating to the Department of State and the Patent Office, the census, boundary commissioners, and claims on foreign governments. He also kept track of diplomatic, consular, and bankers' accounts overseas. To help him with all these responsibilities, Pleasonton had nine clerks, four of whom were designated to handle lighthouse matters.

PLEASONTON'S ADMINISTRATION

While Pleasonton was in charge, the United States experienced a tremendous upswing in lighthouse construction. In 1822 there were 70 lighthouses and several lightboats (as lightships were called in that day); by 1838, the number had grown to 204 lighthouses and 28 lightboats; five years later, there were 256 lighthouses, 30 lightboats, 35 beacons, and nearly 1,000 buoys. Virtually all lighthouses built during Pleasonton's reign were erected on the shore. It was not until near the end of his career that offshore lighthouses began to emerge, the first one being at Minots Ledge in Massachusetts in 1850.

There were two types of lighthouses constructed during Pleasonton's administration. One consisted of a tower with a nearby dwelling. This type was made of fieldstone, cut stone, brick, or wood, and the tower's shape was either conical, octagonal, pyramidal, or square.

The second kind of lighthouse consisted of a one-and-a-half-story dwelling, surmounted by a short tower and a lantern. This configuration came into use during the 1820s and grew in popularity with the fifth auditor. Evidence indicates that this popularity arose when the fifth auditor was directed by legislation to erect a lighthouse in the Maryland portion of Chesapeake Bay; it soon became obvious that the money provided was inadequate to erect a tower and separate dwelling. Rather than go to Congress to seek an additional appropriation, Pleasonton directed the local superintendent to erect the regular one-and-a-half-story dwelling, but to place the short tower and lantern on top of the roof. This solution enabled the lighthouse to be built under contract with the money available. In subsequent years, many lighthouses similar to this were erected at sites where only a low light was required, such as bays, rivers, and entrances to harbors.

Structurally, the tower rested on the rafters, for at that time the lighting system and its container, the lantern, were relatively light. Then, as heavier lanterns and lenses came into use, the support system for the tower and lantern began to reach lower into the dwelling, so that by 1852 the wooden tower of the Blackistone Island lighthouse in the Potomac River extended all the way to the ground. Two lighthouses that were fashioned in this style can be seen in Chesapeake Bay. However, only one, Fishing Battery Island, is close to its original shape. Though out of service since about World War I, it is in reasonably sound condition, but in need of repairs.

U.S. TERRITORY EXPANDS

During the rule of the fifth auditor, the country expanded greatly. Florida came into the Union, adding long stretches of coastline to both the Atlantic and Gulf of Mexico seaboards. The Great Lakes area had a growing population, and products of farming, quarrying, and mining had to be transported from that area to the east. The ports of Alabama, Mississippi, Louisiana, and later Texas were thriving, especially Mobile, New Orleans, and Galveston. Near the end of Pleasonton's tenure, the West Coast was added, creating a need for more

aids to navigation. Interestingly, Pleasonton wanted nothing to do with the West Coast. He wrote to the secretary of the treasury that he had more work than he could handle with the existing lighthouses and asked that the West Coast duties be assigned to someone else. But was his reluctance due to the fact that he smelled a scandal in the offing? Regardless, a scandal involving a government contract did occur. While it reached up and merely touched the secretary, it engulfed John McGinnis, who had been put in charge of West Coast lights.

LIGHTBOATS

During Pleasonton's administration of aids to navigation, he used the term "lightboat" to refer to what is now known as a lightship. It was after the Lighthouse Board came into being that the name changed.

The British had both lightboats and lightships. The British lightboat was shaped like a ship, yet was not equipped to sail. More akin to a navigational buoy, it bore a light and, for the most part, was not staffed. The English lightship, on the other hand, was a real ship converted or designed for lightship purposes, and it was fully staffed.

Above: *Originally built in 1907, this lightship is now part of the South Street Seaport Museum in New York City.*

Though investigated by a Senate committee headed by Sam Houston, the scandal was minor when measured against the others of that period.

THE

INVESTIGATION

OF

1838

Before the in-depth investigation conducted in 1851 (see page 55), the most serious probe into lighthouse affairs occurred in 1838. This inquiry was prompted by an appropriation for a large number of lighthouses. Congress wanted to know whether all these lighthouses were needed; consequently, Congress wrote into the legislation a provision for a commission of naval officers to examine the country's lighthouses. The bill divided the Atlantic coast into six districts and the Great Lakes into two, with a naval officer delegated to examine the lighthouses in each. The investigation determined that thirty-one of the lighthouses authorized in the 1837 legislation could be eliminated. It also found that many of the previously constructed lighthouses were made of shoddy material. The mortar had not yet hardened at the twelve-year-old Stony Point tower or at the Great Captain tower. The investigators often found work being undertaken at that time to be faulty, too. At Sandy Hook, for example, the investigator saw the contractor building a tower using nearby saline sand, not the inland sand called for in the contract. Such findings prompted many of the inspectors to recommend that all construction involving lighthouses be conducted under the supervision of engineers.

The inspectors also found a lot of problems with the efficiency of the lights. At some sites, the keepers gave but perfunctory attention to the light, and went about cleaning the reflectors and lamps with diminished energy. Lamps and reflectors were also often out of adjustment. Because the keepers often had to use short chimneys, many reflectors were blackened with soot. To make matters worse, the silver on many reflectors was rubbed off by the government-authorized cleaner, which was an abrasive. Furthermore, the reflectors were so thin that they were easily bent out of shape.

Although the naval inspectors concluded that 40 percent of the nation's lighthouses had serious defects, Congress, for whatever reason, did not take any action. Thus, American lighthouses continued on the same path for the subsequent thirteen years.

THE

CHALLENGE

OF

THE

FRESNEL

LIGHTING

SYSTEM

During this period naval officers, ship captains, ship owners, merchants, insurers, and various other members of the maritime community urged that the United States adopt the Fresnel lens for its lighthouses. But the fifth auditor of the treasury opposed the lens, saying that it was too expensive, that the carcel lamp used in it was beyond the comprehension of American lighthouse keepers, and that the old system provided just as good a light as that of the Fresnel lens. In reality, the carcel lamp, which supplied a large amount of oil to the circular wicks with a clockwork device, was extremely beneficial, allowing

the flame to burn more evenly and for a longer period of time without overheating the burner.

Though he did offer at one point to run further tests on the Fresnel lens if Congress so ordered, Pleasonton vehemently fought the introduction of the lens up until the end. In 1838 Congress ordered Commodore Matthew C. Perry to visit Europe in order to study lighthouses and to purchase two Fresnel lenses in France: one first-order fixed lens and one second-order flashing lens. Perry shipped the lenses back to the United States, where they were installed in the twin lights at the Highlands of the Navesink, New Jersey. Both produced lights that were far superior to any other lighthouses in the country. In 1851, though badly in need of repair,

they were reported to be of much better quality than the nearby Sandy Hook light, which was equipped with lamps and reflectors. By this time, there were two other lighthouses that had been fitted with Fresnel lenses: one at Sankaty Head on Nantucket Island, Massachusetts, and one at Brandywine Shoal in the Delaware Bay. Legislation authorized both of these lighthouses to be constructed under the direction of an engineer and to be lighted by Fresnel lenses: a third-order lens at Brandywine Shoal and a second-order lens at Sankaty Head. The latter light was fondly referred to by some sailors as the "rocket light" and by others as the "blazing star." Pleasonton's response to the new lights was that more testing still needed to be done.

THE ADVENT OF THE LIGHTHOUSE BOARD

In 1851 Congress authorized the secretary of the treasury to establish a board to study and analyze the condition of aids to navigation in the United States.

and examined the latest equipment for aiding navigation.

The board discovered that there was a lot of justified dissatisfaction concerning the state of the country's aids to navigation. "The lights on Hatteras, Lookout, Canaveral and Cape Florida, if not improved, had better be dispensed with, as the navigator is apt to run ashore looking for them," said one shipmaster; this was not an unusual complaint. A majority of the reflectors were found to be spherical, a design less effective than that of the parabolic reflectors. Further conclusions drawn were that the lighthouses were poorly managed, that the towers were too short to give proper range to the lights, that lighthouses were badly spaced (bunched in urban areas and placed far apart in sparsely settled areas), that the keepers were poorly trained and often outright incompetent, and that lightships were "defective in size, model, and moorings."

The conclusion of the board's 750-page report stated, "The board have not sought so much to discover defects and point them out, as to show the necessity for a better system. Commerce and navigation, in which every citizen of this nation is interested, either directly or indirectly, claim it; the weather-beaten sailor asks it, and humanity demands it." The "better system" that the investigators called for was to have a Lighthouse Board created to manage the nation's aids to navigation. This new

The board was composed of highly respected naval and army officers, as well as a civilian official of high scientific attainment. These men looked into every aspect of aids to navigation, talked to shipmasters, obtained reports on many of the lighthouses, scrutinized the construction and operation of lighthouses,

board would consist of the members of the investigating board plus an additional civilian scientist and an army secretary to match the already suggested naval secretary. The secretary of the treasury would be ex officio president. Lighthouse districts would be established, and a naval officer or an army engineering officer would be assigned to each to oversee the construction and operation of aids to navigation. Most importantly, the board recommended that the Fresnel lens be placed in all existing lighthouses. The secretary of the treasury had already been authorized by Congress to install these lenses if it were in the public interest to do so. Furthermore, the board strongly urged that the Fresnel lens be used in all new lighthouses.

Determined to bring about improvements, the Lighthouse Board set about its business before it had even officially been established. One of the projects in the planning stage at this time was the erection of a lighthouse at Seven Foot Knolls to aid ships in Chesapeake Bay. The fifth auditor had been handling the project, but the secretary, reasonably confident that the board was to be brought into being, asked its chairman, William Shubrick, to review the plans for the proposed structure. The board's comments altered the design of the structure, the materials used, and ultimately the actual construction process. The Lighthouse Board was off to a fast start.

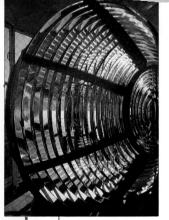

FRESNEL'S LENS LIGHT

Born in Normandy on May 10, 1788, Augustin Jean Fresnel became an engineer and a pioneer in the study of optics. A modest man, he received little recognition during his lifetime. It was not until after his death that most of his papers were published and the world came to learn of his technological contributions.

Fresnel began his research in optics around 1814. By 1822 he had developed a lens for lighthouses that was superior to any that had ever been used. The Fresnel lens looks somewhat like a glass beehive. There is glass at the center belt that magnifies the light, and glass above and below this belt that refracts or bends the light, sending out a thin concentrated layer of light. Originally, a lamp inside the lens supplied the illuminant. The lamps for smaller lenses contained one or two circular wicks; in larger lenses the lamps held four or five circular wicks. The wicks were placed one inside the other. Eventually there were

seven sizes or orders of the Fresnel lens. These orders were numbered one through six with a three-and-a-half order. Order was determined by the distance of the flame from the lens, known as the focal distance. The sixth-order lens had the smallest focal distance, while the first-order lens had the greatest focal distance. The sixth-order lens had the smallest diameter; the first-order lens had the largest.

A lens with smooth glass at its center belt was used to emit a fixed light. On the other hand, glass that was molded into the form of a bull's-eye at the center belt was used to display a flashing light. The flashing effect was achieved by rotating the lens with a clockwork system. A falling weight turned gears that eventually turned the lens.

Fresnel died in 1827, five years after he ran his first successful tests at Cordouan. Without claiming a patent on this invention, he gave his wondrous lens to the world.

This Fresnel lens rotated to give off a flashing light.

Opposite: *Erected in 1850, the Sankaty lighthouse was fitted with a second-order Fresnel lens, which was considered by its users to be especially bright.*

U.S. Lighthouses After 1852

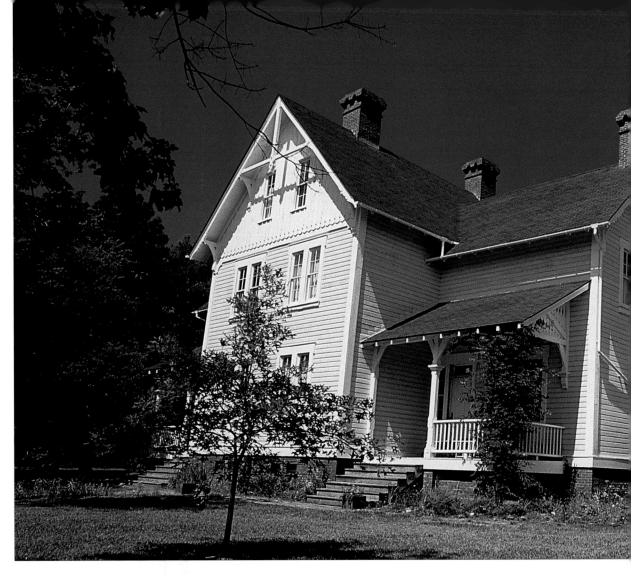

Administrative Reorganization: The Lighthouse Board

In October 1852, Congress officially established the Lighthouse Board. All the board members held some other government job aside from this position; consequently, they did not receive any pay specifically for their work on the Lighthouse Board. Instead, they were compelled to squeeze these duties in with their other obligations.

There was much to do, so the Lighthouse Board quickly began attacking the problems of American lighthouses. Following the advice of the investigatory board of 1851, it established twelve districts, each of which had a naval officer or army engineering officer assigned to it to oversee the construction and operation of aids to navigation within that district. The new Lighthouse Board also took up the call for the Fresnel lenses, urging that these devices be installed immediately.

Adopton of the Fresnel Lighting System

Shortly after the Lighthouse Board came into being, the secretary of the treasury gave permission to begin

Currituck Beach Light station was one of the tall towers erected to fill in the dark coastal area between North Carolina and Chesapeake Bay. The policy of the Lighthouse Board was to have lighthouses situated along the coast every 40 miles (64km).

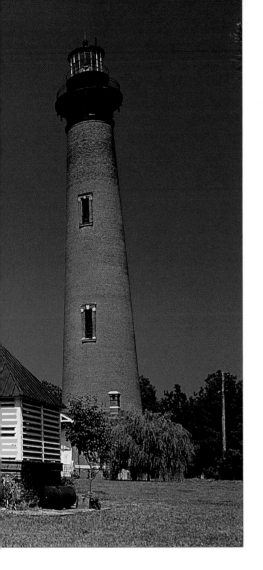

installing Fresnel lenses in America's lighthouses. By the time of the American Civil War, all lighthouses were fitted with these lenses, and most had new lanterns. Of the seven orders of lenses, the first three were considered to be appropriate for coastal lighthouses, while the last three were used for harbor or bay lights. The middle lens, developed later, was used mostly in the Great Lakes; a few of these, however, were installed in the Gulf of Mexico at sites that required harbor or bay entrance lights that were stronger than usual, but not as bright as that projected by the larger and heavier third-order lens.

The Lighthouse Board quickly turned its attention toward one of the

LIGHTHOUSE DISTRICTS

The Lighthouse Board divided the United States into twelve districts— two in the Great Lakes, seven along the Atlantic coast, two in the Gulf of Mexico, and one for the West Coast. As time went on and both the system and country grew, the board added more districts until eventually there were eighteen in all. At first, an inspector, usually an army engineer, managed the district with the assistance of the local collectors of customs. The collectors in turn usually hired and paid the keepers. It was also the responsibility of the collectors to handle various administrative duties, as well as to manage the money designated for lighthouse construction and repairs. In time

the collectors were given a reduced amount of power, and eventually they were phased out of lighthouse administration altogether. Meanwhile, the work of governing a district became too much for one person to handle, so the Lighthouse Board assigned an engineer to each as well. Under these new conditions, the inspector, a naval officer, was responsible for operational matters in the district; this involved conducting quarterly inspections at each lighthouse to ensure that each was operating properly and that the keepers were performing their duties appropriately. The engineer, an army officer, was responsible for construction, repair, and maintenance of the lighthouses.

most important, if not the most important, lighthouses in nineteenth-century America: the one at Cape Hatteras, North Carolina. There had been numerous complaints during the time of Pleasonton's administration that this light was often obscured from view. The problem seemed to stem from a haze that hung at about 90 to 100 feet (27.4 to 30.4m). In an attempt to

improve the situation, the Lighthouse Board equipped the structure with a new first-order Fresnel lens and raised the height of the tower so it could be seen at a greater distance. The new light was 150 feet (45.7m) above sea level, making this structure the first of the tall towers that came to dot the Atlantic coast from Fire Island in New York to the southern coast of Florida.

The light tower at
Ponce de Leon
Inlet is one of the
tallest of the brick
coastal tall towers. In
fact, it is exceeded in
height only by Cape
Hatteras. Though
Ponce de Leon
received a lighthouse
in 1835, a light did
not actually shine
there until 1887
when the present
lighthouse (shown
here) went into
service.

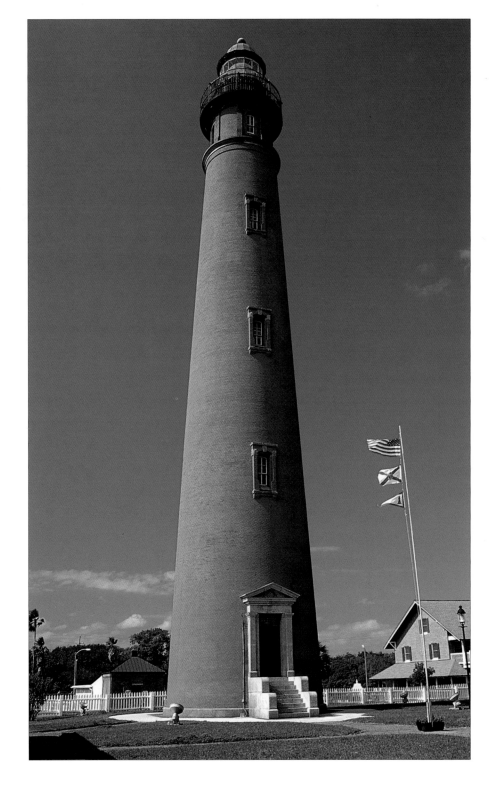

TALL
TOWERS

In the 1850s the Lighthouse Board put
up seven more of these impressively
statuesque towers, most of which ap-
peared along the coast of New Jersey.
The board replaced the 89-foot-tall
(27.1m) tower at Fire Island with a new
one 167 feet (50.9m) tall. This was the
lighthouse most important to transat-
lantic steamer traffic; it was this light
for which ships set their course when
leaving Europe, and it was from this
light that vessels departed on their way
to Europe. Most of the other light tow-
ers installed during this time were
coastal lights, with the exception of the
one at Pensacola, Florida, which marked
the entrance to the area's naval port.

The 1860s were a quiet period for
the construction of tall lighthouses.
During that decade, only one tall tower
was built. To make up for lost time,
however, the Lighthouse Board erected
five tall towers in the 1870s and three
in the 1880s, all of which were located
in the South. These tall towers, like the
previous ones, were made of brick, ex-
cept for the Cape Henry tower, which
was made of iron plates. The last tall
tower erected in the United States was
the Charleston, South Carolina, light-
house, which replaced the old 1876

The first-order lens installed in the
Cape Hatteras tower revolved, giving
the light a flashing characteristic. Com-
pleted in 1854, the refurbished tower
dutifully performed its service until the
late 1860s, when cracks that had devel-
oped in it began to threaten the struc-
ture's stability. At this point, the
Lighthouse Board decided to replace

the tower with one that put the light at
191 feet (58.2m) above sea level. When
it was completed in 1870, this struc-
ture became the tallest light tower in
the United States. With its tremendous
height and its distinctive black and
white spiral banding, the Cape Hatteras
lighthouse is one of the more quickly
recognized lighthouses in America.

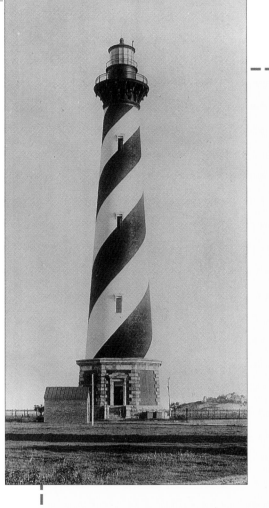

PAINTING LIGHTHOUSES

Painting lighthouses, an innovation of the Lighthouse Board, was done to make them recognizable during daylight hours, thus helping navigators orient themselves. Only coastal light towers were painted as daymarks. For the most part, these painted towers can be seen along the Atlantic coast, from Fire Island, New York, to Dry Tortugas in the Florida Keys. Though there are duplicates in patterns, those lighthouses boasting similar painted designs are widely separated. Fire Island, for instance, is painted with four alternating black and white bands. The nearest light tower painted in a similar fashion is located at Bodie Island in North Carolina. Differing slightly from the one at Fire Island, the tower at Bodie Island has five painted bands—three white, two black. The latter pattern was repeated on the old Charleston, South Carolina, lighthouse during its active days. The Cape Lookout, North Carolina, tower displays a unique diamond pattern. Cape Hatteras has a duplicate in the St. Augustine light tower in that it, too, has the spiral banding. Several of these tall towers are not painted at all, such as the one at Ponce de Leon Inlet, Florida, and that of Currituck, North Carolina. While most tall towers are painted black and white, there are some, such as the one at Jupiter Inlet in Florida, that have been painted bright red. Shorter towers, on the other hand, are usually white.

Left: *The Cape Hatteras lighthouse proudly displays its spiral banding.*
Right: *This lighthouse is the third of three towers erected at Bodie Island.*

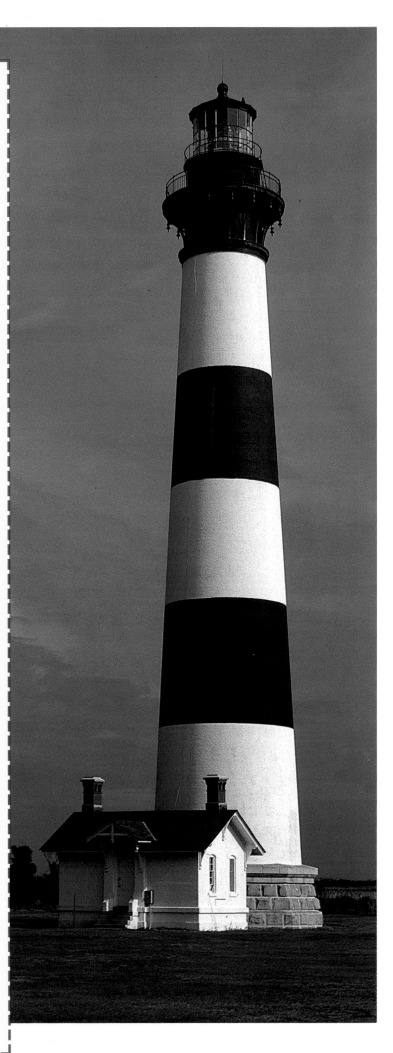

Erected in 1858, this 167-foot-tall (50.9m) tower at Fire Island replaced a shorter one built in 1826. This lighthouse is one of the earliest coastal tall towers.

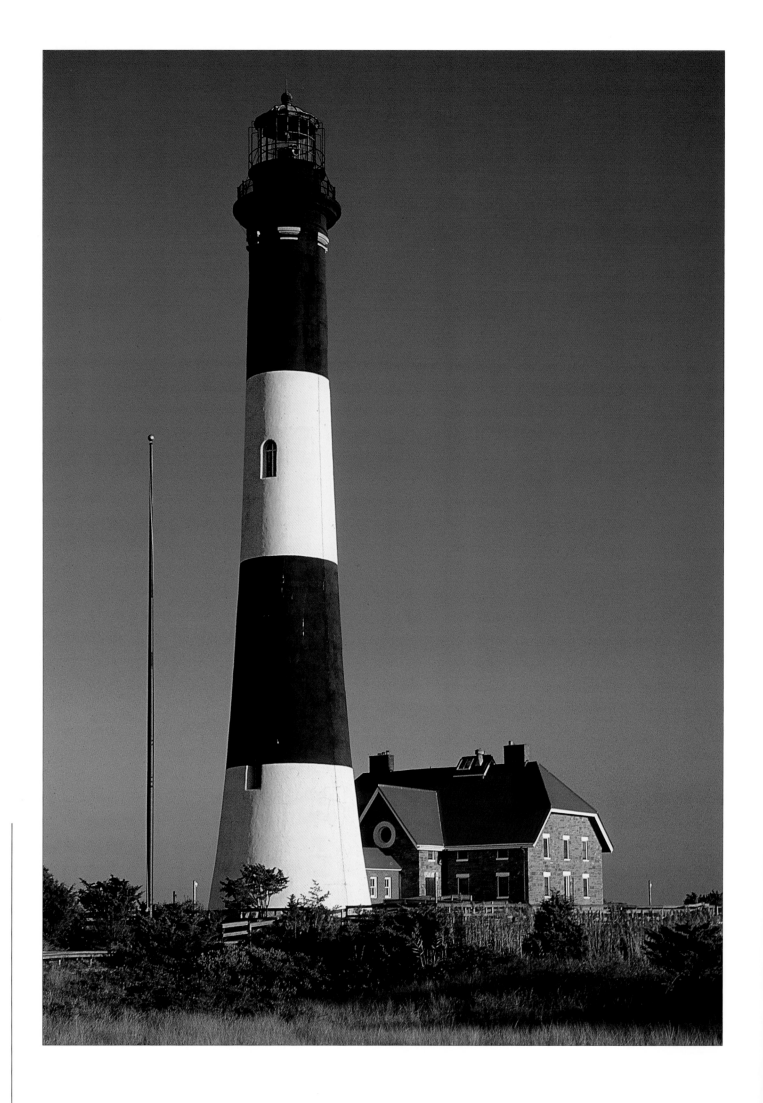

Fuel First Used in Lens Lamps

When first used in American lighthouses, the lens lamps burned oil that came from the head of the sperm whale. It was an exceedingly good lubricating oil that burned particularly well in lamps. Unfortunately, the price of sperm oil increased dramatically between the early 1840s and the early 1850s. At this time England and France were having great success with colza, which was made from rapeseed. The Lighthouse Board thought that if it created a market for rapeseed, farmers would begin growing this plant. But the farmers failed to respond, and the Lighthouse Board had to look elsewhere and consider other options.

One member of the Lighthouse Board, Joseph Henry, experimented with the possibility of using lard oil in lamps. Testing had previously been conducted on this substance, but these earlier results were unsuccessful. Henry, however, found that if lard oil was warmed to a high enough temperature, it burned quite well, so American lighthouses began using it.

Around 1870 the Lighthouse Board began to use mineral oil, or, as we know it today, kerosene. This type of oil worked well, but it was much more volatile and had to be handled with caution. Kerosene was used until about the end of the nineteenth century, when the incandescent oil vapor lamp, similar to a Coleman lamp, came into use. This lamp gave off a bright light and was used in U.S. lighthouses until electricity reached the individual lighthouses, which for some was not until after World War II. The first electrically lit lighthouse in the United States was the Statue of Liberty. Lit upon its completion in 1886, the statue served as a light beacon for seventeen years.

tower that was being threatened by erosion. Located on the northern side of the entrance to Charleston Harbor, this replacement is made of brick and clad in aluminum. Rising 140 feet (42.6m) into the air, the tower, with its light 163 feet (49.6m) above sea level, went into service in 1962.

Pile Lighthouses

Among the new types of construction that arose around the time that the Lighthouse Board was established were the iron pile lighthouses, including both straight pile and screwpile.

The first pile lighthouse was erected at Minots Ledge near Cohasset, Massachusetts. This lighthouse, held in place by nine legs each embedded 5 feet (1.5m) deep into the rock, went into service on January 1, 1850. Several times, storms rattled and shook the lighthouse, but on April 12, 1851, a particularly severe storm tore through the area. Early on the morning of April 17, the pile structure toppled into the water, plummeting the two keepers to their deaths. All that remained after this disaster were bent piles protruding from the rock. The Lighthouse Board decided to replace the pile structure

Left: *A fierce storm wreaked havoc upon the original lighthouse at Minots Ledge. When the tempest had passed, townspeople were stunned to find only water where the lighthouse had once stood.* *Right:* *The conical surface of the heavy stone tower that replaced the original pile light-house at Minots Ledge reduces the force of the sea as it crashes against the structure.*

with a 97-foot-tall (29.5m) granite tower. Fitted with a second-order Fresnel lens, the new tower went into service on November 15, 1860. Now automated, this lighthouse continues to shine, having withstood many dreaded nor'easters over the years.

Though the original pile tower at Minots Ledge was not able to withstand the elements, one pile lighthouse con-structed around the same time has been hugely successful. Designed by I. W. P. Lewis, nephew and critic of Winslow Lewis, this pile lighthouse on southern Florida's Carysfort Reef was erected under the direction of Lt. George G. Meade, an army engineer and later commander of the Union forces at the Battle of Gettysburg. This spider-legged structure, which went into service in 1852, was at first lit with lamps and reflectors. In 1855, however, the Lighthouse Board installed a first-order lens, the light of which was 100 feet (30.4m) above sea level. Currently automated and equipped with a third-order lens, this lighthouse is still in service.

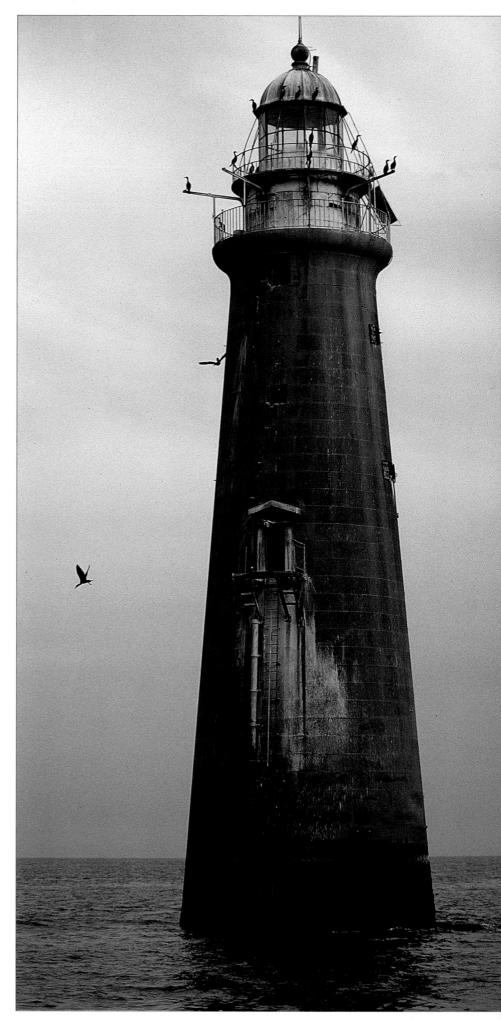

There are a number of these pile-type lighthouses around southern Florida and along the shores of the Gulf of Mexico. Because they were designed to be erected offshore, pile lighthouses could be put on top of a navigational hazard—whether it be a shoal, a reef, or, as in the case of Sand Key, an occasionally disappearing island. Thus, these lighthouses were very useful.

The United States' first bay or harbor screwpile lighthouse was lit in 1850 at Brandywine Shoal in Delaware Bay. Designed and constructed by Major Hartman Bache, the lighthouse was equipped with a third-order Fresnel lens, as Congress had stipulated in its authorization of the project. Fearful of ice damage, Bache had built an ice-breaker that consisted of thirty screw-pile legs spaced evenly around the structure and connected by rods. A similar lighthouse went into service in 1856 at Seven Foot Knoll. Its designers originally fashioned the plans for this structure after the Brandywine Shoal lighthouse, but in the end modified the plans to build a circular, iron-plated one-story superstructure topped by a lantern.

The screwpile design soon became popular for lighthouses at offshore sites in Chesapeake Bay and the sounds of North Carolina. Though all were wooden one-story towers, the superstructure took several forms: octagonal, square, and rectangular. The most popular design was the octagonal one;

in fact, four of the five surviving screwpile structures in America are of this design. Its popularity continues to grow even today. A number of restaurants have adopted this design, as has at least one hotel on the Chesapeake Bay. Architects have also advertised this design for beach houses. Of the five surviving harbor and bay screwpile structures, four can be found in Chesapeake Bay while one is located in Mobile Bay.

When Congress had originally authorized the first screwpile lighthouse, some people expressed the opinion that perhaps this type of lighthouse could eventually replace the lightship. In time, this view became a goal of the Lighthouse Board, which began making the substitution during the Civil War cleanup of Chesapeake Bay. At first, only lightships in harbors and bays were replaced. Those in colder climates and those off the coast were left to brighten these areas. In the 1870s, advancing technology would provide methods to replace more of the lightships.

LIGHTING TEXAS

In 1852 the darkest section of the Gulf Coast was Texas. There were only two aids to navigation there: a lightship that

was stationed inside the Galveston bar and a lighthouse at Matagorda. To rectify the situation, the Lighthouse Board placed lighthouses and other aids along the Texas coast, so that by the time of the American Civil War the board felt the coast was adequately lit to suit the patterns of shipping commerce at the time. But this condition was only temporary, for the Confederates in Texas had the same attitude toward lighthouses as the Confederates in the remainder of the South. They believed that aids to navigation were of greater benefit to the Union forces, particularly to the blockade runners, than to the southern forces. As a result, Confederates not only put the lights out of operation but also blew off the tops of many of the towers so the northerners could not use them as spotting stations. Some keepers even went so far as to disassemble the lens and hide it in a nearby swamp or bury it in the sand.

As these coastal areas came into the hands of the Union forces, the board moved as quickly as possible to put the lighthouses back into operation. But there was much to do, and the board was unable to get to many of the lighthouses until after the war. For example, repairs did not begin on the damaged Aransas Pass lighthouse near Corpus Christi, Texas, until February 1867. The restorers had to remove 20 feet (6.1m) of the top of the tower and rebuild it. The lighthouse went back on duty that summer.

The first lighthouse on the Pacific coast was lit in 1854 at Alcatraz Island. It served until 1909 when it was torn down to make way for a maximum-security prison. Its replacement continues to serve the island, which is one of San Francisco's most popular tourist attractions.

Pacific Coast Lighthouses

Another problem that faced the Lighthouse Board was lighting the Pacific coast. Before the board took over lighthouse administration, a contract had been let to build the first eight lighthouses in this region. This contract was sold by the initial contractor to two Baltimore contractors. They, in turn, purchased a vessel named *Oriole*, loaded it with the materials (except for the masonry), carpenters, masons, and laborers necessary to construct the eight lighthouses, and sailed to California.

California Lighthouses

Oriole arrived in San Francisco in late 1852 and work began on the first lighthouse, located at Alcatraz Island, in December of that year. This site, as well as the other seven, had been selected by the Coast Survey, a bureau created in the 1850s to determine sites for new lighthouses. Part of the work crew was assigned to build the lighthouse at Fort Point near the entrance to San Francisco

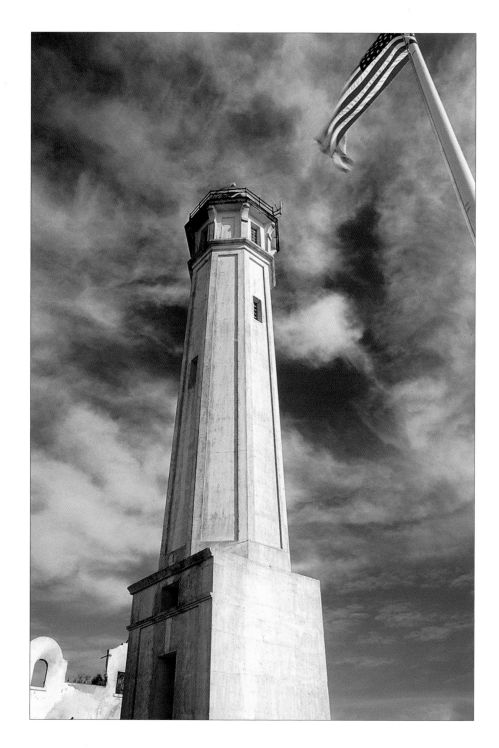

Bay. With work finished on the Alcatraz tower, the crew moved on to Monterey in March to erect the Point Pinos lighthouse. The Coast Survey had picked three sites for this lighthouse, allowing the final decision to be made at the time of construction. With no guidance available from the government, the head of the crew elected to put up the lighthouse on the site where it was easiest to build.

In April a work force moved over to Farallon Islands to erect the lighthouse for Southeast Farallon, which is 23 miles (36.8km) off the coast of San Francisco. Upon arrival, the workers encountered egg pickers collecting the eggs of seabirds to sell in the San Francisco markets. The egg pickers refused to let the lighthouse builders land, fearing that a lighthouse would frighten away the birds. Unable to begin work,

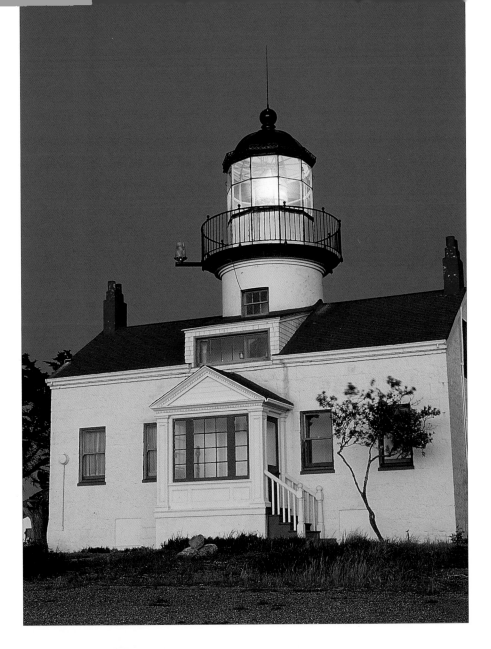

the lighthouse crew returned to San Francisco and reported the incident to the collector of customs, who sent an armed contingent on the Coast Survey steamer to resolve the issue. When confronted by these armed sailors, the egg pickers became more agreeable and decided to welcome the lighthouse builders. The 41-foot-tall (12.4m) Southeast Farallon light was erected on the highest peak of the Farallons, but the site was unsuitable for the dwelling, which consequently was built on the lower, flatter area. The light, when exhibited in 1855, was 358 feet (109.1m) above sea level.

After completing the lighthouse on Southeast Farallon, *Oriole* headed to Oregon to erect the lighthouse needed at Cape Disappointment. As the vessel entered the mouth of the Columbia

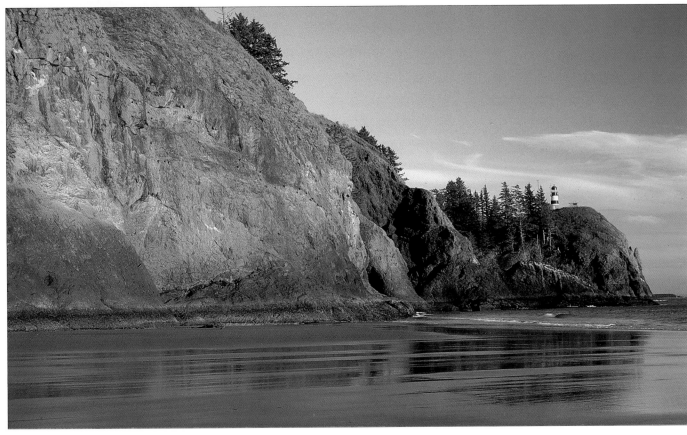

*op: The Point Pinos lighthouse is the oldest active lighthouse on the Pacific coast. **Bottom:** Although the Cape Disappointment light tower is only 53 feet (16.1m) tall, it rests on a rugged cliff that puts the light 220 feet (67m) above sea level.*

Opposite: The original Cape Meares light tower is an iron-plated structure 38 feet (11.5m) tall. Radiating from over 200 feet (60.9m) above sea level, the light could be seen 21 miles (33.6km) seaward when active. Although it was replaced by a simpler structure, the old tower has become a tourist attraction and is part of Cape Meares State Park.

HEIGHT AND SITE

The height of a coastal light depends on its site. On the East Coast, where coastal lights have tall towers, the site is near the land's edge, only a few feet above water. On the West Coast, however, the rugged land near the ocean reaches several hundred feet into the air, requiring only a short tower to support the lantern and lens. For example, the current Cape Meares lighthouse on the coast of Oregon shines its light only 17 feet (5.1m) above the ground. Its site, however, is 232 feet (70.7m) above sea level, allowing the light to be seen for 22 miles (35.3km). Cape Mendocino (1868) is the highest light in the continental United States. Although the tower is only 43 feet (13.1m) tall, the site raises the light to 465 feet (141.7m) above the sea.

River, it struck a shoal and sank within fifteen minutes. Fortunately, all the crew members and passengers were saved, but the materials for the remaining lighthouses were lost.

Undaunted, the lighthouse builders returned to San Francisco, obtained another vessel and more building materials, and headed back north. Upon their safe arrival, they began putting up the lighthouse. When work was well under way, a contingent of workers left for Humboldt Bay to begin work on the lighthouse at that site. A little later, another group headed to Point Conception. As that lighthouse neared completion, part of the work crew journeyed to San Diego to erect the lighthouse on Point Loma. By August 1854, the last of the Pacific coast's first eight lighthouses was completed and accepted by the government.

The contract initially called for the contractors to install each lighthouse's lighting system, which was to be the Argand lamp and parabolic reflector. But shortly after construction began, the Lighthouse Board, which by this time was planning to install the Fresnel lens in each new lighthouse, withdrew the requirement that the contractors supply the lights.

Meanwhile, the board dispatched a naval officer to Paris to buy lenses and lanterns for the West Coast lighthouses. The first two lenses, both third-order, arrived in San Francisco in the autumn of 1853. One of these was installed in

the Alcatraz lighthouse, which on June 1, 1854, exhibited its light for the first time, making it the first light on the West Coast.

During this period, the lighting of the West Coast was impeded by the Lighthouse Board's problem in assigning a competent and permanent inspector to the Twelfth Lighthouse District. The first inspector was Henry Halleck, an army officer who was more involved with his law firm than with the lighthouses. Seeking to further his career in law and the military, he gave up his lighthouse responsibilities and returned to the East. (Halleck was successful in his pursuits and became chief of staff of the army during the Civil War.)

After hiring another officer who did not work out, the Lighthouse Board sent Major Bache who, in addition to his lighthouse duties, also had the responsibility of building and maintaining the army's wagon roads on the West Coast. He held his position as inspector of the Twelfth District until 1857, when he was relieved during a reorganization.

Bache was a man of ability and energy. He undertook his new office by installing a light in the lighthouse at Point Pinos. A lens was already available on the West Coast. It had originally been intended for the Fort Point lighthouse in San Francisco Bay, but a couple of months after this lighthouse had been completed, the army tore it down to make way for a planned fortification. Bache decided to use the lens at Point

Pinos. After altering the tower, the workmen he had hired installed the lantern and third-order lens, lighting it on February 1, 1855. It was the second light on the West Coast. When the Alcatraz lighthouse was torn down in 1907 to make way for the prison, Point Pinos became the oldest lighthouse on the West Coast.

In the meantime, other lenses ordered from France arrived, and Major Bache proceeded to fit the lanterns and lenses on the previously erected lighthouses. Some of these towers had to be altered to receive the heavier lighting system. By late 1856 all of the Pacific's first eight lighthouses were in operation, as were lighthouses at Santa Barbara, at Crescent City, and at Point Bonita at the entrance to San Francisco Bay. By the end of October 1858, Bache had sixteen functioning lighthouses on the West Coast, from Cape Flattery at the Strait of Juan de Fuca to Point Loma in San Diego.

On the foundation that Bache had laid, other inspectors and engineers came to fill in the dark gaps on the West Coast. While some of these lighthouses, such as the one at St. George Reef (1892), were constructed to mark navigational hazards, others, such as the one at Point Sur (1889), designated points where vessels returned to or departed from the coast. Still others, such as Point Arena (1870), marked places where ships needed to turn in order to stay in the appropriate shipping lanes.

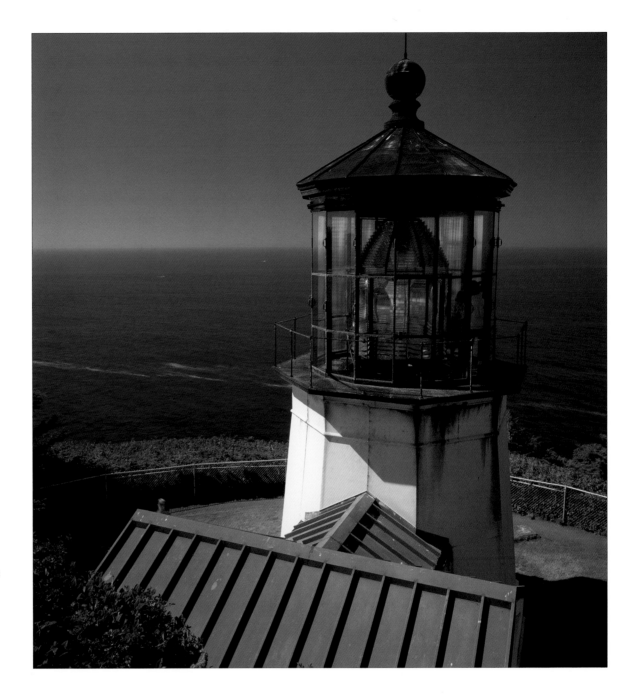

The U.S. Pacific Northwest

In the 1860s maritime traffic was on the rise in Puget Sound. In order to make the waters in this area safer for seamen, the Lighthouse Board erected lighthouses at Whidbey Island (1861) on the east shore to guide navigators into Admiralty Inlet, and at Ediz Hook (1865) to light the entrance to Port Angeles. Point Wilson lighthouse was built in 1879 on the western side as an additional guide to Admiralty Inlet. Other light towers added in Puget Sound were West Point (1881), which acted as a guide to Seattle; Point Robinson (1885), a guide to Tacoma; and Mukilteo (1906), which served to guide vessels to the port of Everett. The Lighthouse Board also erected lights at Destruction Island (1892), Gray's Harbor (1898), and North Head (1898) to guide shipping traffic along the coast of Washington.

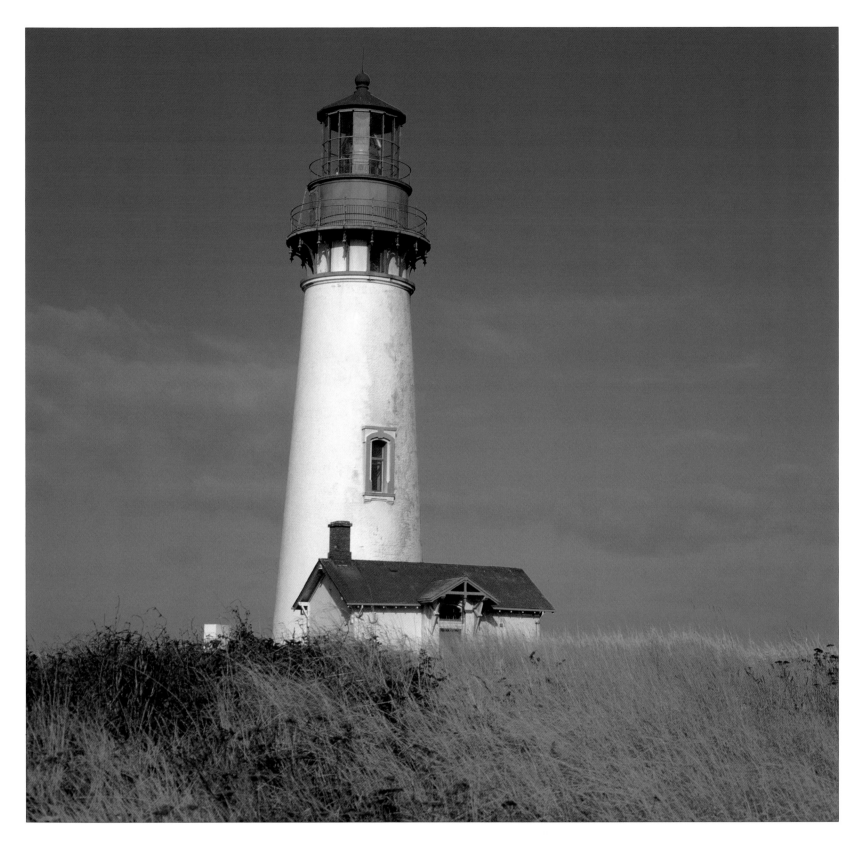

Along the Oregon coast, the Lighthouse Board erected Cape Arago (1866), Cape Blanco (1870), Yaquina Head (1873), Cape Meares (1890), and Heceta Head (1894). The most dangerous place along this stretch of the West Coast was Tillamook Rock.

The lighthouse there, built in 1881, not only served as a warning but also marked the southern approach to the Columbia River. Carving out the rock and building this lighthouse proved a difficult task because of riotous seas and stormy winds. The elements also made

life tough on the keepers. Stones, fish, seaweed, and water would come crashing into the lantern. Water often swept over the station, at one time causing one side of the dwelling to cave in. The lighthouse served until 1957, when it was taken out of service.

THE GREAT LAKES

The lighthouses of the Great Lakes are distinctive and well designed to meet the needs of the area. Although there are no tall towers reaching the heights of the East Coast towers, the lighthouses there that are higher than 90 feet (27.4m) look like their eastern counterparts, proudly displaying all their grace and grandeur. Paint is also used to make these tall towers, as well as other lighthouses in the region of the Great Lakes, distinctive. The pierhead and breakwater lighthouse designs are indigenous to this region. Brick lighthouses and dwellings give a sense of permanence and reliability.

The lighthouses of the Great Lakes run the gamut of architectural styles from the simple one-and-a-half-story dwelling with attached towers to Gothic and Victorian styles. A common type not seen elsewhere is the pyramidal-roofed square structure with a tower rising out of the center peak. Also of note is the crib lighthouse, which is the Great Lakes version of the caisson lighthouse. A vessel would float a crib out to the site where the lighthouse was to be situated. Then the crib was sunk to the lake floor and filled with stone. Over this crib, workers poured a concrete pier, the top of which would be well above water. It was on this foundation that they erected the lighthouse.

One lighthouse of particular interest in this region went into service in 1829 in Barcelona, New York. Known as the Barcelona light, and sometimes called the Portland light, this lighthouse is unique because of its fuel source. For much of its life, it used a nearby "spring" of natural hydrogen gas to light its lamps and 14-inch (35.5cm) reflectors. But the gas gave out in 1838, and the lamps were converted to use oil. Although the Lighthouse Board decommissioned the lighthouse in 1859, the tower and dwelling still stand.

LAKE CHAMPLAIN

Lake Champlain, a narrow and elongated body of water that washes the shores of Vermont, has for a long time been an avenue of commerce. The Lighthouse Board erected several lighthouses along this body of water to guide ships past reefs and other dangers. Some lighthouses, such as Burlington light (1857), were erected to guide vessels into a harbor. Colchester Reef lighthouse (1871) warned Burlington-bound traffic of three sets of reefs to avoid. Decommissioned in 1933, this lighthouse was moved to the grounds of the Shelburne Museum in 1952. Specialists have restored it as a historic lighthouse-maritime museum.

THE CAISSON LIGHTHOUSE

One of the structures found along the northern and mid-Atlantic coast, as well as on the Gulf of Mexico, is the caisson lighthouse. This type of design came into use in the United States in the early 1870s. Usually, the term *caisson* is applied to the whole cylindrical tube that serves as the foundation of the lighthouse, but technically a caisson is the very bottom of the cylinder, where there is a heavy wooden foundation or grillage.

At Duxbury, Massachusetts, a caisson-type lighthouse was erected in 1871. Its construction called for building a coffer dam around the site, which was shallow, and cleaning the pit of

Opposite: The lighthouse at Yaquina Head was actually supposed to have been erected 4 miles (6.4km) north at Cape Foulweather. The ship carrying the construction materials, however, deposited them at Yaquina Head, and the tower was erected at that site instead.

*The Duxbury
light is popularly
known as the
"Bug light."*

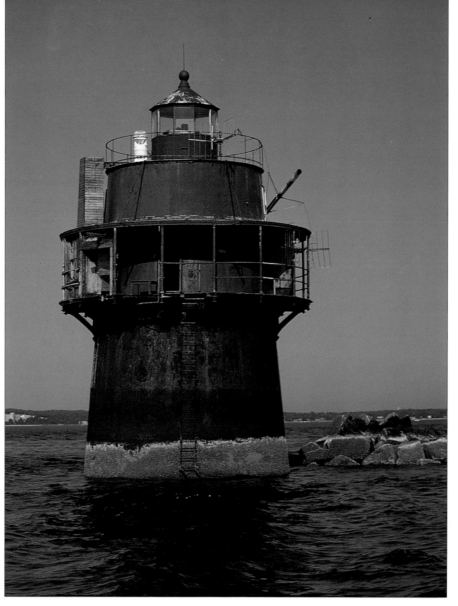

struction, the caisson was turned over so that the original base faced upward and the roomlike creation was on the bottom. Several courses of iron plate were attached to this new top, and concrete was poured into it for trim as it was towed from the construction site to the offshore site where the lighthouse was to be erected. At the lighthouse site, the caisson was lowered to the bottom of the ocean with courses of iron plates being added as needed to contain the rock and concrete. There were several metal shafts by which the workmen could get down to the room on the bottom and through which hoses pumped air so that these workers could breathe. There were also hoses to suck out the debris they excavated. The workers in the room shoveled mud and sand from around the edges, and a giant vacuum sucked the debris up the hoses in the shaft and sprayed it over the side into the bay. As the workers dug away, the caisson sank deeper into the bottom. When the caisson was finally positioned satisfactorily, the workers were removed from the room and concrete filled the shafts and the workroom. The top of the cylinder was shaped to hold a cistern for storing rainwater; above, a cellar was created for work and storage purposes. Then, the lighthouse was erected over the cellar.

Caisson lighthouses were sturdy structures, able to withstand the most severe weather and the glancing blow of a barge. Their great strength enabled

water and debris. When the pit was ready, the concrete-and-rock-filled cylindrical iron tube was set in position on the sea floor. There is controversy regarding whether or not this particular structure merits being called a caisson lighthouse. A true caisson lighthouse went into service in Chesapeake Bay in 1873 to serve as part of a range light guiding shipping into the Patapsco River, the avenue to the port of Baltimore.

There were two types of caisson lighthouses. One type involved dredging the site first to prepare it to receive the caisson. The caisson, with one or two courses of iron plates attached to it in an upright position, was floated out to

the site, where it was positioned on the ocean floor by filling the cast-iron cylinder with stone and concrete. As more concrete and rock were poured into the cylinder, the tube sank into the water and additional courses of iron plates were added to it. Once it had reached the bottom, the caisson was situated by using water and air to clear the sand and muck away. The first caisson lighthouse in Chesapeake Bay, previously mentioned, was constructed in this manner.

The other type of caisson lighthouse was erected by the pneumatic method of construction. In this case, the sides of the wooden caisson were built up to create a room. After con-

them to replace lightships on sites that were too rough for the harbor or bay screwpile lighthouses. They were unable to take the place of most outside lightships, however. In the 1890s the Lighthouse Board tried to erect a caisson lighthouse on the end of Diamond Shoals, North Carolina, but during the placement of the caisson, a roiling sea tipped it over and the contractor gave up. A lightship remained in use there until the 1960s, when the "Texas tower" type of lighthouse came into use. A number of these replaced lightships, but the cost became too great, and the Coast Guard replaced the remainder of the lightships with, for the most part, large navigational buoys.

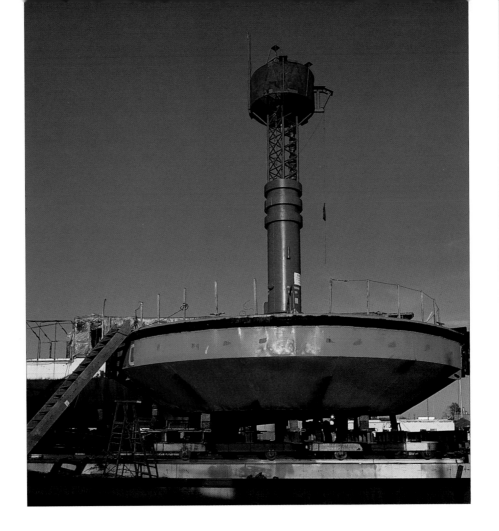

CHANGING ADMINISTRATION OF LIGHTHOUSES

The Lighthouse Board retained control over lighthouse administration until 1910. The board had performed exceptionally well over the years, bringing order and system to the country's aids to navigation and making professionals of the light keepers. The board had also modernized aids to navigation and taken advantage of advancing technology, adapting it to the navigational needs of the country. Its successors have built upon the solid foundation it laid.

In 1910 the Bureau of Lighthouses replaced the Lighthouse Board as the governing body in charge of lighthouses. This change was enacted by Congress, in part because it wanted to establish civilian control over lighthouse activity. The new bureau, known also as the Lighthouse Service, introduced the radio beacon, as well as a retirement system for keepers and other employees. George R. Putnam was a longtime commissioner of the bureau. He retired in 1935, and in 1939 the aids to naviga-

tion function was merged into the Coast Guard. At this point, all workers associated with lighthouses were given the choice of either remaining civilian employees or coming into the Coast Guard as uniformed employees; about half chose each alternative.

Though the Coast Guard did not instigate automation, it carried this cost-reducing activity the greatest distance. In the 1960s, the Coast Guard established an organized program, under which it has automated all but one of U.S. lighthouses. The one lighthouse that is still staffed is the Boston Harbor light, the site of the first lighthouse in the country. An act of Congress requires that it be staffed to commemorate the lighthouse's historic significance and the important role of the lighthouse keeper.

CANADIAN LIGHTHOUSES

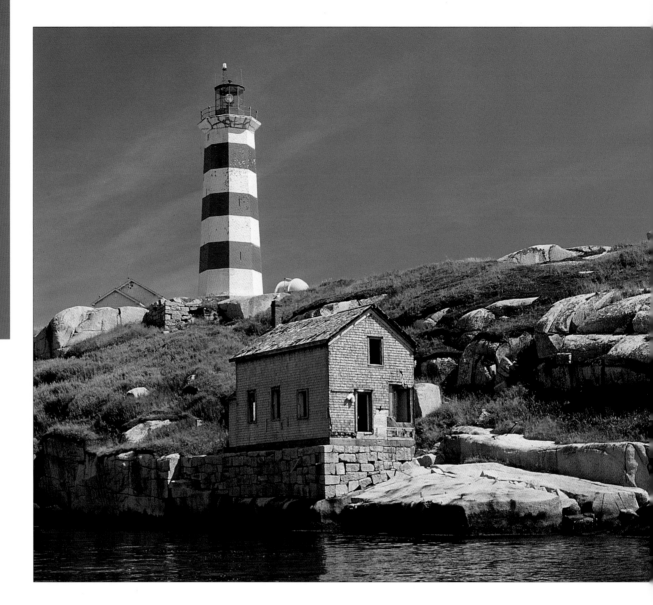

Canada's first lighthouse, which also happens to be the second one erected in North America, went into service in 1734. It would have been in use a year earlier had there not been a delay in receiving the glazing for the lantern from France. The French erected the lighthouse at the fortress of Louisbourg on Cape Breton Island on Canada's Atlantic coast. A pan of sperm oil surrounded by wicks supplied the light for this 70-foot-tall (21.3m) circular stone tower. Duties on coastal and seagoing vessels supported the operation of the lighthouse.

In 1736 the lantern caught fire and burned. Two years passed before the lighthouse could be put back into service. Repairs involved replacing all the wood elements with stone and metal. The lighthouse remained active until 1758, when the British bombardment of the fortress damaged the tower. The tower was left to crumble, and a replacement was not built until 1842.

The second Canadian lighthouse was erected in 1760 on Sambro Island. The Nova Scotia legislative council had authorized the structure in 1758, financing it with money from a tax on liquor and a lottery. Although the tower was 62 feet (18.8m) tall, its site raised the light to 130 feet (39.6m). Funding for the operation and maintenance of the light came from dues paid by vessels entering Halifax Harbor, to which this light still serves as a guide.

During this lighthouse's early years, there were many complaints from commercial and naval ships that the light was obscured. One navy official reported that at times a naval warship would lob a cannonball toward the lighthouse to stir the keepers to get the light burning. Apparently, the lack of visibility was due at least in part to smoke emitted from the lamp that would blacken the lantern's glass. The problem was finally resolved with the installation of better-burning lamps that gave off less carbon, as well as flues to carry off whatever carbon was produced. In time, an additional 18 feet (5.4m) were added to the tower. The lighthouse, now painted with red and white bands, is still active. In fact, it is the oldest existing lighthouse in Canada.

The lighthouse at Sambro Island is considered to be Canada's oldest functional light. For a long time, a cannon served as the fog signal for this site.

MANAGEMENT OF CANADIAN LIGHTHOUSES

In the early days, local commissions governed the establishment and operation of Canadian lighthouses. Their approach was modeled on that of England. Canada had Trinity Houses at Quebec and Montreal that imposed dues upon vessels that used the individual lighthouses. After the uniting of Upper and Lower Canada in 1840, lighthouses came under the jurisdiction of the Board of Works. This agency attempted to improve the operation of lighthouses by standardizing and modernizing the lighting apparatuses, as well as setting higher standards for keepers.

By 1870 jurisdiction over aids to navigation had been transferred to the Department of Marine and Fisheries. The department undertook a vigorous program to provide adequate lights for shipping traffic. Many of these new lighthouses were constructed of wood and had simpler operating lights, so that the keepers, most of whom were unskilled, would have less trouble handling them. The wood structures served well, as did the reflector lights. Canada had a more salutary experience with this type of lighting system than did the United States.

In 1876 the Lighthouse Board of the Department of Marine and Fisheries established six regional offices to build, manage, and operate aids to navigation. A national depot was established in 1903 from which supplies and equipment flowed. Specialists at this depot tested and experimented with lighting apparatuses to improve the efficacy of Canada's lighthouses.

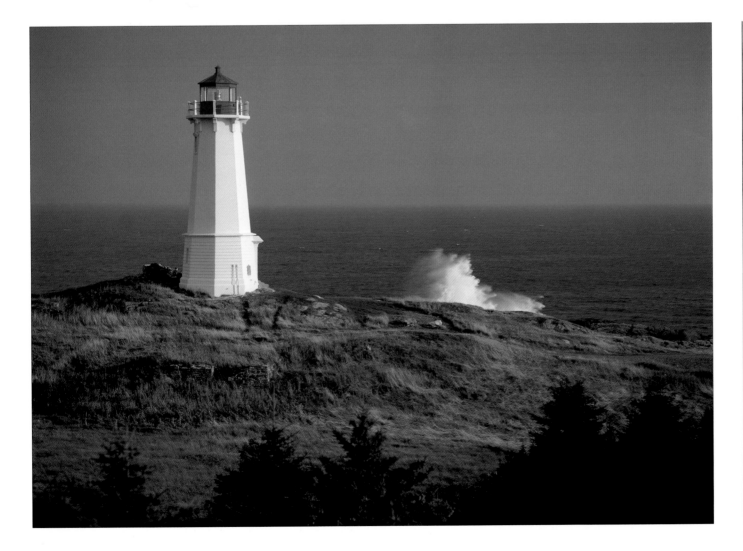

Fort Louisburg was the site of Canada's first lighthouse, erected in 1734. The present tower (shown here) was erected in 1842.

Designed by Colonel
Anderson, Pointe-
au-Père lighthouse is
one of the few rein-
forced concrete towers
in Canada using fly-
ing buttresses. All
Canadian light-
houses of this type
were erected in the
decade preceding
World War I.

In 1904 Parliament sanctioned the
Lighthouse Board, giving it a more
secure status and a broader mission.
In 1911 the board reorganized aids to
navigation into four regions. Continu-
ing along its path of vigorous activity,
the Lighthouse Board made improve-
ments to aids that had grown in impor-
tance, and either eliminated or
downgraded aids that were no longer
needed as much.

In 1936 the Department of Marine
came under the newly founded Depart-
ment of Transportation. Today Canada's
aids to navigation come under the aegis
of the Coast Guard, as is the case in the
United States.

TYPES OF CANADIAN LIGHTHOUSES

Canadian lighthouses are not especially
tall structures, mainly because, like the
West Coast of the United States, the
shoreline is rugged and sites for light-

houses are well above sea level. Wood
was a principal material used in the
construction of Canadian lighthouses,
partly because a wood tower was far
less expensive to build than a masonry
one. The wooden towers were built of
heavy beams in order to create a sturdy
structure.

Bricks and stones were also used
over the years in Canadian lighthouses,
as were metal plates. Some stone tow-
ers have had wood shingles attached to
their exteriors. The Prim Point light
tower on Prince Edward Island is an
example of this kind of construction.
Since the early part of the 1900s rein-
forced concrete has come to be used
for light towers.

Canadian lighthouses come in
many forms. A considerable number
are octagonal, pyramidal structures.
Several are conical, while others are
square. Sometimes the tower is built
into the keeper's dwelling. Other de-
signs, such as the Wood Islands light-
house at Prince Edward Island, are
merely adjacent to the dwelling. A few,
such as the one at Pointe-au-Père on
the St. Lawrence River, have flying but-
tresses to support the tower. Many of
the Canadian lighthouses have been or
are currently equipped with Fresnel
lenses. At least one, Cape Race, has a
hyperradiant lens that is larger than the
first-order Fresnel lens.

Most towers are painted white, but
red is a popular accent color that is of-
ten used to enhance the light tower's

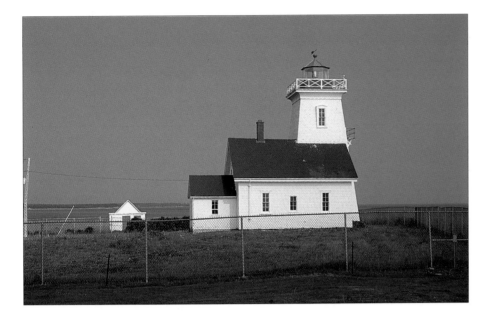

The Bay of Fundy is a body of water located between Nova Scotia and New Brunswick that is notorious for its horrendous tides. Many lighthouses were needed over the years to warn navigators of landforms and navigational obstacles in this area. The first of these aids was the Brier Island light, built in 1809, which guided vessels into the bay. Many other lights along the bay have since been added.

value as a daymark, causing it to stand out during the daytime when the tower is not lit. For the most part, the lanterns are painted red. An octagonal tower may have every other panel painted red. Some have huge red crosses painted on a white tower, while others are painted with large red and white bands.

historian D. Alan Stevenson, Nova Scotia, after erecting the lighthouses at Louisbourg and Sambro, put up a lighthouse at Cape Roseway, on McNutt's Island at the entrance to Shelburne Harbor in 1788. Reputedly, this light could be seen for 25 miles (40km). The structure at the site today is an octagonal reinforced concrete tower.

EARLY CANADIAN LIGHTHOUSES

In the eighteenth century, sea traffic to and from Canada was increasing, so the political entities of the eastern coast turned their attention toward building

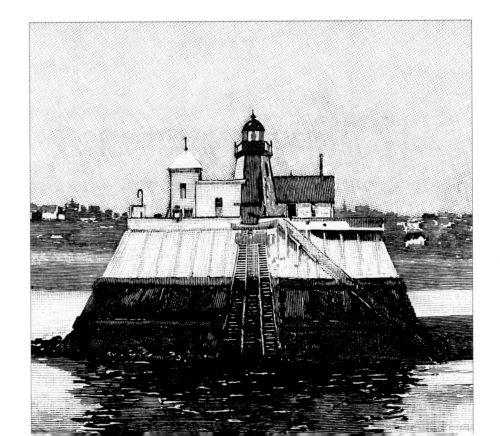

*op: The Wood Islands light tower, now automated, guides ferries to their dock on Prince Eward Island. **Bottom:** Despite the terrible tides, water traffic is heavy in the Bay of Fundy. The beacon shown here guides traffic to and from St. John on the New Brunswick side. Part of this traffic consists of ferries connecting Nova Scotia and*

The Brier Island light tower was replaced and given a metal lantern in 1832. That tower served until 1944 when a reinforced concrete tower (shown here) went up in its stead.

A lighthouse at Seal Island, 18 miles (28.8km) off the southern end of Nova Scotia, went into service in 1830. This octagonal wooden tower still stands and continues to hold the second-order Fresnel lens installed in it in 1859. The light is an important one, guiding traffic into the Bay of Fundy.

OFFSHORE LIGHTS

Canada's eastern coast has a number of islands that are well offshore, creating navigational hazards. More than 100 miles (160km) off the Nova Scotia coast, Sable Island posed a great danger to mariners. Although two lighthouses were recommended as early as 1801, none were built at this site until the latter part of the nineteenth century. In 1873 the government finally erected two wooden lighthouses, one at each end of the crescent-shaped island. In 1917 steel skeleton towers replaced these wooden ones.

St. Paul Island, at the entrance to the Gulf of St. Lawrence, is regarded as one of the most dangerous navigational hazards on Canada's eastern coast. Several shipwrecks occurred on the island, taking the lives of hundreds.

dred lives in one wreck, and on one night in 1835, four vessels crashed to their destruction on the island's rocks. Finally, in 1839 two lighthouses were erected on the island, one at the northeast end and one at the southwest end, along with a lifesaving station staffed by six lifesavers. Constructed of wood, each tower was equipped with a Fresnel lens. One had a fixed light, while the other displayed a flashing light.

The main avenue into the Gulf of St. Lawrence is Cabot Strait. Bird Rocks, located about mid-gulf on the strait's inbound route to the St. Lawrence River, received a 51-foot-tall (15.5m) wooden tower crowned by a second-order lens in 1870. In its early years, this station, which is still active today, was equipped with a cannon that

PRINCE EDWARD ISLAND

Prim Point, Prince Edward Island's oldest lighthouse, marks the entrance to Hillsborough Bay on the southern side of the island. A 60-foot-tall (18.2m) brick conical tower painted white, this light station has been in service since 1846. Today it has an automated light to guide vessels into the bay.

The sample of lighthouses at Prince Edward Island includes octago-

Head (1853), Seacow Head (1863), and East Point (1867), as well as square, pyramidal wooden towers. Examples of the latter include the 40-foot-tall (12.1m) Blockhouse Point tower (1851) and the 50-foot-tall (15.2m) tower gracing Wood Islands (1876).

Located on the western end of Prince Edward Island, the West Point tower (1876) is another square, pyramidal wooden structure. The lighthouse was automated in 1963, at which time the keeper's dwelling was taken down. With no one present at the site on a regular basis, the tower became the target of vandals. Appalled at what was happening, local citizens rebuilt the dwelling and in 1988 opened a chowder kitchen, a craft shop, and guest rooms.

Top, left: The view from the West Point lighthouse lantern is delightful. Note the Fresnel lens in the lantern, and the auxiliary light on the outside railing. **Top, right:** *The West Point lighthouse's use of black banding is seldom seen in Canada.* **Bottom:** *Seacow Head lighthouse was erected in 1863. It is an octagonal wood tower, a design common on Prince Edward Island.*

*op, left: The Blockhouse Point light tower is located near Charlottetown on Prince Edward Island. **Bottom, left:** East Point is the itinerant lighthouse of Prince Edward Island. Erected in 1867 about a half mile (0.8km) from the point it was designed to mark, the lighthouse was moved to within 200 feet (60.9m) of the point in 1885. When erosion threatened in 1908, it was moved farther back, to its current location. **Right:** The oldest lighthouse on Prince Edward Island is Prim Point. Unlike most lighthouses in this region, the tower is made of brick. Now automated, the lighthouse rises up against a beautiful landscape.*

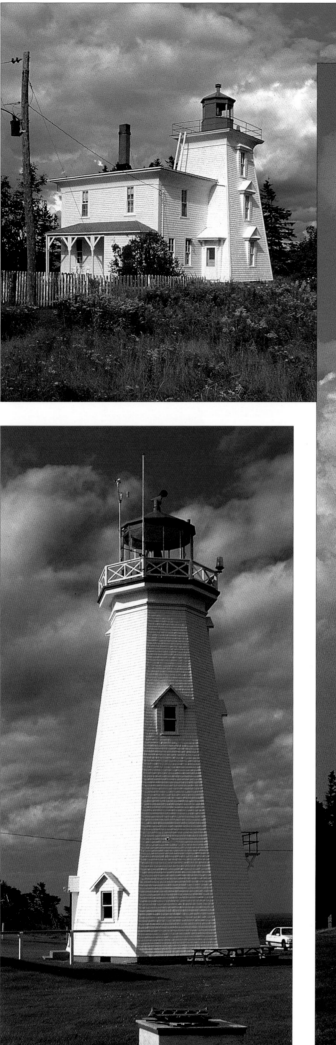

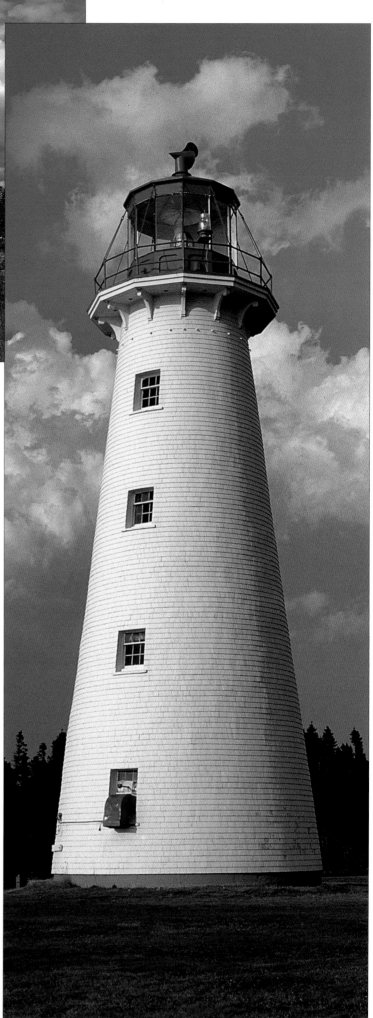

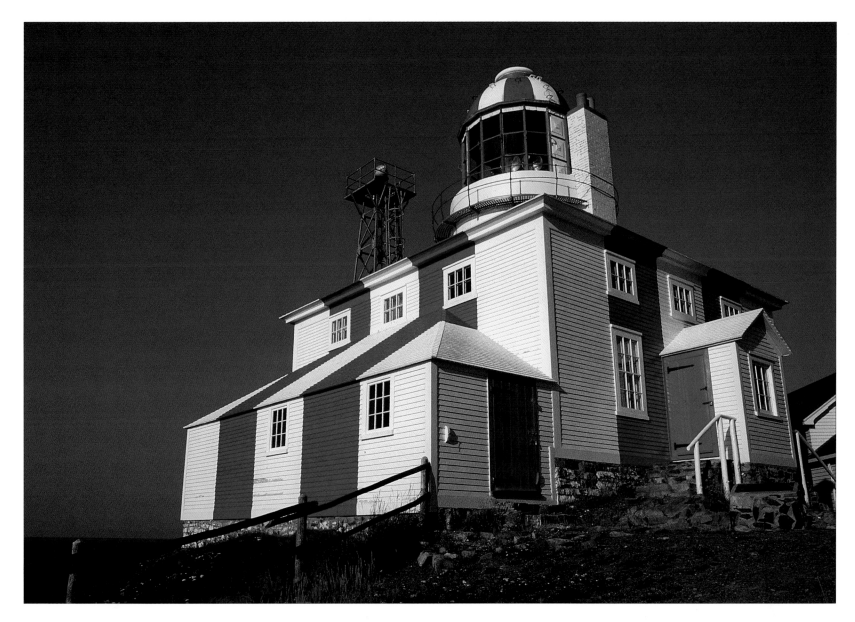

NEWFOUNDLAND LIGHTS

While wood was the primary material used for the lighthouses of Prince Edward Island, cast iron and steel found favor in Newfoundland, for they were considered more durable and easier to maintain. Cape Pine light tower (1851), which served to guide ships along the southern coast of Newfoundland to the

Cabot Strait entrance into the Gulf of St. Lawrence, was an early iron tower. Ferryland Head lighthouse (1871), which continues to guide vessels along the eastern coast of Newfoundland, was another iron tower.

Although cast iron and steel were popular, other materials were used in Newfoundland lighthouses as well. Cape Race light tower (1856), a landfall light, was built of stone. One of Canada's most important lights, this structure greeted ships from Europe until 1906 when it was replaced by a reinforced concrete tower surmounted by

a lantern containing a hyperradiant lens. The 96-foot-tall (29.2m) tower is still active today. Other stone towers, such as the one at Cape Bonavista (1843), have been preserved as museums.

Wood was also used in some lighthouses of Newfoundland. Cape Ray lighthouse (1871), located by the Cabot Strait, on the north side of the entrance into the Gulf of St. Lawrence, is one such structure. Together with the Channel Head light, located only a few miles to the southeast, this tower guards ships against shores considered to be exceptionally dangerous.

The lighthouse at Cape Bonavista went into service in 1843 to be of assistance to the fishing and sealing industry in that area. The old lighthouse was in operation until 1966, when a light on a steel skeleton tower took over the job.

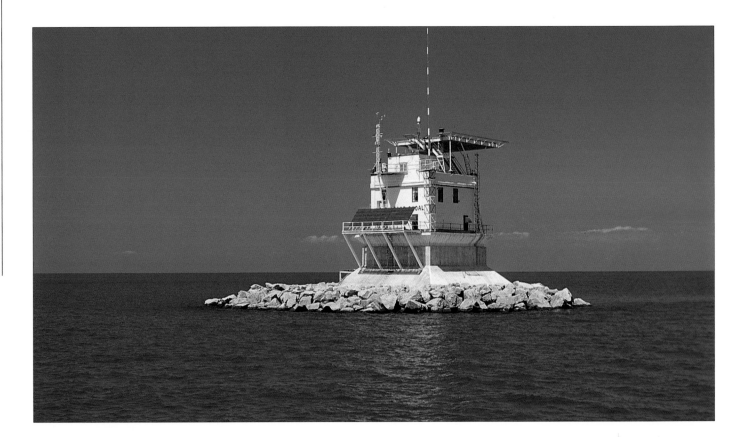

GREAT LAKES

In the early part of the nineteenth century, the Canadian government turned its attention toward the Great Lakes. Settlements had been spreading west, and in time shipping traffic increased, calling for aids to navigation. With the help of masons from the local military, the government erected a hexagonal masonry light tower on Lake Ontario at the mouth of the Niagara River in 1804. Located at Mississauga Point, this lighthouse, Canada's first on the Great Lakes, served for ten years before it was taken down to make way for fortifications.

LAKE ONTARIO

The next lighthouse to be erected on the Great Lakes was put up at Gibraltar Point on the island that forms the harbor of Toronto. Authorized in 1808, the hexagonal stone tower was originally 52 feet (15.8m) tall. Workers raised its height to 82 feet (24.9m) in 1832. Surrounded today by a city park, the tower stands as the oldest existing lighthouse on the Great Lakes.

Over the years a number of lighthouses were erected to mark harbor entrances, bays, passageways, and navigational hazards on the lake. Many of these towers were made of stone. One such structure was built in 1833 at Point Petre, the extreme southwest point of Prince Edward Peninsula; this tower used a set of reflector lights

purchased from Winslow Lewis of Boston, the developer of the lights then in use in U.S. lighthouses. During the same year, the government erected a circular stone light tower on the west end of Simcoe Island. This 45-foot-tall (13.7m) tower continues to serve as a landfall light for traffic headed for the St. Lawrence River.

Another stone tower was built in 1838 at Burlington Bay, which is located at the western end of Lake Ontario. This conical structure rises 79 feet (24m) into the air. In 1961 a reinforced concrete tower was built to take its place. Although the Coast Guard has tried to tear down the original tower, local preservationists have protected it.

A range light consisting of two white, square, pyramidal frame towers aids traffic at Port Dalhousie on the

southwestern shore of the lake. Apparently built in 1879, the front tower is 45 feet (13.7m) tall, and the rear one is 54 feet (16.4m). This range light remains the main guide into the port.

Lake Ontario also has one crib light. Known as Peter Rock light, this aid, which warns vessels of a rock hazard, is of particular importance to traffic coming from the east and headed for Port Hope.

LAKE ERIE

Lake Erie acquired its first Canadian lighthouse, the Long Point tower, in 1830. It was a circular stone tower about 50 feet (15.2m) tall that guarded ships against a sand spit running 20 miles (32km) into the lake. The light tower was undermined, and in 1843 the government built a replacement, an octagonal wooden tower 60 feet (18.2m) tall. In 1916 this lighthouse was replaced by an octagonal reinforced concrete tower rising 102 feet (31m) into the air. Painted white, this lighthouse is still active today.

Pelee Island lighthouse (1833) marked the dangerous Pelee Passage to the upper lakes. The 40-foot-tall (12.1m) circular stone tower emitted a fixed white light. Inadequate for the increase in traffic that arose, a replacement lighthouse was built in 1861. Sixty-one feet (18.5m) tall, the new wooden tower was placed on a stone-

filled caisson. In 1902 a conical steel tower with a third-order lens was erected at the site on a steel caisson filled with stone and cement. About this time, another caisson structure, the Southeast Shoal lighthouse, was placed at the passage. Each of these lighthouses was designed to mark a critical turn.

LAKE HURON

The lighthouse at Goderich was the first to be erected on Lake Huron. Built in 1847 on a cliff 100 feet (30.4m) above lake level, the 33-foot-tall (10m)

square tower is still active. Huron also contains six imperial lighthouses that were erected during the latter part of the nineteenth century. These tall conical towers, each over 85 feet (25.9m) high (except for one 60-footer [18.2m]), served the east coast of the lake and Georgian Bay. Only two remain active.

LAKE SUPERIOR

Much of the Canadian lighthouse construction on Lake Superior occurred after the 1930s, by which time lighthouse specialists had developed inexpensive,

Goderich lighthouse continues to be of great importance to the traffic on Lake Huron.

but quite acceptable, towers and lights that required little attention. Nevertheless, there are a few of the more traditional lighthouses present in Canada's portion of this lake. The light at Quebec Harbor, an old fishing village on Michipicoten Island, was installed in 1872. It was the first Canadian tower to be erected in the lake. One year later, the Porphyry Island lighthouse, which marked the entrance into Black Bay, went into service. Over the years, Canada built a number of other lighthouses on Lake Superior. An especially well-regarded one was the reinforced concrete tower erected on Caribou Island in 1912.

BRITISH COLUMBIA: THE FIRST LIGHTS

In the 1850s, British Columbia, like the western territory of the United States, was considered a frontier. The coast

was developing, and shipping was growing. As harbors became increasingly busy, the need for navigational aids increased.

British Columbia's first lighthouse was built in 1860 on Fisgard Island at the entrance to the Esquimalt Harbor near Victoria. The island on which the lighthouse rests is granite, as is the foundation of the lighthouse itself. Attached to the dwelling, the conical light tower, which is made of brick, originally supported a lantern fitted with a fourth-order Fresnel lens.

British Columbia's second lighthouse was also erected in 1860, the site being Race Rocks at the eastern end of the Strait of Juan de Fuca. Three years earlier, the United States had built a lighthouse on Cape Flattery at the western, or Pacific, end of the strait. The U.S. light guided vessels into the strait, while the Race Rocks light aided vessels as they moved down this strip of water. Some time after its construction, the Lighthouse Board had the conical sandstone tower at Race Rocks painted with wide alternating black and white bands.

These two lighthouses, along with a lightship stationed in the Strait of Georgia at the mouth of the Fraser River in 1865, were the only aids to navigation in British Columbia for nearly ten years. But in the early 1870s the Lighthouse Board began to focus on the need to light the Pacific side of Vancouver Island, particularly the harbors along the coast.

THE OUTSIDE LIGHTS

This outside coast had a reputation for having many shipwrecks, not only on the ocean shores, but also in harbors and rivers. Indeed at some sites, keepers found that rescuing seamen and others was a fairly common occurrence.

*F isgard Island
lighthouse is a
sturdy structure.
Keepers tended the
lighthouse until
1928, when it was
automated.*

Cape Beale lighthouse was one of the first to be erected on the dangerous side of Vancouver Island. Situated on a high bluff at the southern end of the entrance into Barkley Sound, the 31-foot-tall (9.4m) square, pyramidal wooden tower was lit in 1874. Its site placed the focal plane of the light at 167 feet (50.9m) above sea level.

With the increase in lumber and coal traffic on the Pacific coast, the members of the Lighthouse Board directed their attention toward how they could aid this burgeoning traffic. To start, they decided to put a lighthouse at Carmanah Point east of Cape Beale. Lit in 1891, the tower itself was 46 feet (14m) tall, but the site raised the light

to 173 feet (52.7m) above sea level. This helpful new lighthouse was located at the entrance to the Strait of Juan de Fuca across from the Cape Flattery light; together these lights guided vessels into the strait. The Carmanah light also served as a landfall light for traffic from the Orient bound for British Columbia and Puget Sound. The keeper of

as a landfall light for steamers from the Orient. Three years later, a lighthouse went into operation at Pachena Point, about 10 miles (16km) east of Cape Beale. Like the lighthouse at Lennard Island, it was a hexagonal wooden tower surmounted by a first-order lens. It was outfitted with lifesaving equipment, as well as a fog signal.

Across Barkley Sound from Cape Beale, an unwatched light (a 31-day lamp) was installed at Amphitrite Point in 1906. After a tidal wave smashed the light tower, a replacement was erected to mark the northern entrance of the sound. This two-tiered dwelling surmounted by a lantern went into operation in 1914.

Other lighthouses that served this area were the ones at Kains Island (1907), Estevan Point (1910), and stormy Triangle Island (1910).

THE LOWER INSIDE LIGHTS

As the lighthouses facing the Pacific were going up, other lighthouses were being erected to guide shipping to and from the ports of the lower end of the Strait of Juan de Fuca and the Strait of Georgia.

One of the earliest of these lighthouses was built at Point Atkinson in 1875. A square wooden tower resembling the one at Cape Beale, this lighthouse was located at the northern

this light thereby had the additional duty of notifying Victoria by telegraph of Canada-bound ships so that the merchants could prepare for their arrival.

As the years passed, other lighthouses came to brighten the darker

segments of the Pacific shore. In 1904 Lennard Island, 50 miles (80km) north of Cape Beale, received a new lighthouse that was to warn the burgeoning coastal traffic of the treacherous reefs in that area. The new tower also served

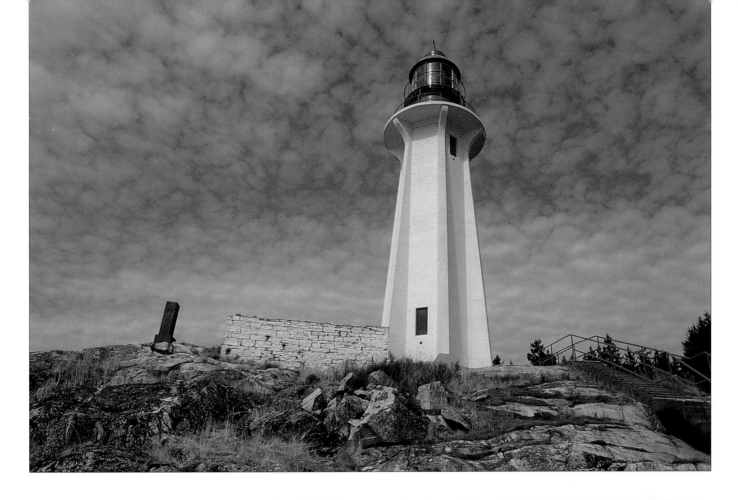

entrance of Burrard Bay, which leads to the harbor of the city of Vancouver. The station was outfitted with a fog signal in 1889. The Lighthouse Board demolished the old tower in 1910 and later replaced it with a hexagonal reinforced concrete tower braced by six buttresses.

Inside Vancouver's harbor, the Department of Marine and Fisheries erected a lighthouse at Brockton Point in 1890 for the purpose of guiding vessels toward their docking or anchoring destination. The first lighthouse at this site was essentially a dwelling that radiated a guiding light out of a specially designed window on the second floor. This structure served until 1914, when it was replaced by the lighthouse that presently illuminates the area.

Other lighthouses designated to aid the traffic in these straits were erected at Berens Island (1875), in

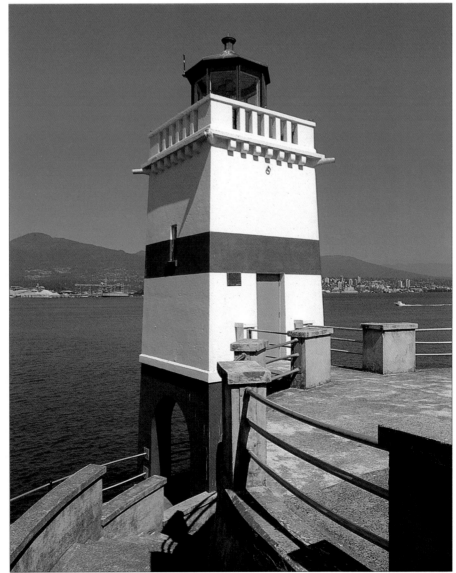

Opposite: *Pachena Point lighthouse, located east of Cape Beale, has a particularly difficult coast to guard ships against.* **Top:** *Point Atkinson lighthouse began service in 1875 and was replaced in 1912. The latter tower had a third-order lens, the light of which was 108 feet (32.9m) above the sea.* **Bottom:** *The first lighthouse at Brockton Point did not allow for much privacy as large glass windows designed to let the light shine forth also provided a clear view of the keeper's dwelling. A new square tower (shown here) was erected in 1914, but the old lighthouse was retained as living quarters.*

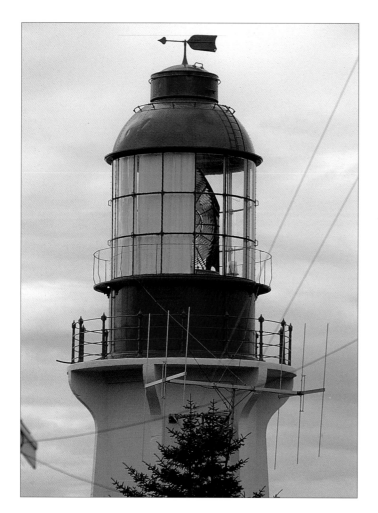

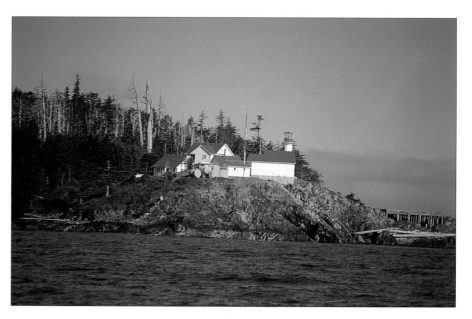

*op, left: Langara lighthouse is one of the loneliest posts in the Canadian lighthouse service. It has taken a special salary to attract keepers there. **Top, right:** Scarlett Point lighthouse is another tough station, due in great part to isolation. **Bottom:** The foghorn at Egg Island lighthouse.*

Victoria, Capilano (1908), and at Albert Head (1930) at the southern end of the Royal Roads, which was the Pacific port of the British Navy.

INSIDE PASSAGE

The Inside Passage of British Columbia is the strip of water that separates mainland Canada from Vancouver Island. Except for a few sites, such as Sand Heads at the mouth of the Fraser River and Point Atkinson leading to the port of Vancouver, the Lighthouse Board had devoted little attention to this passage. By the 1880s, however, traffic up and down the passage, as well as across it, was increasing. Cross traffic

received help in 1885 when a light went into service at Active Pass, which is on the route from Discovery Island (near Victoria) to Vancouver. Though the pass was dangerous, steamboats traversed it with reasonable ease. In 1895 Portlock Point raised a light that also led traffic to Active Pass.

Other lights soon dotted the Inside Passage. Farther north, a lighthouse was erected on Sisters Island in 1898. That

year also saw a lighthouse go up at Cape Mudge, leading traffic to the Alaskan gold fields. In 1905, the Scarlett Point lighthouse was activated to mark the entrance into Christie Passage, which leads to Queen Charlotte Sound.

Today the Inside Passage is well marked to Queen Charlotte Sound. Beyond are the northern lighthouses, which served the gold rushers heading to Alaska.

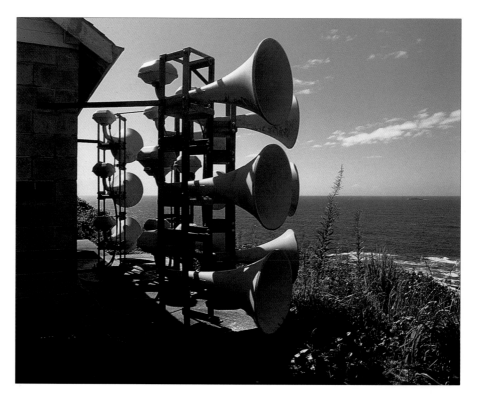

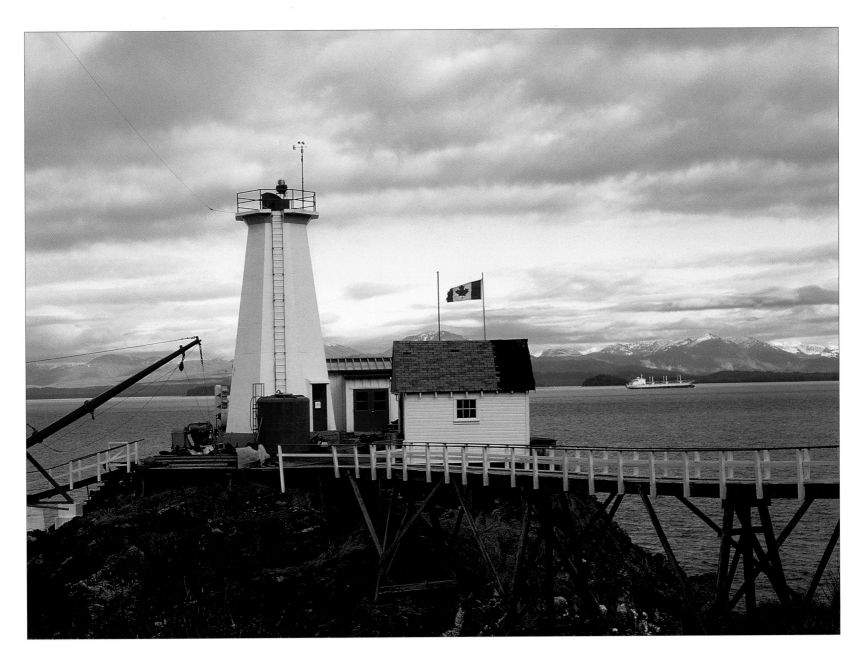

Northern Lights

In addition to serving the traffic of the gold rush, the lighthouses that were installed at the northern end of the Inside Passage provided direction toward Prince Rupert for vessels traveling from the Orient. Green Island (1906), Lucy Island (1907), and Langara Point (1913) were all typical lighthouses established to benefit this port. Simple in design, these structures were small and compact.

Egg Island lighthouse was established in 1898 at the entrance to Fitzhugh Sound to lead gold seekers north. The structure was a square two-story dwelling with a lantern mounted on a truncated pyramidal roof. In 1948, however, the lighthouse was brought to a dismal end when a tidal wave crashed down on the island, destroying everything but the foundation of the dwelling. A similar structure at Ivory Island in Milbake Sound was also the victim of tumultuous waters; in 1904 a wave swept most of the station away.

Years later in 1963, another wave inflicted extensive damage upon the fog building. Yet another wave wreaked havoc in 1982, flooding the radio room and tossing a 1,000-gallon (3,785l) water tank into the dwelling.

As in other nations of the world, Canada's lighthouses are now being automated. There is a rising interest in the preservation of lighthouses in Canada, and we can hope that there will be enough concern expressed by Canadian citizens to save these magnificent structures for future generations.

Lucy Island's first lighthouse was a two-story dwelling with a short tower protruding from the roof. The structure suffered many storms and at least one tsunami that weakened it. Eventually, the tower needed to be replaced by the present structure, shown here.

LIGHTS OF THE CARIBBEAN, BERMUDA, HAWAII, AND ALASKA

PUERTO RICO

Probably the best-lit island in the Caribbean is Puerto Rico. The plan for lighting the island was developed by the Spanish, who nearly completed their

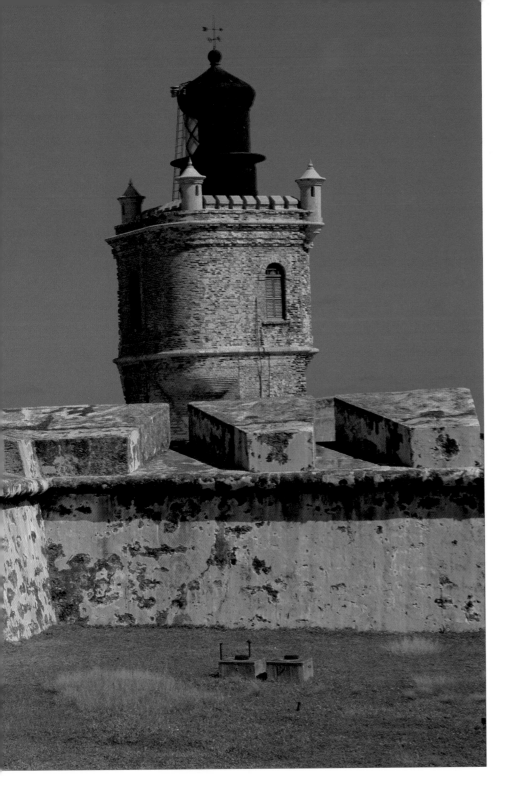

lens that was later replaced by a first-order lens. Its purpose was to guide vessels along the island's north and east coasts. Five years later, Spain placed a lighthouse on the west side of the Virgin Passage between Culebrita Island and Savana Island. Situated on a 230-foot (70.1m) hill on the southern end of Culebrita, the cylindrical gray tower rose out of the top of the dwelling, displaying its light at 305 feet (92.9m) above sea level.

Several harbor-entrance lights with sixth-order lenses were also installed by the Spanish. They included Cardona Island (1889) at the entrance to Ponce Harbor, Point Figuras (1893) at the entrance to Port Arroyo, and the Guánica light (1893) on Point Meseta at the entrance to Guánica Harbor. The Spanish also placed a third-order light on Vieques Island to mark the entrance into Port Ferro.

Throughout their possession of Puerto Rico, the Spanish continued to erect many lighthouses. The last major lighthouse to be erected there, though, was built at Arecibo (1898) by the United States military government as a guide to Arecibo Roads. Though over the years the United States has expanded the use of aids to navigation in Puerto Rico, this expansion has consisted mainly of range lights, buoys, and other lesser aids. It was the Spanish who were the main contributors to the region's lighting system; they had planned well and built well.

work before the Spanish-American War led to the cession of the island to the United States.

El Morro, a magnificent fortification that the Spanish had built in 1539 and that had received various additions over the centuries, was the site of Puerto Rico's first lighthouse. This lighthouse went into service in 1853. Severely damaged by Admiral Sampson's bombardment during the Spanish-American War, it was rebuilt in 1899. The reconstruction of the lighthouse did not hold, however, so in 1908 the U.S. Lighthouse Board constructed another tower, which is still active today.

Continuing along with their mission to light Puerto Rico, the Spanish erected a lighthouse on Cape San Juan, at the northeast corner of the island, in 1880. This coastal light was originally equipped with a third-order Fresnel

Opposite, top: El Morro is located at the entrance to the harbor of San Juan, Puerto Rico, and has resisted many assaults by the Dutch and English, including Sir Francis Drake. **Opposite, bottom:** *The present lighthouse at El Morro was designed by engineers from the U.S. Lighthouse Board to replace the heavily damaged Spanish lighthouse.*

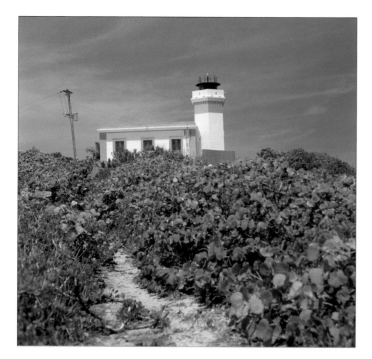

The British Virgin Islands have few aids to navigation. With the exception of a range light, about all that are used are minor aids and natural features. The U.S. Virgin Islands, on the other hand, have a substantial number of aids to navigation, including lighthouses, many of which the United States inherited when it purchased the islands from Denmark in 1917.

Like the Spanish in Puerto Rico, the Danes had created a good basic lighthouse system. When the United States acquired the Virgin Islands in 1917, it also acquired five lighthouses. The Muhlenfels Point lighthouse marked the entrance into St. Thomas Harbor. This light originally sat on a steel skeleton tower, but within a few

*op: Arecibo lighthouse, located on the north side of Puerto Rico, is a white hexagonal tower attached to a square flat-roofed dwelling. **Bottom:** A series of shipwrecks in the early 1900s caused the authorities to consider increasing the height of St. David's lighthouse (shown here) a second time, but they eventually decided to leave the tower as it was and to erect an automated beacon at North Rock, which had been the cause of many of the wrecks.*

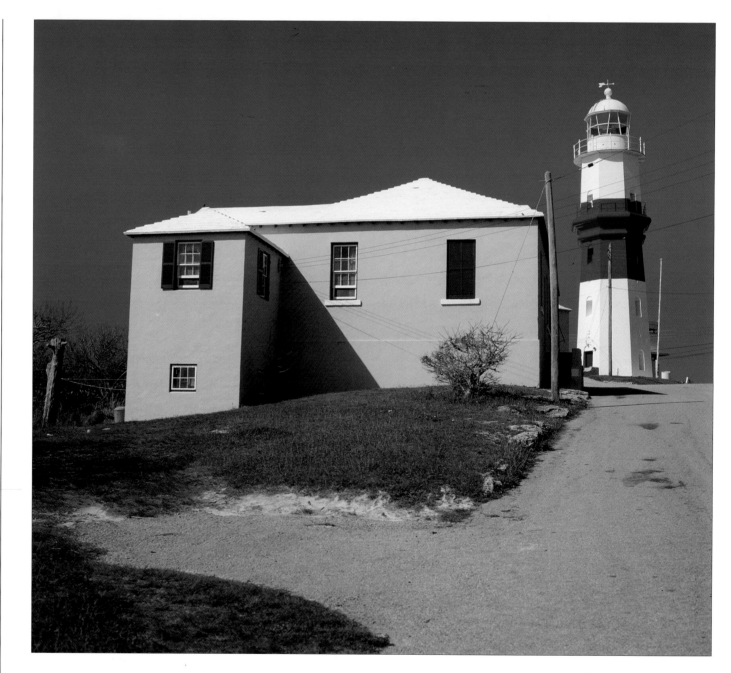

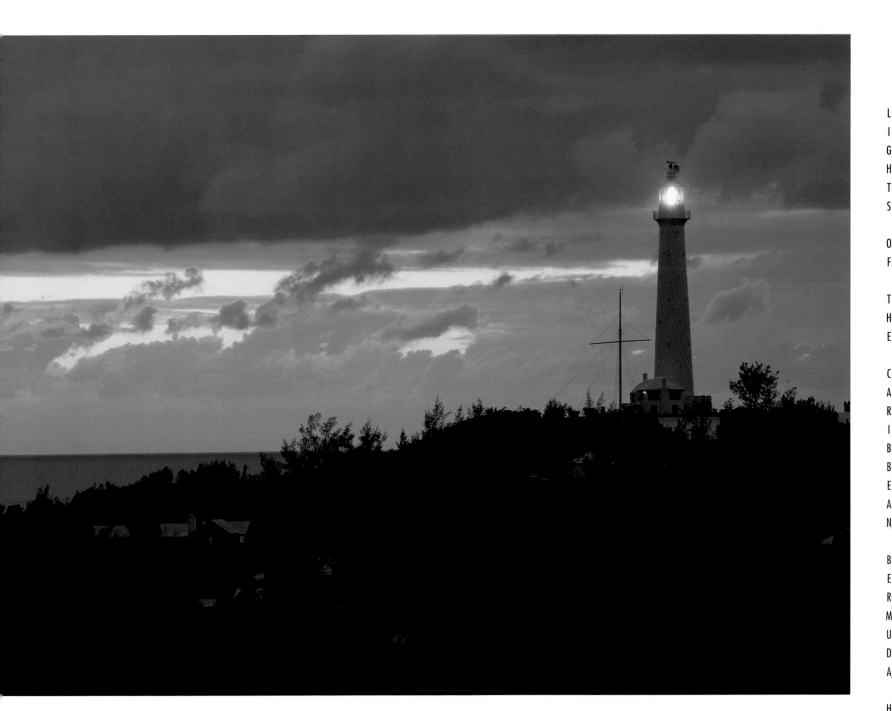

years the U.S. Lighthouse Service sub-
stituted a white cylindrical tower. Just
off St. Thomas, the Danes had erected
a steel skeleton tower at Buck Island
around 1913. On St. Croix, Denmark
had built a brick dwelling surmounted
by a light tower sometime before 1919
at Fort Louisa Augusta, located on the
promontory at the east entrance to
Christiansted Harbor. The southwest
cape at Frederiksted and Hams Bluff
also bore lighthouses.

BERMUDA

For more than 350 years, Bermuda has
been an important base for the Royal
Navy, though it was not until the nine-
teenth century that aids to navigation
began to appear there. The Gibbs Hill
lighthouse at the southwestern end of
the island went into service in May
1846. Made of plates fashioned in

England, this conical cast-iron light-
house was 130 feet (39.6m) tall.
Equipped with a first-order lens, this
tower guided vessels into the harbor.

At the other end of the island is a
lighthouse known as St. David's. Stand-
ing 55 feet (16.7m) tall, this octagonal
tower was made of limestone obtained
at the site. Erected in 1879, the height
of the tower eventually had to be in-
creased in order for the light to be visi-
ble over some nearby hills.

*The Gibbs Hill
lighthouse was
designed by the
British engineer
Alexander Gordon.
It is thought to
be the second iron
plate lighthouse
ever built.*

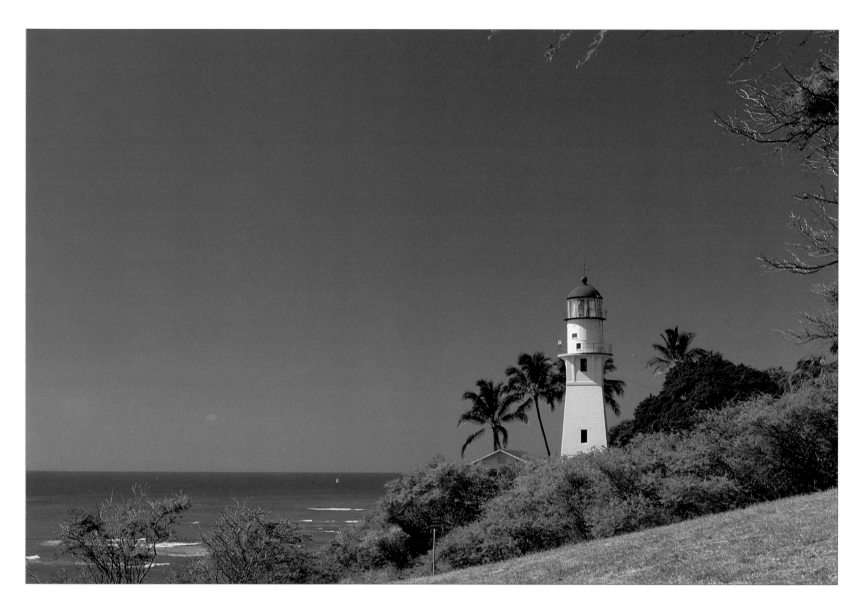

Diamond Head lighthouse was erected in 1899, but by 1917 cracks threatened the tower. The Lighthouse Service replaced it with a reinforced concrete tower.

HAWAII

Although the United States acquired Hawaii in 1898, it was not until 1904 that the Lighthouse Board was given the responsibility of managing the lighthouses in this territory.

At this point, district specialists were finally dispatched to the islands to examine the lighthouses and other aids to navigation. They found that Hawaii had nineteen lighthouses, twenty daymarks, twenty buoys, and sixteen private aids. Only two lighthouses,

Diamond Head and Barbers Point, had Fresnel lenses. The other lighthouses were "generally of a very crude character." All six lights on the island of Hawaii itself were found to be "very cheap and of short range." On Maui one lighthouse had "two ordinary kitchen lamps." Several lamps had either a red cloth tied around them or a red screen placed in front of the light. In general, the lights were weak and could be seen from only a short distance.

Once it had established itself in Hawaii, the Lighthouse Board moved quickly to have small Fresnel lenses or lens lanterns fitted in all the active

lighthouses. It also rebuilt some of the towers, developed a policy to take over all private aids, and determined where additional lighthouses were needed.

The Lighthouse Board and its successor, the Lighthouse Service, installed lighthouses and beacons to mark harbor entrances, rocks, and shoals. The board also installed such coastal lights as the one at Kauhola Point. Built in 1917, this tower was replaced in 1933 after it had been gutted by a fire. The new structure was a conical reinforced concrete tower built from the same plans as the Nawiliwili tower. An airport beacon provided its light.

The Lighthouse Board established two large and important coastal lights. One is the Molokai lighthouse erected on the north shore of Molokai Island in 1909. The light emitted by its original second-order lens measured 2,500,000 candlepower. The other light was erected in 1909 on Oahu.

The board had noted in 1905 that all the traffic traveling from Puget Sound south to Panama struck the Hawaiian Islands on the east side of Oahu at Makapuu Point, but there were no lights on that side of the island

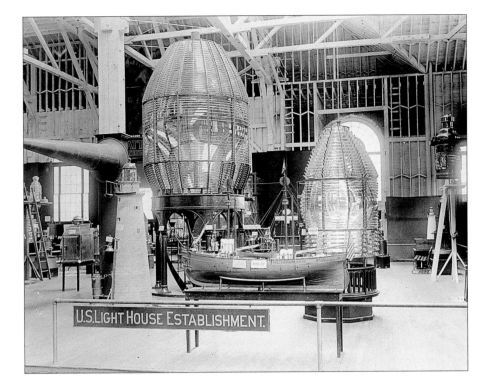

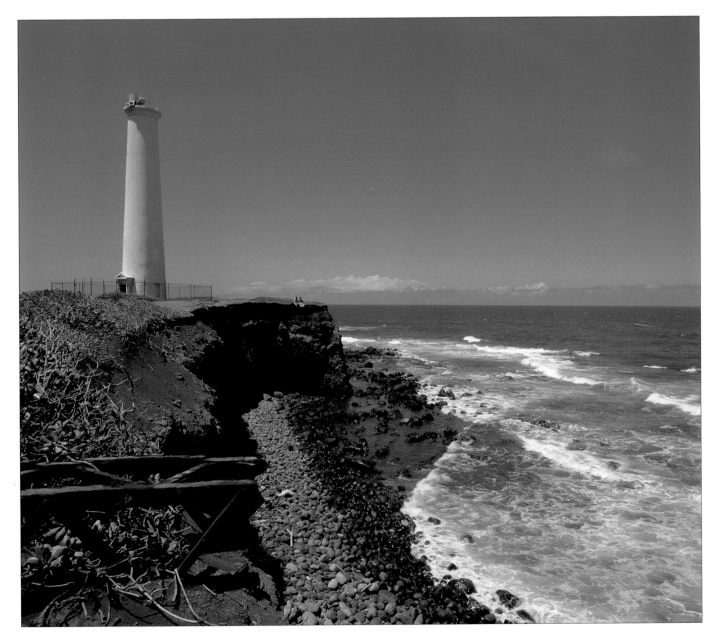

op: At the World's Fair in Chicago in 1892–1893, the Lighthouse Board displayed an extensive exhibit. One item shown was the hyperradiant lens, eventually to be used at Makapuu lighthouse. To the right of the hyperradiant lens is a first-order Fresnel lens. **Bottom:** *The first Barbers Point light tower went into service in 1888. A short conical tower, it was found in time to be inadequate; consequently, it was replaced in 1933 with a 72-foot (21.9m) cylindrical reinforced concrete tower, which proved to be of greater assistance to shipping. In 1964 it was automated.*

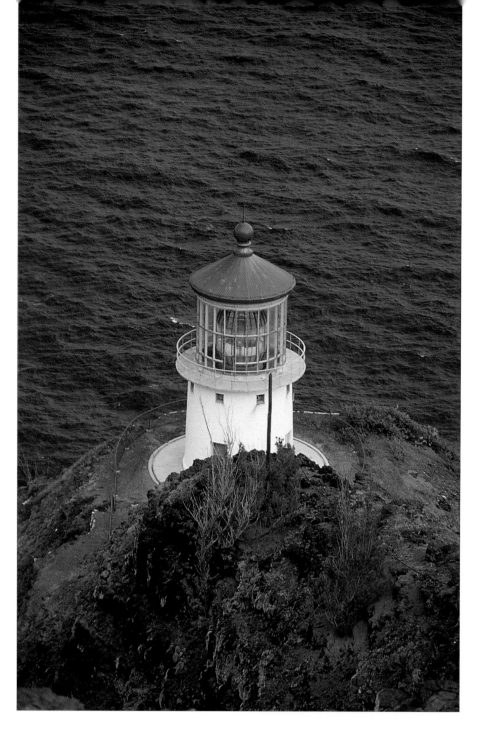

first-order lens; the focal distance—the distance from the illuminant to the interior surface of the lens—for a hyperradiant lens is just over 52 inches (132cm), whereas the focal distance for a first-order lens is just over 36 inches (91.4cm). Developed by the Stevenson family, that remarkable group of Scottish lighthouse engineers, the hyperradiant lens is the largest lens ever produced. By 1913, there were only about twelve hyperradiant lenses in use around the world.

One other highly significant lighthouse erected in Hawaii is located at Kilauea Point on Kauai. This white, conical concrete tower, 53 feet (16.1m) tall, supported a second-order Fresnel lens 216 feet (65.8m) above sea level. It was a landfall light for those vessels coming from the Orient. Kilauea was the last staffed lighthouse to exist in Hawaii. It was not until 1976 that the Coast Guard automated it, putting up a

*Top: Makapuu lighthouse is a short tower that nests like a bird on the hillside. **Bottom:** Kilauea Point, like so many other lighthouses, is on the National Register for Historic Places. This lighthouse is highly significant, particularly for the landfall function it once performed.*

to warn the navigator that he was approaching land. In 1906 Congress appropriated $60,000 to remedy this. Because the site for this landfall light was nearly 400 feet (121.9m) above sea level, only a short tower was needed. Although the cylindrical reinforced concrete tower was only 46 feet (14m) tall, the light of the hyperradiant lens was 420 feet (128m) above sea level.

The hyperradiant lens at Makapuu was the only such lens the United States ever acquired. This type is larger than a

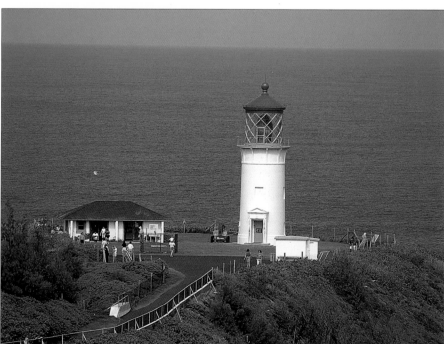

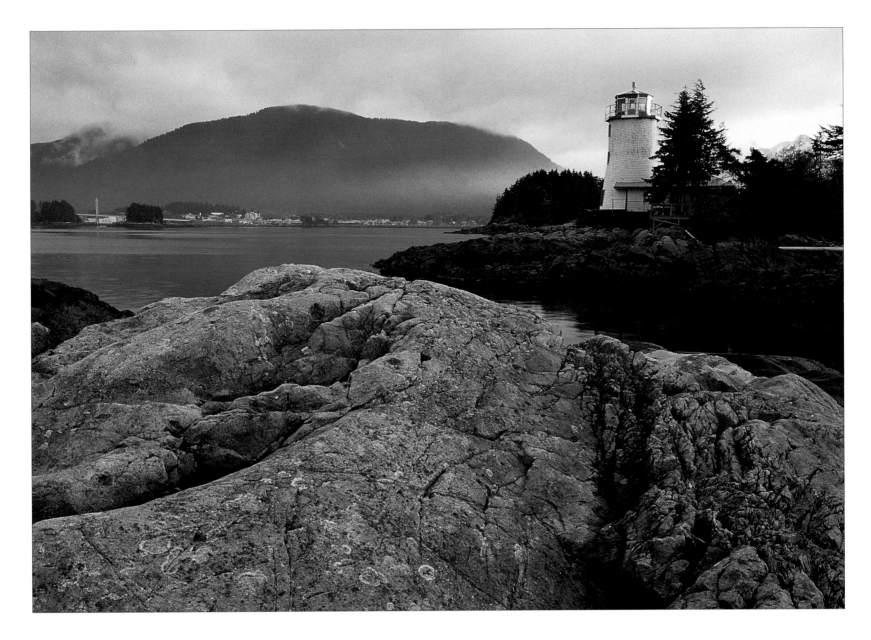

monopole and aerobeacon nearby. The light has a range of 25 miles (40km). Meanwhile, the old tower has become part of the Kilauea National Wildlife Refuge, where it is open to the public.

ALASKA

When the United States purchased Alaska from Russia in 1867, it also acquired a navigational light. Located in the cupola of the Baranof Castle in Sitka, this light reportedly used seal-oil lamps and a large reflector. The U.S. Army looked after the light until the troops departed in 1877.

The Lighthouse Board took little interest in Alaska, and by the time of the gold rush in 1897 and 1898, Sitka had fourteen buoys and a small beacon light, all the navigational equipment in Alaska. With the rush to the goldfields, shipping traffic was becoming heavy and many ship captains who transported people and goods to Alaska had little knowledge of the Alaskan coast and waters. As a result, many ships were holed by unseen rocks or broken apart on rocky shores hidden by fog.

Perhaps it was this loss of people and ships that encouraged Congress to set aside $100,000 in the year 1900 for the Lighthouse Board to study the navigational needs of the new territory. Officials recommended eleven lights on the southeast coast of Alaska and four on the west coast, noting that priority should be given to lights at Southeast Five Fingers on the route from Juneau to Skagway, Point Retreat and Sentinel Island near Skagway, and Fairway Island in Peril Strait.

Cape Edgecumbe light tower guides shipping into Sitka Sound.

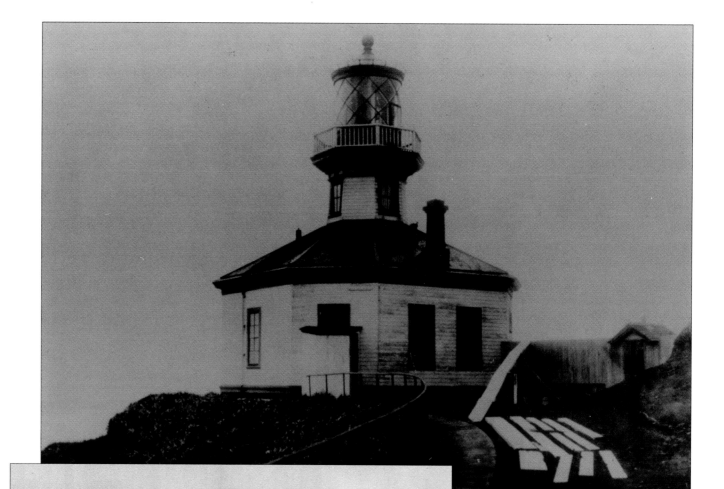

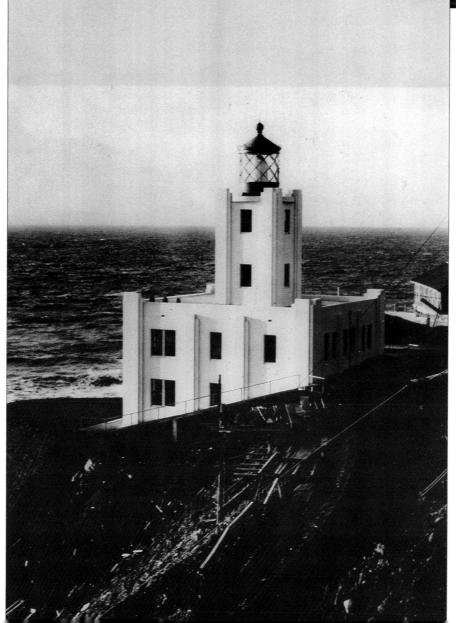

Congress appropriated money for the work in 1901, and the Lighthouse Board let contracts for the lighthouses at Southeast Five Fingers and Sentinel Island, both of which went into service in March 1902. Money was soon appropriated for other lighthouses on the Inside Passage to Skagway, including Mary Island (1903), Tree Point (1904), Guard Island (1904), Lincoln Rock (1903), and Point Retreat (1904). Many of these lighthouses were made of wood and, consequently, had eventually to be replaced with concrete or iron structures. On the other hand, Eldred Rock (1905) was made of reinforced concrete and has survived. This lighthouse consists of a dwelling with an octagonal tower rising from the roof.

Two of the earliest light stations on the outside passage were Scotch Cap and Cape Sarichef. Erected in 1903, Scotch Cap marked the Unimak Pass. The station originally had an octagonal wooden tower. This structure's replacement, a reinforced concrete tower, was destroyed in 1946, when an earthquake-generated tidal wave swept the station along with its five keepers into the water. There were no survivors. A temporary tower was used at the site until a new station was built in 1950.

Cape Sarichef, 17 miles (27.2km) from Scotch Cap at the other end of Unimak Pass, went into service in 1904. The Bering Sea washes the shores of Unimak Island on the Cape Sarichef side, making the lighthouse the only staffed one in the Bering Sea. Rebuilt in 1950, the light is 177 feet (53.9m) above sea level.

Other outside lighthouses erected along the Alaskan coast include Cape Hinchinbrook (1910) at the entrance to Prince William Sound; Cape St. Elias (1916), a landfall light; Cape Spencer (1925), which marks the nor-thern entrance to the Inside Passage; and Cape Decision (1932), Alaska's last coastal light, which marked one of the middle accessways to the Inside Passage.

There is no question that over the years various government entities have diligently attempted to increase the safety of those who travel the seaways. Not only have they increased the number of aids to navigation—whether major lights or guides to berths—but they have also adjusted to and taken advantage of advancing technology to improve the efficacy of these structures. Comparing the Pacific Coast *Light List* of 1943, which lists 2,080 aids, with the l988 *Light List*, which lists 31,000 aids, reveals the tremendous amount of progress that was achieved during a relatively short period of time.

Made of reinforced concrete, the Cape Spencer lighthouse has a 25-foot-tall (7.6m) tower on its roof, placing the light at 105 feet (32m) above sea level.

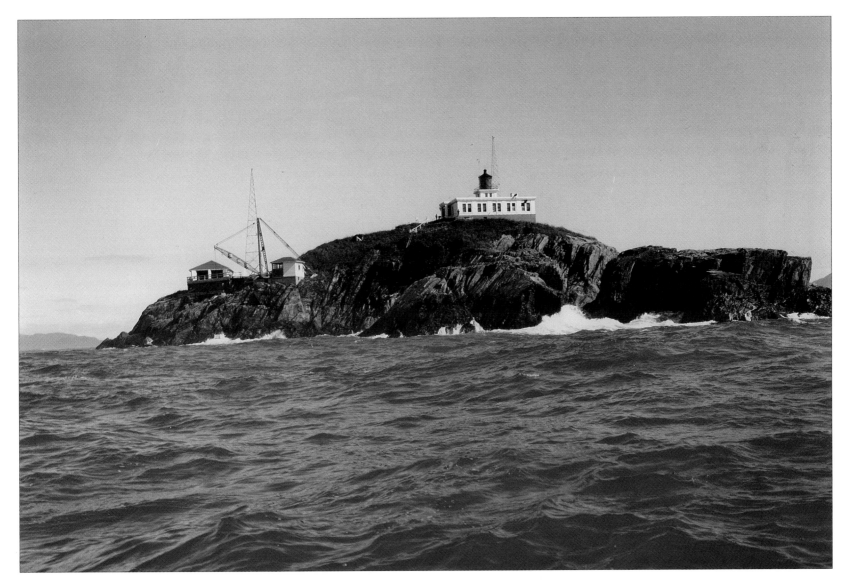

LIGHTSHIPS

Although the lightship arrived late in the history of aids to navigation, it is quickly becoming a thing of the past. The first lightship ever was situated at the Nore Sandbank, at the confluence of the Thames and Medway Rivers in England. Placed at the site in 1731, this vessel was a typical one-masted sloop bearing a crosstree from which hung two lanterns, each holding two candles. Like most of the English lighthouses, the vessel was privately owned and the owner collected dues from those who used it. This lightship was a success, and its popularity prompted the positioning of a lightship at Dudgeon Shoal some distance off the Lincolnshire coast. Other stations were soon established, and by the end of the eighteenth century England had five lightships actively on duty.

England also directed its efforts toward improving the quality of light used on these vessels. In its first attempt at amelioration, the nation introduced the relatively new Argand lamp. Later

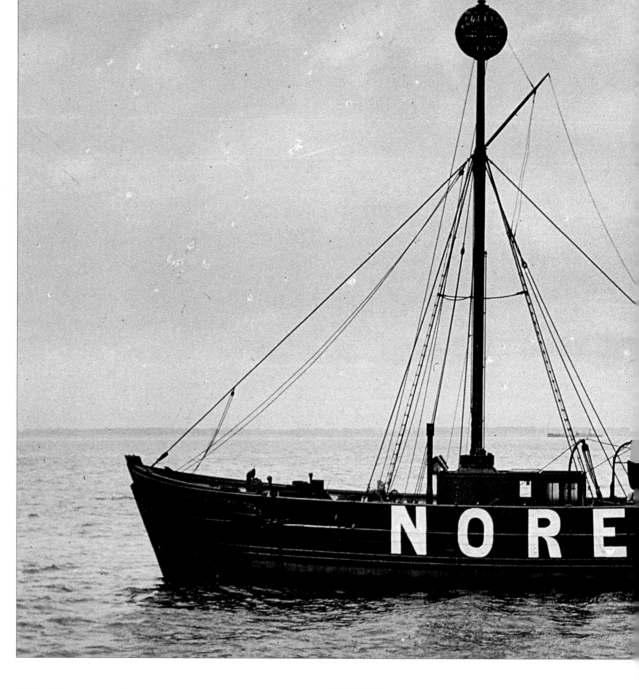

England began considering using a reflector for the lamps, as well as the use of a lantern with more than one light. These systems were useful in preventing the light from being obscured by the ship's mast.

During the nineteenth century the use of lightships to illuminate dark waters spread to various other nations, including Canada, France, the Netherlands, and the United States.

CANADA

One instance in which Canada used the lightship as an aid to navigation occurred in the middle of the nineteenth century. To direct shipping traffic into the Fraser River, a lightship was placed in the Strait of Georgia at the river's entrance. Gold had been discovered up

Nore Sandbank was the first lightship station in the world.

the Fraser, attracting numerous prospectors who traveled the river carrying supplies and equipment.

Known and labeled as *Sand Heads No. 16*, the lightship went into service in 1865. It survived for fourteen years, until a rotting hull made the vessel unusable, at which point it was replaced by a sturdy screwpile lighthouse with a wooden superstructure. Solidly built, the lighthouse served until the year 1905, when the

channel into the river shifted, reducing the lighthouse's accuracy as a guide.

This ineffective aid to navigation was replaced by a better-positioned lightship, which served until 1911, by which point it had fallen into a grave state of disrepair. The old screwpile lighthouse was reactivated until a replacement lightship could be secured.

United
States
Lightships

The first lightship in the United States was anchored in 1820 at Willoughby Spit in Chesapeake Bay. Because this location was too exposed for a 70-ton (63.4t) vessel, the fifth auditor moved it to the less rigorous station of Craney Island the following year. By 1823 six additional inside light vessels—ones stationed in bays, sounds, harbors, or rivers—were activated, and the first outside lightships—ones stationed in the ocean—went on duty guiding shipping traffic into and out of New York Harbor. By 1837 the United States had twenty-six active lightships; fifteen years later, when the Lighthouse Board took over, the number had grown to forty-two.

Early in its career, the Lighthouse Board had developed a policy that where and when possible inside lightships would be replaced with lighthouses, the major underlying reason being that lighthouses cost much less to build and operate than did lightships. This plan of action had been prompted by the development of the screwpile lighthouse, which, like the lightship, could be placed in the water on or adjacent to the navigational hazard. Later, in the 1870s, the caisson lighthouse came into use. Being of sturdier construction, it too could be placed on or near the hazard. It was also capable of withstanding extremely tumultuous waters. With these new advances in lighthouse construction, the number of lightships used by the United States dropped from forty-two to twenty-four by the year 1889.

However, due to the identification of a number of new sites dangerous to ships off the U.S. coast, the use of lightship stations took an upward turn, and by 1917 there were fifty-three of these vessels in service. In more recent years, though, other technology has come along that has permitted the permanent replacement of lightships. The "Texas tower" type of lighthouse came to replace a number of lightships on the East Coast. However, these replacements were quite expensive, so the Coast Guard turned to large navigational buoys instead. The British refer to this type of buoy as a lanby. The United States prefers to use the initials LNB.

Weighing more than 100 tons (90.7t), these buoys have a diameter of 40 feet (12.1m) and hold light towers 40 feet (12.1m) above the water. In addition, the buoys have fog signals, radio beacons, and radar-identification signals.

Early Development and Management of Lightships

In the United States, little occurred early on to further the evolution of lightships. Those ordered by Stephen Pleasonton, the fifth auditor of the treasury, were no different from the regular sailing ships, and management of these aids to navigation was guided by the auditor's zeal to save money. If a ship had to come off station, Pleasonton did not assign a replacement. Sometimes lightships would be in port for months, and little was done to notify navigators of their absence. For example, in February 1825, the Diamond Shoals lightship snapped its moorings and suffered considerable damage. Once in port, it stayed there for nearly ten months while undergoing repairs. Meanwhile, the Diamond Shoals station, one of the most dangerous in the United States, was without a light.

After being back on station for about five months, the lightship parted its moorings again in May 1826. Pleasonton directed the captain to obtain another vessel and return to the station to search for the anchor and cable. Unsuccessful in this hunt, the skipper returned to port. Pleasonton then decided to offer a reward for anyone who could find the anchor. Again, the effort was fruitless. Finally Pleasonton did what he should have done in the first place: order a new anchor and cable. It was not until November that the lightship resumed its station.

Ten years passed and nothing had changed. When the important Sandy

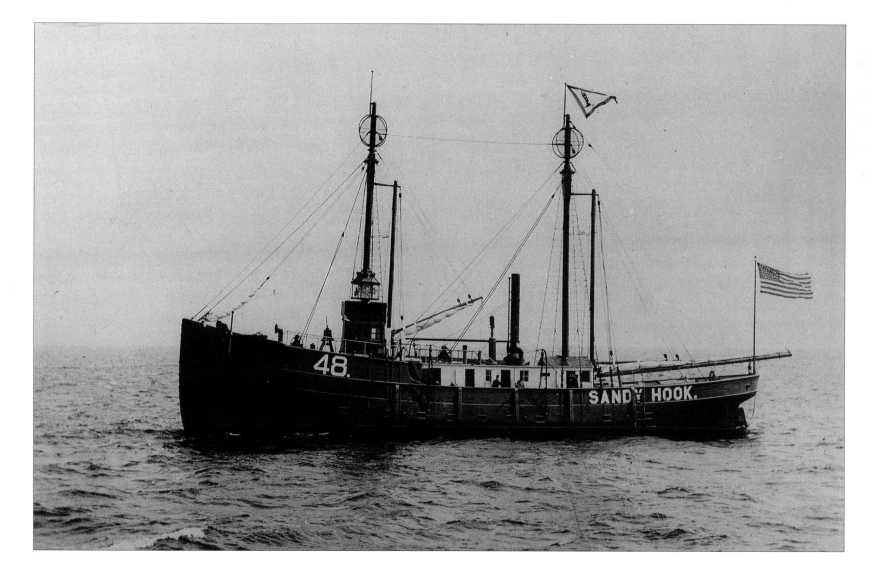

Hook lightship popped its moorings, repairs kept it in port for over a month. In the meantime, no relief vessel was sent to the station. About the same time, the Michilimackinac lightship spent virtually the entire shipping season in port awaiting repairs.

Pleasonton finally purchased a relief lightship in 1837. He assigned it to Norfolk, where it was on call by all stations. It is doubtful, though, that it ever served in the Great Lakes. In 1851 it was still the only relief lightship owned by the government.

The 1838 investigation of aids to navigation concluded that the majority of lightships were in good order and manned by competent seamen. A significant number, however, were found to be in poor condition. Hulls were rotten, and the captains and crew members were not always on board. One vessel at Smith Point, Virginia, at the mouth of the Potomac River, not only had an absent captain and crew, but was left solely in the hands of a fourteen-year-old boy. He had been left in charge even though he did not have the strength to raise the heavy lantern to the masthead. The inspector for that area said that in general the lightships there were kept by local farmers.

The lanterns used on lightships during this period varied in shape and size. Each vessel had one or two lanterns, and the light was produced by a compass lamp, also known as a common lamp, which had many wicks.

For the most part, lightships also had a fog signal, usually a bell, but in at least one instance a cannon. When lightships were fitted with more modern fog signals, such as the horn or siren, the bell was retained as a backup.

Lightships and the American Civil War

When the Lighthouse Board took charge of U.S. aids to navigation, it endeavored to whittle down the number of inside lightships. But it had not gotten much further than stating a policy when the Civil War began. Lighthouses and lightships became the targets of the rebels. All lightships from Maryland south were burned, sunk, or hidden.

The Lighthouse Board did not sit idly by waiting for the war to end. Rather, it attempted to restore as many stations as it could and, in some cases, to establish new ones. The most expedient way to set up a new station was to purchase a used ship and quickly outfit it as a lightship. The vessels that the board bought for this purpose ranged from tugs to brigs. For a few stations, such as the two located in the Potomac, the board ordered new vessels from shipyards. When the war ended, the Lighthouse Board attempted to salvage the lightships that had been damaged by the Confederates, even to the point of raising sunken ones.

Numbering Lightships

It was around this time that the Lighthouse Board began numbering its light vessels. Numbering progressed from north to south. Once all had been numbered, new vessels were given the next unused number. While the number identified the lightship, the name written on the ship's side referred to the station it occupied at that time. When the vessel was moved from one station to another, the old station's name was painted over and replaced by the name of the new station; the lightship's identification number, however, remained the same, no matter where the vessel was located.

Improvements of Lightships

Throughout the world, lightships underwent little change during most of the 1800s, but in the latter part of the nineteenth century England, Ireland, France, and the United States were all trying to improve the design, propulsion,

Opposite: Built in South Boston in 1891, lightship No. 48 was immediately assigned to the Sandy Hook station, where it remained until 1894, when it was sent to port for repairs. In 1895 it was assigned to the Cornfield Point station in Connecticut. It remained there until 1925, when it was condemned and sold. It was the first lightship to have the capability of using a flashing light.

Sub Sinks Lightship

In August 1918 the crew of the Diamond Shoals lightship saw a German submarine sink a U.S. freighter. The radio operator of the lightship sent out a message to all vessels in the vicinity to seek refuge. Apparently, the Germans heard the broadcast and ordered the crew to leave the lightship. After the crew departed, the gunners on the German submarine fired six shots into the lightship. Their assault was temporarily interrupted when a freighter came into view. The Germans sank this vessel, and then resumed firing shots at the lightship until it sank.

As a result of the lightship's message, though, over twenty ships took refuge in the bight of Cape Lookout. The Bureau of Lighthouses placed buoys at Diamond Shoals and did not send a lightship back until World War I was over.

construction, lighting, and living accommodations. These countries flattened the hulls of lightships and installed bilge keels to inhibit rolling. The modern lightship is designed for sea-keeping ability, that is, the ability to stay on station during rough weather.

For many years, lightships had hulls made of wood, a particulary unfortunate material for vessels stationed in southern U.S. waters, where the marine worm thrived, greatly shortening the life of wooden ships. It was a problem recognized by both the fifth auditor and the Lighthouse Board, which commented, "A whole plank is completely riddled with worm-holes before the least indication is first visible on the skin of the ship inside."

Though there were a couple of iron-hulled lightships on duty in the 1860s and early 1870s, there was strong resistance against employing this type of vessel. Naval architects argued that an iron-hulled lightship could not withstand the shocks of rough seas that wooden hulls absorbed, and iron ships would suffer greater damage if driven ashore.

The Lighthouse Board began to ease into metal hulls in 1881 when it ordered lightship No. 43, which was to have a metal hull sheathed with yellow pine. Another step along these lines was the use of the composite hull, which had a steel frame covered with wood and metal topside. By 1900 virtually all parties involved seemed to accept the

metal hull. The last wooden lightship was ordered in 1902.

For many years, lightships were propelled by the wind. Engines were not ordered until 1891, when they were used in No. 56 and No. 57. These first engines were relatively weak, so the tenders had to tow the ships to their stations. Over time, however, lightships received engines of greater power that would move them along at ten knots.

As all this activity was occurring, naval architects were also improving the habitability of these vessels. By the year 1894, the lightship labeled No. 58 had a stateroom for each officer and two-man staterooms for the crew.

Over the years, the mooring of lightships improved. The anchor increased in weight and the cable became sturdier and longer. Moreover, with the addition of engines in new lightships in 1894, the crew could better keep the ship on station in rough seas. The Lighthouse Board did not like these vessels being away from their stations, and the engines reduced the need to depart.

In 1894, each of the three Lake Michigan lightships was moored to a 5-ton (4.5t) sinker; in this same year the lightship at Diamond Shoals, one of the most exposed sites in the country, was held on station by a mushroom anchor and chain, which together weighed 14 tons (12.6t). As a precaution, lightships were equipped with two mushroom anchors, one for emergencies.

The Dangers of Lightships

Lightship duty was, without question, the most dangerous occupation of the government's civilian service. The crew members not only were subjected to rough seas and severe weather, but also stood a strong likelihood of being rammed by another vessel trying to make its way to port in the fog. Sail ships and barges under tow were the chief culprits of such accidents. If the vessel at fault could be identified, it would have to pay for the repair of the lightship. But more often than not a barge would carom off a lightship and disappear into the fog.

Ice and storms have also brought about the demise of many lightships. In 1913 a lightship 13 miles (20.8km) from the harbor of Buffalo, New York, disappeared in a storm, taking six crew members along with it. Six months later, the vessel was found containing two bodies. The Bureau of Lighthouses had the vessel raised and taken to Buffalo. In 1918 the lightship at Cross Rips station suddenly vanished. It was not until fifteen years later that a dredge retrieved wreckage in the vicinity of the station. Investigators speculated that the vessel had been crushed by ice. These are just a couple of lightships that have been destroyed and lost.

Lightship No. 103, built during the early 1900s, is the last surviving lightship designed specifically for duty on the Great Lakes. It is currently on display in Port Huron, Michigan.

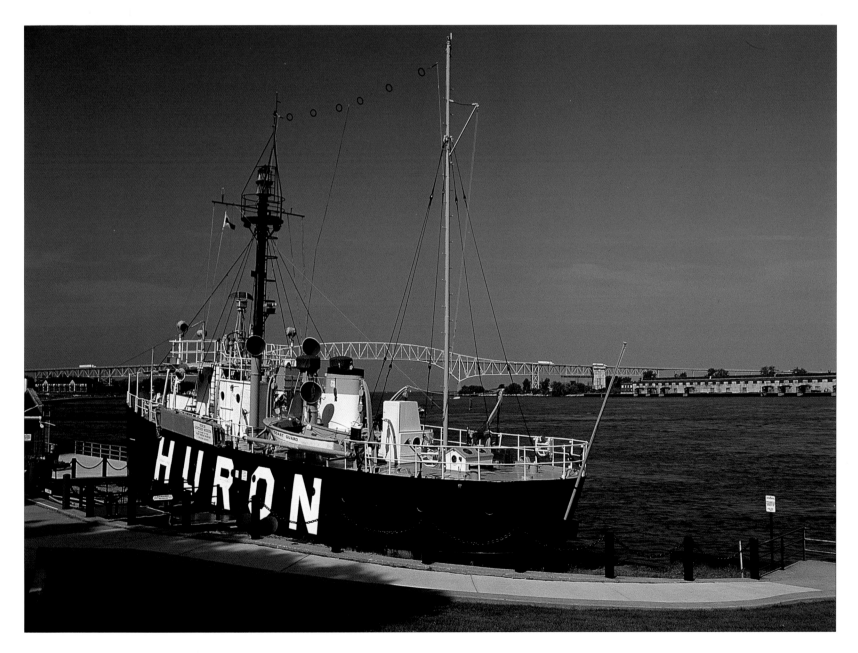

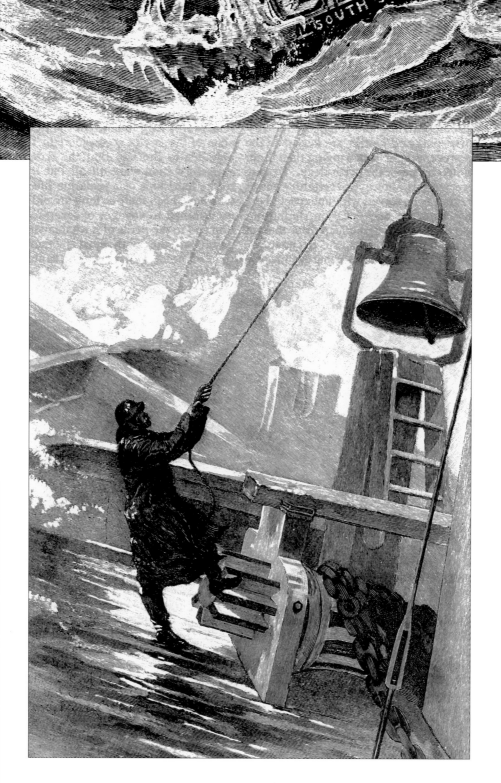

Top and bottom: Lightship No. 1 served at Nantucket New South Shoal station from 1856 to 1892. It served at several other stations until 1930 when, at the age of 75, it was retired from lightship duty.

LIGHTSHIPS

TODAY

Although the lightship was a great success as an aid to navigation, it has rapidly fallen into disuse. By 1985, Great Britain had only eighteen lightships, down from forty-five only ten years before. In the United States no lightships remain active; the last one on duty, at the Nantucket Shoals station, went out of service in 1983. Although no longer in use, lightships are alive and well in the United States; a number of them have been preserved in museum settings where they are popular visitor attractions that can be enjoyed by all.

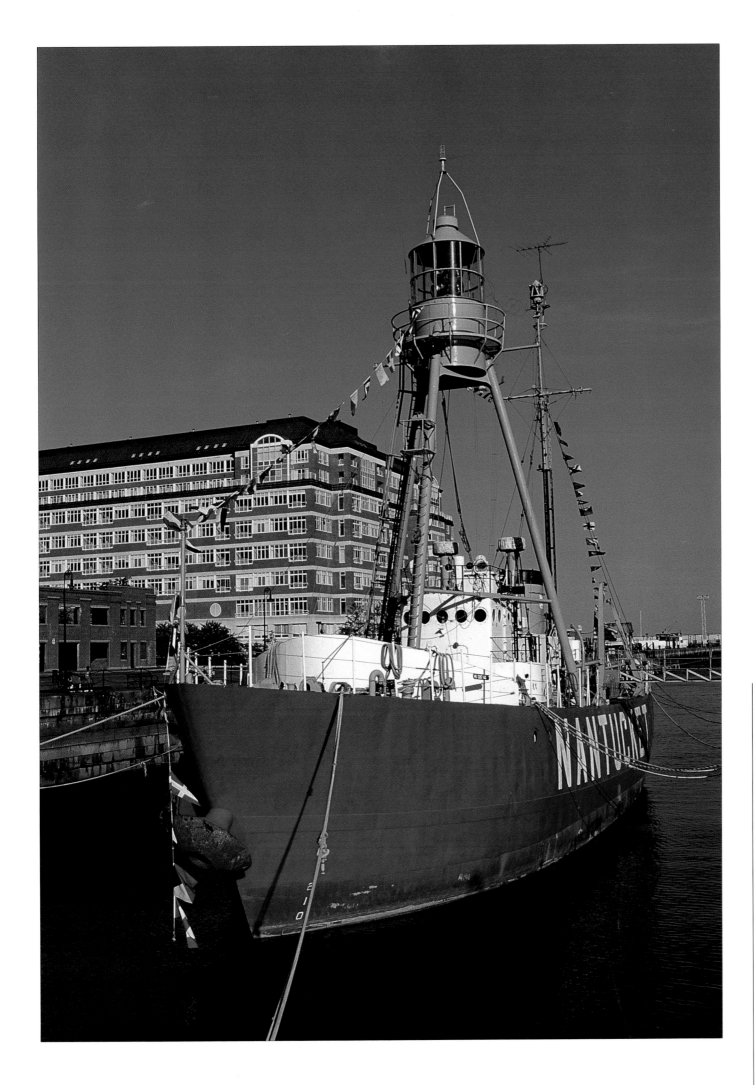

Nantucket Shoals lightship station came into existence with the abolishment of the Nantucket New South Shoal station in 1892. The Nantucket station lasted until 1983, when its lightship was the last taken off station. Two light vessels sank while at this station.

THE KEEPERS

Today, many lighthouses are automated, igniting just before sunset and clicking off shortly after sunrise, operating solely from solar power. Hence, the traditional lighthouse keeper has become a dying breed, replaced by technicians who live and work hundreds of miles from the lighthouses they tend, visiting the structures only four times a year.

For over two millennia, the lights required a human hand to start them and keep them operating during the course of the night. During the last hundred years, however, technology has been developed that permits lighthouses to run with only occasional attention.

THE KEEPER

But it was not always this way. Up until recent years, the keeper was the key element in lighthouse operation. Since the middle part of the nineteenth century, the performance of keepers has been professional, dedicated, and exemplary. British lighthouse historians Douglass Hague and Rosemary Christie feel that in the early days English keepers were often underpaid and exploited, particularly by those private citizens who owned lighthouses. This treatment, they believe, led to corruption. In 1836, when all English lighthouses became the responsibility of the Trinity House of Deptford Strond, conditions changed. England's lighthouses began to improve, as did the treatment of keepers. The lights of Scotland and Ireland had already been put under better management and operated in an improved fashion.

In the United States, which had relatively poor aids to navigation throughout the first half of the nineteenth century, the influence of

Quarterly supplies ranging from food to tools and equipment were brought to the station by the district tender.

politicians in the appointment of keepers contributed to the inferior quality of American lights. (Of course, this was not the only factor determining the efficiency of U.S. lighthouses; also at fault was the primitive illuminating apparatus used during this time.) It was not until the Lighthouse Board took over the management of aids to navigation in 1852 that the quality of these lighthouses improved.

Before the union of Canada, the Canadian organizations managing lighthouses were rather lax, and generally light keepers did not maintain their lighthouses well. But after 1841, the Department of Public Works became responsible for lighthouses and instituted stricter practices in their operation, which resulted in improving the quality of Canada's lighthouses.

FEMALE KEEPERS

Though the keeping of lighthouses is generally regarded as a male activity, women have been involved over the years. In fact, some of the better-known keepers who achieved status for heroism have been women. When the American states transferred their lighthouses to the jurisdiction of the central government in 1789, one of the keepers who transferred to government service was female. From 1820 to 1852 the fifth auditor of the treasury gave special treatment to women, insisting that the widow of a recently deceased keeper had first preference for the keeper's position at that lighthouse. A number of widows took advantage of this offer, and by 1852 the fifth auditor proudly claimed that the nation had thirty female keepers.

After 1852 the Lighthouse Board issued a policy against hiring women, saying that special approval from Washington was required. Despite this restrictive policy, women continued to obtain positions as keepers. One such woman was Ida Lewis, keeper of the Lime Rock lighthouse in Rhode Island, who later became a nineteenth-century celebrity for the rescues she had achieved over the years. President Ulysses S. Grant, Admiral George Dewey, and numerous other prominent officials came to visit her and pay their respects. Kate Walker, a widow whose husband had been the light keeper of the Robbins Reef lighthouse in New York Harbor, rescued more than fifty fishers in distress over the years. On top of taking care of the lighthouse, which she tended until she was seventy-three years old, she raised two sons, rowing them a mile each day to Staten Island so that they could attend school. Women served as either keepers or assistant keepers on all coasts of the

PAY OF CANADIAN KEEPERS

Over the years Canadian keepers have been poorly paid, making it difficult at times for those in charge of Canadian lighthouse administration to find and hire competent, dilgent employees. After British Columbia joined the Dominion in 1871, keepers received drastic pay cuts. In 1880 the keeper at Race Rocks, for example, had his salary reduced to $125 a year (20 percent of his former salary); to make matters worse, his wife was fired as assistant keeper, and he was told he would have to pay the salary of her replacement. Moreover, if a keeper took leave for a vacation or family need, he had to hire and pay a substitute keeper to maintain operations in his absence. These poor conditions continued until 1958, when assistant keepers became civil servants.

United States. The last female civilian lighthouse keeper was Fannie Salter, who retired in 1947 after twenty-two years of devoted service at Turkey Point in Chesapeake Bay.

Though the United States seems to have had more female light keepers than Great Britain and Canada, these two countries have, over the years, had women serve as keepers and assistant keepers, not the least of whom were the nuns at Youghal, Ireland (see page 15). Canada's first female principal lighthouse keeper was Mary Ann Croft; having succeeded her aged father in 1902, she served as the keeper at Discovery Island for thirty years.

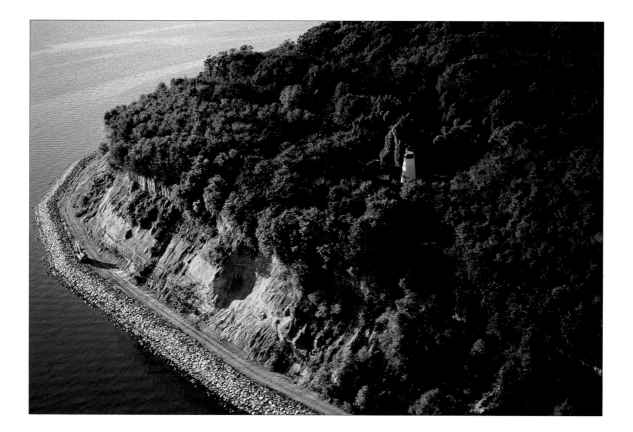

T R A I N I N G

K E E P E R S

For many years, training of light keepers was virtually nonexistent, and any directions for operating a lighthouse were limited. In the United States, for example, before 1852 all the written instructions a light keeper received were listed on only one sheet of paper. Moreover, there was no one to give guidance to a new keeper, except the local commissioner of customs, who oversaw the lighthouses in his district.

The commissioner's advice was even more general than the sheet of directions. And since each lighthouse had only one keeper, a new keeper had no one with whom he or she could consult.

By the middle of the nineteenth century, most advanced nations had developed sets of written instructions for the operation of their lighthouses. In 1851 American military officers spoke highly of the instruction manuals for the lighthouses and lightships in France and Great Britain. Filled with admiration, these officers reported that England had instructions that were "full and explicit," "printed in large type," and "kept in the quarters of the keepers, in frames, so that no one can ever be at a loss to know his duty."

After 1852, the newly established U.S. Lighthouse Board began producing books of instructions that spelled out in detail the duties of keepers, the operation and management of the lens lights and other equipment, as well as answers to common problems. Canada, too, had ample instructions for keepers, such as *Rules and Instructions for the Guidance of Light Keepers*.

The Lighthouse Board also went about trying to hire better-qualified people as keepers, particularly people who could read. This effort had mixed results in the early years because it was not until 1871 that civil service reform was instituted, which effectively did away with the involvement of the collectors of customs in the appointment

AFRICAN-AMERICAN KEEPERS

The fifth auditor of the treasury stipulated that African-Americans were not permitted to work in U.S. lighthouses and lightships; the only exception was that they could serve as cooks aboard lightships. Despite the restriction, African-Americans did in fact work with aids to navigation during the reign of the fifth auditor. On occasion, lighthouse keepers in the southern states used slaves to tend their lighthouses. One such keeper was the one responsible for the Cape Hatteras lighthouse. This man was actually dismissed for having slaves work in the lighthouse. George Worthylake, the first lighthouse keeper at Boston Harbor lighthouse, was drowned on the way back to the lighthouse. With him when the boat went down were his family and a slave who most likely performed lighthouse duties to relieve Worthylake, who also served as the port pilot. At the time of the 1838 inspection of lighthouses, one

inspector found that a lightship had been left in the charge of a fourteen-year-old African-American boy.

When the Lighthouse Board took over lighthouse administration, it did not prohibit hiring African-Americans, but it did require the district inspector to obtain the board's permission before doing so. During the American Civil War, the board established a lightship at Port Royal Harbor, South Carolina, and hired four "contrabands" (former slaves) to operate it. In 1870 two young African-Americans tended the Lower Cedar Point screwpile lighthouse in the Potomac River. The keeper was Robert Darnell and the assistant keeper was John F. Parker.

The historian cannot help but feel that African-Americans were more extensively employed in aids to navigations than the records indicate, especially considering their involvement in all other aspects of maritime work.

BIRDS

———

Although they seem harmless, birds actually used to be a source of danger for lighthouses. Attracted to the light, birds have been known to fly directly at it, smashing panes of glass and sometimes injuring the lens. Sometimes only a stray bird would fly into the lantern, but often entire flocks were attracted to it. In order to keep the lens from injury, the keepers used to shoot the birds to drive them away from the lantern. At some sites a heavy wire netting was placed around the outside of the lantern to protect the lens.

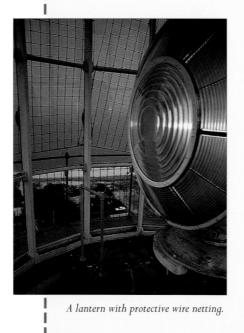

A lantern with protective wire netting.

of lighthouse keepers. After 1852, the board staffed lighthouses with two to three keepers; later, when fog signals and radio beacons were introduced, additional keepers were added. Nevertheless, formal training was minimal; for the most part, keepers learned what they needed to know on the job.

In the United States, no specified apprentice position has ever existed. A lighthouse would have a principal keeper, first assistant keeper, second assistant keeper, and so on. A new employee would take the lowest assistant title. In Great Britain today there is an apprentice position: supernumerary assistant keeper. The apprentice is put on a twelve-month probation and assigned to a number of different lighthouses. If the apprentice passes probation, he or she will be designated an assistant keeper and assigned to a specific light.

———

ATTITUDE

———

The attitudes of keepers toward lighthouses varies depending on the individual. For the most part, keepers have tolerated their assignments, knowing that the situation is only temporary and that they will later be assigned elsewhere. Some, however, have been driven to insanity by the solitude their jobs entail. Still others have actually preferred the isolation of rock island

lighthouses. One of the keepers tending Eddystone during the early part of the twentieth century, for instance, could find peace and contentment only while he lived at the rock-bound structure. Deeply enamoured of his job and the ensuing seclusion, he gave up his relief turns for two years. While he was at the lighthouse he was "quiet and orderly," but when he went ashore his inability to cope with this separate world led him to drink to excess. As soon as he returned to the lighthouse, however, he was fine.

———

THE

———

DANGERS

———

OF

———

LIGHTHOUSE

———

KEEPING

———

Lighthouses are often located in tumultuous, isolated waters, which pose danger to the keepers living there. In various spots, oceans have been known to rise up and wash over light towers and the attached dwellings, injuring,

and sometimes killing, the keepers and their families.

But there are also instances in which the residents of lighthouses have braved incredible tempests and lived to tell the tale. One such instance occurred at a U.S. light station on one of the rock islands off the coast of Maine, which are often subject to violent storms known as nor'easters. It was here that Abbie Burgess achieved fame when her father went ashore to pick up mail and groceries. A New England storm arose, and the waves prevented him from getting back to Matinicus Island, 25 miles (40km) away. Meanwhile, Abbie had an invalid mother and four younger sisters on her hands. Fortunately, she had helped her father with the lighthouse in the past, so she knew the rules and methods of operation. Each evening during her father's absence, she activated the light. When water flooded the dwelling, the beleaguered women were compelled to seek shelter in the two light towers, each of which was located at one end of the dwelling. Despite the danger, Abbie kept the lights burning for four weeks, until her father returned.

Only one year later the women were confronted with another tempest when Abbie's father went ashore for his pay and supplies. Although this storm was shorter—it lasted three weeks—it was more difficult because they ran out of supplies and had to survive on one egg and a cup of cornmeal a day.

RESCUES

Throughout the years, keepers have played a big part in rescuing victims of shipwrecks and capsized boats. Although the successful efforts of Grace Darling and her father to save passengers of the sinking *Forfarshire* off the northeast coast of England have been chronicled far and wide, other rescues have not received much publicity. Marcus A. Hanna was the keeper of the Cape Elizabeth lighthouse, more popularly known as "Two Lights" because two lit towers were situated there until 1924. In the midst of a severe snowstorm, he rescued two sailors from the schooner *Australia*, for which he received a gold medal. On at least two occasions, Canada gave silver watches to American light keepers in recognition of their efforts to rescue crew members and passengers of Canadian vessels. The United States Lighthouse Service made it a point to list rescues in the monthly issues of their *Bulletin*, the organization's widely distributed house organ. While most of these rescues were fairly routine, some were hairraising experiences, fraught with danger.

Canada, too, had its share of heroes and heroines. One was Minnie Patterson, wife of the keeper of Cape Beale lighthouse in British Columbia. When her husband saw a vessel in distress, she traveled 6 miles (9.6km) through thick forest, muck, and marshy areas in an eighty-knot gale to alert the tender *Quadra* of the impending tragedy. The rescue was successful, and Minnie was acclaimed the Grace Darling of Canada. Like Grace Darling, she died of tuberculosis a few years after her heroic act.

In several instances, Canada installed a lifesaving station at sites near lighthouses where shipwrecks occurred more frequently than usual, such as Sable Island, Seal Island, and Saint Paul Island. Though the lifesaving staff did the heavy lifting in a rescue, light keepers often participated, particularly in pulling survivors ashore.

PASTIMES

Serving at lighthouses or on lightships could be monotonous and dreary duty. Often, keepers at isolated stations would take up fishing and hunting as diversions. Also, lighthouse organizations circulated libraries for the use of keepers and their families. To the children, the arrival of the quarterly library was a time of great joy—a chance to explore books they had not already read. These libraries had a wide range of offerings, including novels, biographies, adventures, religious works, and magazines. Canada began circulating these libraries in 1865, and several years later the United States followed suit.

Another popular pastime of light keepers was gardening. Not every station, however, was properly equipped to allow for this diversion, so keepers often needed to be resourceful in their efforts. In certain cases where only rock abounded, a keeper would transport barrels of soil to the station and place it in an area where he or she would be able to grow a few flowers. At one rock island lighthouse in Canada, the keeper and his wife searched out potholes, filled them with soil, and then planted flowers. Patience was a necessity for lighthouse gardeners as storms often washed away the soil, forcing the keeper to start all over again. Other hobbies prevalent among keepers and lightship crews were basket weaving, wood carving, and fretwork. In more recent years, some keepers have taken correspondence courses.

THE INSPECTOR

One event that universally brought apprehension to light keepers and their families was a visit by the inspector. The inspectors from all different countries

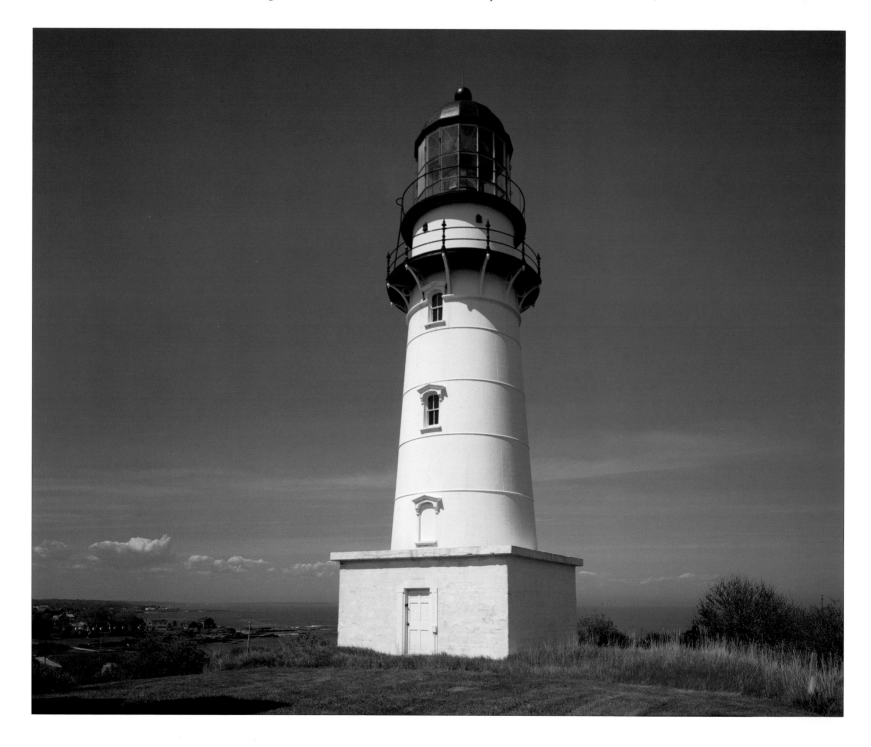

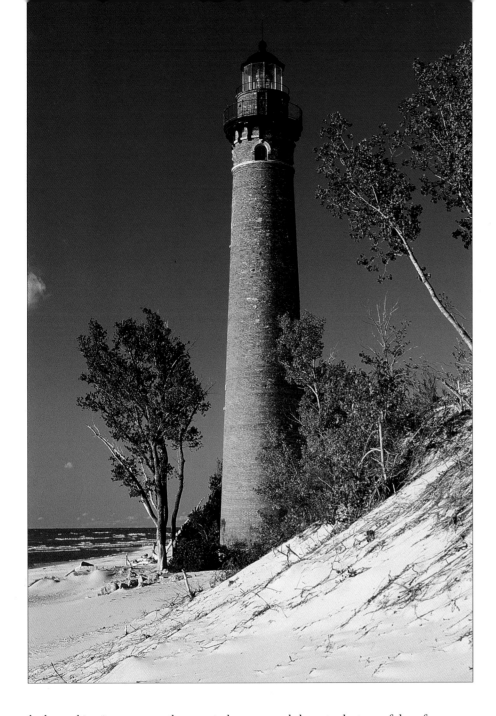

LIGHTHOUSE
KEEPERS
TODAY

With automation now at work in most lighthouses, keepers are becoming obsolete. Many enthusiasts feel that the disappearance of the keeper has removed the heart from the lighthouse. Mariners no longer have a human being looking out for them and providing safety; instead, a robot turns on the light fifteen minutes before sunset, turns it back off the next morning, and, when conditions warrant, activates the fog signal. Some say that the human side of the lighthouse is being sacrificed on the altar of the budget.

It is true that the heart has been removed from lighthouses, but in actuality this is not just a matter of budget. The fact is that the lighthouse has lost much of its usefulness, and today is of help primarily to small fishing vessels. Larger vessels have radar, sonar, and satellite navigation to assist the navigator in determining the ship's location. With its closed bridge, a large ship would not even hear a fog signal. Furthermore, fog is of little consequence to such a vessel, which can activate radar to guide it safely along its course.

had one thing in common: they wanted each station to be spic and span with no dust or dirt in sight. The inspector did not announce when he would arrive; the keepers and families just knew that this ominous visit would occur once a quarter. When a tender was seen in the distance flying the inspector's flag, the news was passed quickly around the station, and everyone would scurry about to ensure that the station was thoroughly clean and in top operating order. The inspector would alight with white gloves in hand. Equipment,

workshop, tools, tops of door frames, dwelling, tower, oil butts, privy, storage areas, and everything else associated with the station were examined. Most stations passed, but the keepers of those that did not were warned that if conditions did not improve by the time of the next inspection, action would be taken. One California keeper, who received two bad inspections in a row at a brand-new station, was dismissed on the spot despite his twenty-one years of duty. Cleanliness was indeed next to godliness in the lighthouse service.

AFTERWORD

Although there has always been a deep interest expressed by the people of European and North American countries in their lighthouses, not a great deal has been done to preserve lighthouses until recent years. The pride in and fascination with lighthouses has manifested itself mostly in books and magazine articles, focusing primarily on the people operating the lighthouses.

Historic preservation usually begins at the local level, and the preservation of lighthouses has been no exception. One of the earliest instances of lighthouse preservation occurred in 1882, when, after the construction of the new Eddystone lighthouse, the citizens of Plymouth, England, raised money in order to have the upper portion of the old lighthouse moved ashore and reerected. For the most part, though, concern for saving these magnificent structures has surfaced only during the twentieth century.

Great Britain and Canada are in the early stages of lighthouse preservation. Canada has been the more active of the two, and consequently, government and commercial interests there have witnessed the magnetic pull of lighthouses for tourists. In fact, lighthouse automobile trails have been developed in order to attract tourists. Some lighthouses in recent years have been turned over to Parks Canada, local historical societies, and local governments for public use. It is anticipated that the move toward preservation will increase over the years.

In the last twenty to twenty-five years, interest in lighthouses and lightships has substantially increased in the United States, perhaps because of the beginning of the wholesale automation of lighthouses and the replacement of lightships with automated aids to navigation. Most people can understand the necessity and rationality of automation since it saves a great deal of money, but emotionally many do not like the change. The U.S. Coast Guard exacerbated this feeling with some insensitive alterations of light towers. On at least one tower the lantern was removed and replaced by an airport beacon light. Mile Rock lighthouse, a steel structure near the Golden Gate Bridge in San Francisco that is clearly visible from the shore, had its tower taken down to the first tier, despite public protest. A helicopter landing pad was erected atop the surviving structure.

In recent years, the Coast Guard and various other governmental agencies have developed a healthy attitude toward preserving U.S. lighthouses. They have been careful—overly zealous, some would say—in leasing lighthouses to public and local groups.

Although it used to take several years for a historical preservation group to obtain a lease from the Coast Guard, conditions have changed. The Coast Guard has not only sped up the leasing process, but is now also transferring ownership, and therefore complete responsibility, to local historical and government agencies.

In the mid-1960s, during the early stages of automation, the Coast Guard tore down a number of wooden screwpile lighthouses in Chesapeake Bay and replaced them with automated lights on small platforms. Vandalism, the potential for fire, and the high cost of maintenance had all sparked this action. Three of the screwpile lighthouses have been moved to museums around the bay, and one remains in its historic location, accessible only by boat.

There are numerous other places around the United States where the Coast Guard has had to remove wooden outbuildings at automated light stations for the previously mentioned reasons. Cape Mendocino light station in California, Little Sable light station in Michigan, and the Makapuu Point light station in Hawaii are but three examples where all outbuildings have been removed.

A large number of lighthouses have survived as historic structures open to visitors. Many of these light stations have gone to other governmental areas, such as parks, forests, and wildlife reservations. The National Park Service

has about fifty old lighthouses scattered around the country in various parks. At some of these still-active sites, the Coast Guard has retained ownership of the light tower, such as at Sandy Hook, New Jersey, and Bodie Island, North Carolina. At others, the Park Service owns the light station. At still others, the Coast Guard and a wildlife refuge hold joint ownership.

The Coast Guard has leased many lighthouses to local historical societies. For example, the Presque Isle Lighthouse Historical Society in Michigan has leased this old lighthouse from the Coast Guard. It maintains the old structures and is developing a museum on the history of the lighthouse. Similarly, the Coast Guard has leased the Cana Island lighthouse in Wisconsin to the Door County Maritime Museum.

Well over a hundred lighthouses have either been transferred by the Coast Guard to another governmental or nongovernmental organization, or leased by the Coast Guard to public or private groups. The vast majority of them are in the hands of organizations that are opening the lighthouse to the public. Several light stations have been converted to bed-and-breakfast inns, and a number of others have been leased to American Youth Hostels Inc. and converted into hostels.

With this great interest in lighthouses, an infrastructure has developed. There are organizations devoted to lighthouses (see above), books are

ORGANIZATIONS

The following organizations are the most prominent ones dealing with lighthouses and lightships:

Great Lakes Lighthouse Keepers Association
P.O. Box 580
Allen Park, MI 48101
Focuses on lighthouses and lightships of the Great Lakes. Publishes The Beacon, *which provides information about Great Lakes lighthouses and activities of local lighthouse associations.*

The Lighthouse Preservation Society
P.O. Box 736
Rockport, MA 01966
Concerns itself with lighthouse preservation, technical assistance to local historical lighthouse groups, and government-policy issues related to lighthouses. Issues a newsletter.

The U.S. Lighthouse Society
244 Kearney St., Fifth Floor
San Francisco, CA 94108
Encourages the preservation of lighthouses and conducts regional tours of lighthouses several times a year. Issues a quarterly historical magazine called The Keeper's Log. *Publishes excerpts from the* Lighthouse Service Bulletin *(1910–1939) and reports on current activities related to lighthouses and lightships.*

being written and printed, and at least one gift store—located in Wells, Maine—has come into being. Aside from selling books, sculptures, paintings, and other gifts solely related to lighthouses and lightships, this shop also issues a monthly lighthouse newspaper called the *Lighthouse Digest*.

Although most maritime museums around the United States have objects related to lighthouses on display, there is but one museum devoted solely to lighthouses, lightships, and other aids to navigation. Started by Ken Black, a retired Coast Guard employee and

captain of lightships, the Shore Village Museum is located in Rockland, Maine. Stuffed with lenses, foghorns, and numerous other items related to aids to navigation, this museum is a must-see for the lighthouse buff.

Many lighthouses are being saved today by dedicated people who do not have a great deal of money, but who do possess enormous amounts of enthusiasm, energy, and ingenuity. I encourage you to visit these lighthouse sites and view not only these wonderful structures, but also some of the most beautiful seascapes in the world.

FURTHER READING

Aikin, Ross R. *Kilauea Point Lighthouse: The Landfall Beacon on the Orient Run.* Kilauea, Hawaii: Kilauea Point Natural History Association, 1988.

Baker, T. Lindsay. *Lighthouses of Texas.* College Station, Tex.: Texas A&M University Press, 1991.

Bush, Edward F. "The Canadian Lighthouses," *Occasional Papers in Archeology and History No. 9.* Ottawa, Ontario: Branch of Historic Parks and Sites, Indian and Northern Affairs, 1974.

Clifford, Mary Louise, and J. Candace Clifford. *Women Who Kept the Lights: An Illustrated History of Female Lighthouse Keepers.* Williamsburg, Va.: Cypress Communications, 1993.

Dolding, Michael. *Bermuda Light: The Story of Gibbs Hill Lighthouse.* Bermuda, 1990.

Engel, Norma. *Three Beams of Light: Chronicles of a Lighthouse Keeper's Family.* San Diego: Tecolote Publications, 1986.

Gibbs, Jim A. *Lighthouses of the Pacific.* Westchester, Penn.: Schiffer Publishing Ltd., 1986.

Gleason, Sarah C. *Kindly Lights: A History of Lighthouses of Southern New England.* Boston: Beacon Press, 1991.

Graham, Donald. *Keepers of the Light: A History of British Columbia's Lighthouses and Their Keepers.* Madeira Park, British Columbia: Harbour Publishing Ltd., 1987.

————. *Lights of the Inside Passage: A History of British Columbia's Lighthouses and Their Keepers.* Madeira Park, British Columbia: Harbour Publishing Ltd., 1993.

Grant, Kay. *Robert Stevenson: Engineer and Sea Builder.* New York: Meredith Press, 1969.

Hague, Douglas B., and Rosemary Christie. *Lighthouses: Their Architecture, History and Archeology.* Wales: Gomer Press, 1975.

Holland, Francis Ross. *America's Lighthouses: Their Illustrated History Since 1716.* Brattleboro, Vt.: Steven Greene Press, 1972. Reprint, New York: Dover Publications, 1988.

————. *Great American Lighthouses.* Washington, D.C.: Preservation Press, 1989.

Hyde, Charles K. *The Northern Lights: Lighthouses of the Upper Great Lakes.* Lansing, Mich.: Two Peninsula Press, 1986.

Love, Dean. *The Lighthouses of Hawaii.* Honolulu: University of Hawaii Press, 1991.

Lowry, Shannon, and Jeff Schultz. *Northern Lights: Tales of Alaska's Lighthouses and Their Keepers.* Harrisburg, Penn.: Stackpole Books, 1992.

Majdalany, Fred. *The Eddystone Light.* Boston: Houghton Mifflin Co., 1960.

McCarthy, Kevin M., and William L. Trotter. *Florida Lighthouses.* Gainesville, Fla.: University of Florida Press, 1990.

Mills, Chris. *Vanishing Lights: A Lightkeeper's Fascination with a Disappearing Way of Life.* Hantsport, Nova Scotia: Lancelot Press Ltd., 1992.

Naish, John. *Seamarks: Their History and Development.* London: Stanford Maritime, 1985.

Nelson, Sharlene P., and Ted W. Nelson. *Umbrella Guide to Washington Lighthouses.* Friday Harbor, Wash.: Umbrella Books, 1990.

Parker, Tony. *Lighthouse.* New York: Taplinger Publishing Co., 1976.

Perry, Frank. *The History of Pigeon Point Lighthouse.* Soquel, Calif.: GBH Publishing, 1986.

Putnam, George R. *Lighthouses and Lightships of the United States.* Boston: Houghton Mifflin Co., 1917.

Shanks, Ralph, and Lisa Woo Shanks. *Guardians of the Golden Gate: Lighthouses and Lifeboat Stations of San Francisco Bay.* Petaluma, Calif.: Costano Books, 1990.

Small, Connie. *The Lighthouse Keeper's Wife.* Orono, Maine: University of Maine Press, 1986.

Stevenson, D. Alan. *The World's Lighthouses Before 1820.* London: Oxford University Press, 1959.

Stick, David. *North Carolina Lighthouses.* Raleigh, N.C.: North Carolina Department of Cultural Resources, 1980.

Talbot, Frederick A. *Lightships and Lighthouses.* Philadelphia: J.B. Lippincott Co., 1913.

Thurston, Harry, and Wayne Barrett. *Against Darkness and Storm: Lighthouses of the Northeast.* Halifax, Nova Scotia: Nimbus Publishing Ltd, 1993.

PHOTOGRAPHY CREDITS

INDEX